"In prose as clean and clear as [...]
fiction responds to writers and artists with real insight-
fulness and surprises—and humor. I ended up thinking:
I *needed* this book. It is eye-opening and splendid. Oh,
this is a wonderful collection of essays!"
 —ELIZABETH STROUT, author of *Lucy by the Sea*

"Ann Beattie's essays on literature, photography, and art
are a joy: reading them is like conversing with her bril-
liant mind—beautifully lucid, frank, nuanced, elegant
and intimate."
 —CLAIRE MESSUD, author of *The Burning Girl*

"Exhilarating and enthralling, this is a collection of
one brilliant essay after another. To hear Beattie's
nonfiction voice is a marvel: You come away feeling
like you've had a passionate and indelible conversation
about literature and art."
 —LILY KING, author of *Euphoria*

"These remarkable essays have the verve and wit of Ann
Beattie's short stories, but a fiction writer recedes behind
the story and these pieces are more personal. We are right
there with her, watching her lively mind at play. What
an extraordinary privilege! Her intellect is formidable but
informal—at ease, confident. Rather than being stricken
mute by her talents, we share her joy as she confides in us
what she loves. These pieces are brilliant and entertaining,
and I will be visiting them again and again."
 —BOBBIE ANN MASON, author of *Dear Ann*

"These are dazzling essays, acute and subtle and very wise. Ann Beattie shows here that she is not only one of our finest fiction writers but a philosopher of the short story. I know of no one who has thought with such insider's brilliance about the form (see especially her breathtaking analyses of Peter Taylor, Alice Munro, and John Updike, as well as her own processes). Then she goes ahead and sensitively yet playfully explores the art of painters, photographers, and sculptors. All in all, it's a must-have book to read and re-read."

—PHILLIP LOPATE, editor of
The Glorious American Essay

"It comes as a surprise, but shouldn't, that Ann Beattie is also a master of nonfiction—essay, travel writing, elegy, striking retrospective considerations of writers, artists, and photographers. These pieces enchant precisely because we see a mind building its particular, spirited intelligence by attention to others. These pieces "are illuminated by her simultaneously nonjudgmental, shrewd insight and the luminosity of her prose." That's Beattie on Alice Munro's fiction, but it captures the quality of mind she brings to bear in this winning record of a reading life and a history of looking deeply, attentively at visual art. Read these essays to learn how to write—and to see."

—PATRICIA HAMPL, author of
The Art of the Wasted Day

MORE TO SAY

MORE TO SAY

ESSAYS & APPRECIATIONS

Ann Beattie

SELECTED AND INTRODUCED BY
THE AUTHOR

BOSTON
GODINE NONPAREIL
2023

Published in 2023 by
GODINE
Boston, Massachusetts
godine.com

ACKNOWLEDGMENTS
The author and publisher wish to thank the various publications where many
of these pieces first appeared, often in slightly different forms.

LIBRARY OF CONGRESS CATALOGING-IN-PUBLICATION DATA
Names: Beattie, Ann, author.
Title: More to say : essays & appreciations / Ann Beattie ;
 selected & introduced by the author.
Description: Boston : Godine, 2023.
Identifiers: LCCN 2022016818 (print) | LCCN 2022016819 (ebook) |
 ISBN 9781567927528 (paperback) | ISBN 9781567927535 (ebook)
Subjects: LCGFT: Literary criticism. | Art criticism. | Essays.
Classification: LCC PS3552.E177 M67 2023 (print) | LCC PS3552.E177
 (ebook) | DDC 814/.54--dc23/eng/20220603
LC record available at https://lccn.loc.gov/2022016818
LC ebook record available at https://lccn.loc.gov/2022016819

First Printing, 2023
Printed in the United States of America

For Stephani Cook

CONTENTS

ON PHOTOGRAPHERS & OTHER ARTISTS

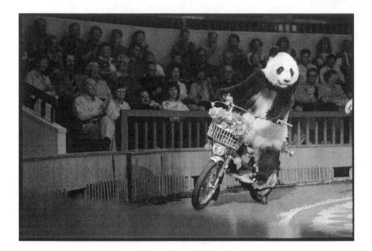

"A giant panda practices for the Tour de France," was all *Travel + Leisure* magazine told its readers about this bear riding a motorbike at the Acrobatic Theater of Shanghai. That was probably enough. Of course, if you could read the panda's mind, there'd be a lot more to say.

—JOHN LOENGARD

Introduction

BEING A CERTAIN age automatically puts you in the witness protection program, even if you were never that *kind* of witness. You don't look the same, you're not where you're expected to be, and the shocked neighbors, if they ever discover your true identity, are abashed because they thought you "fit right in" (though after thirty summers in Maine, I have yet to meet those neighbors).

I've had fun sneaking around, moonlighting as a nonfiction writer. My friends hardly ever commented, I assume because they never even saw my nonfiction. One time, my photographer friend Bob Adelman and I were talking to a friend of his, and Bob was recounting, pretty hilariously, a misadventure he'd had while on assignment with a writer. Bob's life was synonymous with bizarre setbacks. A couple of times I chimed in to clarify a minor

point. His friend said, breathlessly, as an afterthought to his own amazement, "Who was the writer?"

"I was," I said.

(Another time, Bob took me to dinner with his old friend Bill Smith. I didn't realize until the evening ended that I'd been talking to Martin Cruz Smith.)

The great thing about writing nonfiction is that you can select your perspective among things that come to you—I mean, by narrating situations you've observed, rather than generated. I was lucky in these essays and appreciations, because often the opportunities were handed to me. I would never otherwise have known anything about Grant Wood, except for being able to conjure his most famous painting. *Empathy* is one of the buzzwords of the day, but sometimes, in observing or when conducting an interview, I felt the same thing I experience when writing fiction: I'm both the creator and a pretender who can succeed only if I understand and have questions about what I conjure, or, in nonfiction, what comes right at me. As with everything else in life, the easy assignments often turned out to be difficult in some way, whereas the hard ones seemed to simultaneously bring forth a fortuitous circumstance or perfectly imperfect moment that kickstarted me, and then kicked me in the ass if I didn't stay on course.

Writers make up these metaphors and disclaimers. They vary because writers vary. We do, apparently, need to pretend that someone's in control, even if we are that someone.

IN THIS BOOK, the focus is on the writing I've done about other writers and artists. I'm married to one, Lincoln Perry, but had I not been asked to write a text for his paintings done in Charlottesville, where we lived, and also for his mural in the University of Virginia's Cabell Hall, I would never have had reason to step back and ask myself some basic questions, or to spend so much time looking at his work. (You can omit the "Duh" and point and say "That's good" to your husband, but not to the reader.) There's a lot of looking or reading that takes place before I start to write an essay. There's not a lot of anything that happens before I write fiction: no plot in mind, probably an image, possibly an indescribable feeling I still have trouble understanding after introspection; it's—please don't think me only a child of the 1960s—a *mood*. When I write nonfiction, I'm trying to pick up an external vibe, trying to become informed enough to inhabit someone else's world fairly.

But enough about that inchoateness. I'm primarily a fiction writer. I'd like to think that in Cambridge, Massachusetts, when I enrolled in the only photography class I ever took, I might have stopped writing and started photographing instead—at the time, that was exactly what I wanted—but if I have any motto, it's (former students may leave the room) *Writers will do anything to avoid writing*. Still: from the time I first saw Diane Arbus's work, in the early 1970s, I was in love with black-and-white photographs, and we never really broke up. Now, I wander my upstairs hallway and look at framed photographs by friends such as Georgia Sheron, Curt Richter, John Loen-

gard, and Holly Wright—all discussed in this book. Other photos I bought before I met their creators (if I ever did). I never look at the images and wonder what the "story" is behind them, or, worse yet, use them as a point of departure for writing *my* story. They don't exist to inspire my work, and they're done in a different medium; essentially, there's no analogy between writing and photography that matters—at least, to me.

(When my husband and I have given presentations together, we're inevitably asked what the relationship is between painting and writing. "None," would be the short form, though surely something can be said, and from time to time we've tried, because, hey, we usually get free lunch.)

I guess the way I feel about all these attempts to elucidate something I find in the work that moves me and (equally appreciated) that escapes me in photography or writing is that now that I'm no longer a student, it's delightful to be a student.

It was my good luck to know personally so many of the people I've written about. (Oh, for one more ride down Duval Street in Key West late at night, windows open, with Harry Mathews in the passenger seat, asking Lincoln to turn up the volume on Chumbawamba's "Tubthumping": *I get knocked down, but I get up again*). Some of the writers in this collection I met coincidentally, though maybe that's not the way to put it: Peter Taylor was instrumental in getting me my first real teaching job, at the University of Virginia (I'd read only a few of his stories before that); I'd never have met David Markson if not

for a mutual friend. I met Craig Nova because my dear friend, the late photographer Tom Victor, who had no driver's license, flew me with him from New York to Vermont (People Express was still flying at cut-rate prices) so I could drive him in a rental car to photograph Craig— whose wife, after I sat waiting in the parked car for a long while, came out and asked the driver in for coffee. And though I'd seen her read, I would never have met Alice Munro had she not been waiting for our shared editor, the wonderful Ann Close, who for reasons I no longer remember visited me the semester I taught at Northwestern, and Alice, who was traveling with Ann, got tired of waiting in the car. Can you even imagine what it was like to look up and see Alice Munro, in a hat, walking right toward me in Evanston, Illinois?

So, yes, there were good times on the road (Quiz: *Who remembers expense accounts?*), some flattering, even startling invitations to work with, or to write about, artists I admired. It was great to have opportunities that required my stopping and staring, moments that helpfully defamiliarized the world. Now, Josh Bodwell, at Godine, has given me the chance to publish some of my long-ago writing, as well as some more-recent work—essays that might have stayed hiding in plain sight forever, because they always pretty much did. How I wish I could now reveal, like many others, that all this time I've been writing mysteries under a pseudonym, but alas, no. In approaching my subjects, I've been given the advantage of forgetting myself (as in: *Up to that old writing trick again, Beattie?*), at the same time that my subjects took chances by letting me

into their homes and studios, making themselves vulnerable, as we always do, when we talk to others. Some of the writers who've died—Peter Taylor, Nancy Hale—simply, initially, took a chance by befriending me.

It was an odd experience, locating the pieces to include in this collection, because they were written when I knew more (or less) than I do now, and also because I don't look at past work. I admit that there were happy surprises. I think I *was* correct when I wrote about Lincoln: "He's doing what he does [painting] not to get an answer … but to pose a question, which, by implication, makes the audience better able to articulate their own uncertainty. In so doing, they enter the world of the paintings." This, I think, is what artists want to do: find a way to lure the reader or viewer into an alternate realm, to overcome the audience's resistance to being taken away from their own lives and interests and priorities.

When you use words, you have to come up with something as irresistible as a carrot is to a horse. Of course, this also applies to me (I'm much better suited to offering carrots than to being a horse, take my word for it), and whether they were requested by an editor or self-generated, one thing these assignments did was present me with a "given," and a guarantee that whatever I came up with could never be entirely mine.

Don't we all love to be tantalized? And doesn't everybody love to play hooky? Apparently my father spent his youth skipping school, pursued by truant officers. My mother did not, though sometimes, when I was young, she'd lay out a lunch of six candy bars for each of us,

washed down with Coke ("No need to tell Dad"). Maybe it's sort of ridiculous that in journalistic writing, I was working in order to avoid work, but it was, and remains, a motivating factor. Fiction gave me some recognizability. It's the reason I was given assignments or indulged when I came up with ideas. But nonfiction always gave me a thrill, even if it provided only an illusion of freedom. Freedom and flexibility—for me, those are the conditions under which imagination sparks. Not that I didn't want to write well in both genres, not that I didn't want to benefit by articulating interesting new things to myself, just that the writing collected here had nothing to do with my self-consciousness about Ann-the-Writer, which was always inhibiting. Going out with my old cassette recorder (yup) and my notebook also reminded me to try to be a bit more generous when I was on the other side, being interviewed. My subjects have sometimes told me the more interesting question to ask, and they've loaned me books they think will help shape my thinking—if they're wrong, that can, indeed, also be helpful.

I love being able to enter artist's spaces, where, for example, their works' subtexts can simply appear. I won't let people into my writing room, and turn down requests to photograph it. It's not that I have anything so private, or so tellingly sentimental. It's just that once the interloper asks a question and I hear my perfunctory response, the valued artifact, or photograph, or Valentine deflates. I guess the room is something of an echo chamber, a riddle, a time capsule of in-jokes and insects that glow in the dark. But *wow!* was I ever amazed by Jayne Hinds Bidaut's loft with

the lazing iguana. She was brave to let me in, and I guess I exhibited some bravery myself.

I've digressed here because the way I see into things as a fiction writer is different from the way I extrapolate meaning when I'm writing about what's observable. Touchable. Quite simply, in nonfiction the situation presents itself to me, then—a bit like the way a cat either snubs you or jumps in your lap—there I am in the world of unpredictability, whether or not I want to be. Unlike fiction, you can't press DELETE and get rid of Kitty.

In fairness to myself, I wasn't writing only to avoid other writing, and I wasn't just playing dress-up, though I had a romantic fantasy that I was. The visual artists and writers in this book are ones I admire, and from whom I've learned a lot. I might have spoken their introductions into the microphone, but they're the stars.

Ann Beattie
2022

MORE TO SAY:
ON WRITERS

A Dream of a Writer: Peter Taylor

The American Scholar, 2017

MATTHEW HILLSMAN TAYLOR Jr., nicknamed Pete, decided early to become simply Peter Taylor. The name has a certain directness, as well as a hint of elegance. Both qualities are also true of his writing, though his directness was reserved for energizing inanimate objects, as well as for presenting physical details. (His sidelong psychological studies, on the other hand, take time to unfold.) It was also his tendency to situate his characters within precisely rendered historical and social settings. His stories deepen, brushstroke by brushstroke, by gradual layering—by the verbal equivalent of what painters call "atmospheric perspective." Their surfaces are no more to be trusted than the first ice on a lake.

Born in Trenton, Tennessee, in 1917, Taylor was a self-proclaimed "mama's boy," though he said his mother never showed favoritism among her children: he had an

older brother and two older sisters. She was old-fashioned, even for her day. He adored her, and women were often the focus of attention in his fiction. The women in Taylor's stories are capable, intelligent, if sometimes unpredictable in their eccentricities as well as in their fierce energies and abilities.

How wonderful that all the stories are now collected in two volumes in the Library of America series (*Peter Taylor: The Complete Stories*). A reader unfamiliar with Taylor's work will here become an archaeologist; American history, especially the Upper South's history of racial divisions and sometimes dubious harmonies, is everywhere on full display. Taylor was raised with servants. The woman who was once his father's nurse also cared for him. Traditions were handed down, as were silver and obligation. Though he seldom wrote about people determined to overturn the social order, Taylor never flinched when presenting encounters between whites and Blacks—whether affectionate, indifferent, or unkind—and dramatized them forthrightly.

The stories, rooted in daily life, use the quotidian as their point of departure into more complex matters. Writers have little use for the usual. Whenever a writer takes the pose that the events of his story are typical and ordinary, the reader knows that the story would not exist if this day, this moment, were not about to become exceptional. Taylor mobilizes his characters and the plots that they create as if merely observing, as if capably evoking convention and happy to go along with it. To add to this effect, he sometimes creates a character, often a narrator,

whom the reader can take for a Peter Taylor stand-in: a
child, a college professor, or a young man like Nat, the
protagonist of his novella-length "The Old Forest," whose
thwarted desires and covertness about tempting fate are
at odds with what society condones and also with his in-
experience. In that particular story, one woman turns the
tables and, in the closing lines, another woman—Nat's
fiancée, Caroline—kicks the table right out of the room.
It is one of the most amazing endings in modern fiction,
with a revelation that rises out of the subtext:

> Though it [says Nat, referring to leaving home and reject-
> ing an identity determined by others] clearly meant that
> we must live on a somewhat more modest scale and live
> among people of a sort she [Caroline] was not used to,
> and even meant leaving Memphis forever behind us, the
> firmness with which she supported my decision, and the
> look in her eyes whenever I spoke of feeling I must make
> the change, seemed to say to me that she would dedicate
> her pride of power to the power of freedom I sought.

The present tense of "The Old Forest" is the early
1980s, when Nat is in his sixties. The story's action, how-
ever, takes place in a remembered 1937, just before Nat,
then a college undergraduate, is to marry Caroline. His
wedding plans go away when, while driving near Overton
Park in Memphis with another young woman, he has a
minor car accident, after which the woman flees into the
ancient woods in the park and disappears. The mystery
of her disappearance must be solved before the marriage

can take place. Nat, as narrator, has alerted us early on (no doubt so we might forget about it) that the story we're about to read happened in the Memphis of long ago. It ends in an epiphany we never see play out. The future—the "now" of the story—is only eloquently suggested. The story of the forty intervening years is barely, glancingly told—shocking as some of the few offered details are. Virginia Woolf's surprising use of brackets to inform the reader of the death of Mrs. Ramsay in *To the Lighthouse* was stunning; Taylor's narrator, who hurries through his account of family tragedies, is equally shocking, as the information he relays appears to be but a brief aside to the story he wishes to tell.

Every writer thinks hard about the best moment for a story to begin and end. Taylor does, too, but his diction—his exquisite and equivocal choice of words—often suggests that beneath the surface action of the story dwells something more, something uncontainable. With "pride of power" comes the hint that Caroline is fiercely leonine as well as heroically self-sacrificing. This, however, is projected onto her by Nat: it "seemed to say to me." In other words, it's worth noting that an idea has been planted, in both Nat's mind and the reader's, yet it is unverifiable; we do not get to read the story of a lifetime that might otherwise inform us or offer a different interpretation of what we're asked to understand. Elegant prose, calculated to convince, appears at the story's end—a literary high note, almost one of elation, on which to conclude.

But I wouldn't be sure. In retrospect, the story tells us a lot about Nat (perhaps that he can be as annoying

as a gnat), who intermittently interrupts the narrative to inform us with disquisitions about the historical significance of the old forest. It's a ploy to distract our attention from all that's forming below the surface ("missing the forest for the trees"). Nat, writing from the perspective of maturity, knows himself, yet not entirely; he feels he must do the right thing, but does so only when prodded by Caroline, a strong woman. He is adamant that they must find another way, a new way forward in which something is lost (Memphis, his family, and their expectations of him) but something is also gained (autonomy and the ability to pursue one's passion). All this leaves the lioness a little on the sidelines, and the present-day reader might be saddened that the Caroline of 1937 understands that her only way forward is to attach herself to Nat, a man—but, at the moment the story concludes, the two characters are united by the writer in their own version of triumph.

With apologies to the New Criticism (originated and practiced by some of Peter Taylor's most important teachers, including Allen Tate, John Crowe Ransom, Cleanth Brooks, and Robert Penn Warren), here is where I conflate the life of the writer with the actions and thoughts of his stand-in character. The tension that arises within the protagonist from a psychological or emotional conflict is a common theme of Taylor's stories. As is the idea of a trade-off or compromise. As is ambiguity, a feeling of unease that can creep over the reader like a shadow, so slow moving that it's accepted without question. It's not until later that one looks for its source, and there is where Taylor always outfoxes the reader. He will purposefully

disrupt a story's forward momentum to delve into the narrator's past, causing what might seem to be equilibrium, when jammed up against the story's present moment, to create disequilibrium.

What makes me so admiringly queasy is not this juxtaposition and the discordant tone it sounds but what the methodology evokes more broadly: Peter Taylor, as writer, occupying the role of both Orpheus and Eurydice. He repeatedly creates narrators who guide the reader through the story toward an expected and just resolution but who then hesitate, or momentarily lose their moral focus, and so scuttle that resolution. Taylor's characters want to come out into the light, but the person who can best guide them, the writer himself, is impelled to make them look over their shoulder and face the omnipresent past, with all its implied demands. The possibility of faltering, the *probability* of it, is a recurring undertow in his stories. It's as if, in his worst fears, Taylor, relegated to Eurydice's powerless and inescapable position, might himself need rescuing. The way out is never easy or clear, even with a narrator's guidance, and so daunting that one can't go it alone. Taylor's main characters always need to bring someone with them; individuals, in Taylor's fiction, must exist in pairs. After all, his narrators are mortal.

The writer's use of intrinsic doubt—of aporia as a rhetorical strategy—is also fascinating. Just when we're almost hypnotized by the narrative abilities of some of his eloquent yet dissembling characters, there comes a shift in tone, really a *sotto voce* moment, in which the narrator second-guesses himself or the tale he is telling, thereby indicating that ev-

erything the reader hears must not be taken at face value. Quite a few of his stories verge on being mysteries ("The Oracle at Stoneleigh Court," "First Heat"), though not the conventional kind that pose suspense-filled puzzles that will eventually be solved. Rather, Taylor's puzzles are articulated so that some potential accommodation, some new way to go on with one's life, may become apparent. Though the reader may not register it immediately, at the end of a Taylor story some essential riddle remains.

Peter Taylor embodied contradictions. He often explored them in his fiction, though rarely does he leave us with a feeling that things have been comfortably reconciled for himself or his characters. There remains an oscillation, an internal push-pull, as if the mind were a vibrating tuning fork. Currently, in the age of memoir, there's a lot of self-important talk among writers about writing as a means to self-salvation. To the extent that this applies to Taylor, his characters are proof that the energy generated by inner turmoil is synonymous with really living. Take his story "Je Suis Perdu" as a beautiful example. Its real-life point of departure is that the Taylors, in the mid-1950s, went to France with their two young children. The story chronicles a day in the life of an unnamed American husband and father (he is thirty-eight) who is morbidly preoccupied with aging and mortality. As always in fiction, this day starts as a usual day—the day before he and his family leave Paris. Our protagonist goes to the Luxembourg Gardens, where Taylor begins to expose him to various backdrops, beginning with Poe-like monstrous façades. His thoughts turn to the French painter Jacques-Louis David and his

only landscape, an oil-on-canvas view from the building in which he was imprisoned. We can't fail to understand the import of this implied link between the two men. The character also considers the Panthéon, the mausoleum for France's secular saints, projecting his dark mood so that it, too, is personified into monstrousness. Late in the story, our protagonist seems to be suddenly overwhelmed with a kind of emotional vertigo, along with the disoriented reader: "When the mood was not on him, he could never believe in it." Taylor is always aware of individual words, and all they might convey: significantly, it is "the" mood, not "his mood." It becomes "his"—it is personalized— only on the last page of the story.

Yet again, the writer provides us with a psychological study (this one more explicit than most), not to solve the mystery of his protagonist's conflicting moods but rather to *create* anxiety with its articulation: it is a beautiful day in Paris; he loves his wife and children; he's been away from his job in America, working on a book he has just finished. *Aha.* So this is also a story about writing, and about one writer's personal demons being projected onto the external world. Consider the "cute" antics of his baby son, which impress the reader as more grotesque than humorous, the boy's spinning reminiscent of the devil's; also, his wife, who, in her slip, does not disrobe but instead gives him the slip as she goes off to dress; and his daughter, who is too tightly wound, her shrieking portending the nightmarish perceptions that will soon overwhelm her father.

The story is divided into two sections, titled after Milton's pastoral poems "L'Allegro" and "Il Penseroso." Some-

times described as paired opposites, each poem actually embodies its own contradictions in an embedded complexity that would appeal to Taylor, who never thought in terms of either-or. Also, Taylor would never invoke Miltonic high seriousness if not to alter it—in this case, by wittily playing against it. This is a story about a man who should be all right but isn't. Its ending is qualified by the indelibility of every revelation that, earlier in the story, we've been so immediately immersed in; Taylor overwhelms both reader and character with the intensity of the character's inner conflict. Our own moods plunge as we read. Here's what the writer depends on: once we see something, we can't not see it; once we feel something, we can't be told we don't. It sounds so obvious, but few writers have the mastery to haunt the reader long after their characters have ostensibly shaken off their demons. The story's final paragraph, with ellipses that convey what must remain unspoken, the "buts" still too painful to articulate, expresses a tentativeness that purports to end with enlightened awareness: "But this was not a mood, it was only a thought." This sounds like an important distinction, yet it's more likely that the character is grasping at straws—word straws—desperate to regain (or at least feign) equilibrium. We, however, have felt the bleakness of his mood; we retain the after-image of the Panthéon transformed into a glaring monster.

Near the story's end, Taylor expands his horizons: we find ourselves reading an unexpected parable about America, and furthermore this consideration—which we now understand has been a significant part of the sub-

text—mitigates the ending's potential upswing. We're taken aback, just as we are at the end of *The Great Gatsby*, though without the enlightened exhilaration. In Taylor's story, as in Fitzgerald's novel, one has gone to a foreign land (in *Gatsby* we hear about the Dutch sailors; the characters' predecessors have also moved, in Taylor's story, to a new frontier); the protagonist of "Je Suis Perdu" has become something of an actor (he grows, then shaves off, a mustache; Gatsby, with his rainbow of colorful shirts, has nothing on this guy). Time and again in Taylor, the visitor is never, ever, truly accepted, however well he tries to act the required role. It's the status quo that our protagonist desperately returns to—or tries to—at the end of "Je Suis Perdu," words his daughter utters that, we come to understand, expand in their connotations so that, metaphorically, we see it is he, the father, who is lost. We know "the mood" will descend again.

An admirer of Hemingway (*there* we see shadows before we suspect the source), Taylor, as his talent matured, increasingly turned toward another early influence, Henry James. Taylor has also been compared (too often and too easily) to Chekhov. He admitted that he learned a lot from the Russian, particularly how to consider things from many perspectives. But in reading or rereading Taylor's work after many years, I was struck by certain other influences that I'd previously passed over: Freud, for example. (Taylor, on being sent students' analyses of his story "A Walled Garden": "As I read their papers, I began to think, 'Well, you know, that didn't occur to me while I was writing it, but in a way that's why it works as well as it

does.'" It's not unusual for writers to write from an uncon-
scious level, though Taylor's level-headedness—at least in
interviews—seems so atypically rational, one wonders
whether he isn't being a bit coy in his modesty.) I was
surprised at the number of times the progression of a story
and its symbols seemed so obviously Freudian, or to hint
at allegory. When Taylor began writing, psychoanalysis
and Freud's surprising new ideas were in the air. Freud's
and Jung's ways of thinking were part of the cosmology of
some of Taylor's closest friends and fellow writers, such as
the poet Robert Lowell.

Taylor did not compose in a white heat, though, or
dash off rough drafts. He was an urbane, educated man
who also clearly perceived the world intuitively and
through his senses. He was keenly attuned to tone, tim-
ing, gestures, and subtleties. Taylor was also a playwright,
working in a mode that informed his fiction. Time and
again he lets us see people acting, whether they're gazing
into a foggy mirror, as in "Je Suis Perdu," or rationalizing
aloud a bit too much, as Nat does in "The Old Forest."
Taylor's habit was to compose a text over many months,
which makes me wonder how often he must have stared
at the wallpaper, only to suddenly see an alternate, hid-
den pattern emerge. His involvement in art began with
a childhood desire to paint, an aspiration he shared with
other highly visual writers such as John Updike and Eliz-
abeth Bishop. *He drew his dreams.* Perhaps more than he
let on, he trusted unconscious forces.

A case could be made that his writing conveys so much
immediacy because, awake, the writer was trying to con-

nect the dots, ashes of a dream that lit up here and there unexpectedly, in the moment of its being dreamt. Though the dreamer cannot be both dreamer and interpreter of the dream, there's no prohibition against waking up, remembering, pondering, and incorporating the dream's meaning in its reshaping into a story. Taylor often deliberately immerses the reader in the illogic of a dream ("Demons," "A Cheerful Disposition," "The Megalopolitans") and gives us a visceral sense of how that feels. With guidance (his conscious mind perfects the story), its symbols, when they have their dots connected, form the character's personal psychological map—one that at times we are better able to understand than the character can.

Taylor was also interested, at least as a subject of fiction, in the occult, in tarot cards, in ghosts—as was Henry James. Reading Taylor, one is reminded more than once of James's "The Jolly Corner." Of course this story would appeal to Taylor, with its hints of what is unseen becoming manifest and the implied question of what one's life would be like if it could be relived. Taylor's early story "The Life Before," which appeared in the Kenyon undergraduate magazine *Hika*, shows his interest in characters who are haunted: the protagonist and his wife conjure up their guardian angel, a seemingly ageless man named Benton Young, who appears in the doorway of the hotel in which they live to remind them of the power of his love, which comes as a kind of blessing to these two people who each love him in different ways. There is much more to the story, but placed in a context of his other "ghost" stories and his collection of one-act plays titled *Presences*

(1973), this early story is a little unsubtle in technique, yet also significant. (One can understand why plays appealed to Taylor: "In fiction you've got to prepare for the ghost for pages and make it right, whereas in a play you just say, 'Enter ghost.'" Taylor could be quite witty.)

Socially, Taylor was a raconteur who never told stories for easy laughs any more than he let them inflate into tragedies. I met him in 1975 and remained a friend of him and his wife, Eleanor, for the rest of their lives. He and his former student John Casey were the people who got me hired at the University of Virginia when I was twenty-five. Was I awestruck? Not really, because he made anyone he befriended feel so comfortable. Was I intimidated by his wizardry in constructing a story? I just assumed anyone who could write stories like his was a genius. Do I wish I'd asked him questions about everything, from what books to read (his students were treated to this, because he read aloud in class) to how certain effects were achieved in his own fiction? At the very least, couldn't I have interviewed him? I'd like to go back in time and give my younger self a shove. But I got from him, because of his attention as well as his talent, what some other lucky people also received: the idea of how a person might have a life in writing.

In the early stories, and even more so in the later ones, his narratives zig and zag through time as he gestures to other literary texts, and sometimes to works of visual art, with which his writing is in dialogue. Many of the stories (particularly the longer ones) are intended to approximate oral storytelling, rich in episodic digressions and a mixing of the important with the seemingly unimportant. Read-

ers perceive different connotations, different connections, depending on their level of literary awareness. "A Walled Garden," for example, is a prolonged apostrophe that sounds more than a little like one of Robert Browning's dramatic monologues, though anything Taylor took in was made his own.

"Venus, Cupid, Folly and Time," written in the indirect third person (until the anonymous narrator, having cleared his throat for twenty-five pages, at last steps forward), asks us to believe a narrator who casually assumes that his views and the reader's coincide, yet who also informs us of things no one else would realize or put together in the same way. At the heart of the story is an account of the last of the annual parties given by Mr. Alfred Dorset and "his old-maid sister," Miss Louisa Dorset, for the children of provincial Chatham, Tennessee. Brother-sister incest, the story's subtext, is never observed but instead is displaced, prismatically: we see many puzzling points of light before the picture that the narrator is painting comes into focus. We "see" it in its pictorial or visual equivalents—lovemaking arrested in time (an echo of Keats?) as depicted in Rodin's sculpture *The Kiss*, as well as in the busy Bronzino canvas that gives the story its name. There the naughty Cupid fondles his mother's breast, while the child Folly, rushing up behind them, prepares to shower them with a fistful of rose petals. These images—together with a plaque of Leda and the Swan—hang on the walls of the Dorsets' home. Into this highly sexualized setting comes an adolescent named Tom, whose actions disrupt the children's party and upend the lives of its hosts. If the

reader hasn't suspected it before, the "uninvited guest" of Taylor's story is played against that of Poe's "The Masque of the Red Death," though the stakes are not quite so sensational, or so deadly; instead, they remain murky and hauntingly disturbing, since there is no one form of evil to unmask. "Venus, Cupid, Folly and Time" also, in places, mimics a fairy tale. By extension, it might be America's fairy tale about itself, gone wrong: "The wicked in-laws had first tried to make them [the brother and sister] sell the house, then had tried to separate them . . ."

Taylor is a writer who so loves to keep our senses sharp; our eye is forced to work like a borer bee as it moves closer to the meaning below the intricately contrived surface pattern. In this story, the calculated miscalculation of a teenager's joke—a mock seduction—echoes the off-the-page "real" seduction (the incest of the Dorsets, who, as Miss Louisa tells us, "have given up everything for each other"). All this is played against the backdrop of sexually evocative sculptures and paintings—to which is added the suggestion that time (and sexual maturity) does, and does not, change everything. The old siblings being teased, in the reader's presence, have already been relegated to twisted figures depleted by time: the sister, symbolically wearing (like a wedding dress) a "modish white evening gown, a garment perfectly fitted to her spare and scrawny figure . . . never to be worn but that one night!"; her brother, like a Tennessee cousin of Gustav von Aschenbach in *Death in Venice*, "powdered with the same dark powder that his sister used."

The use of exclamation points in this story is purposeful: they indicate faux surprise and mock the Southern

Gothic horror genre, which insistently telegraphs its shocking revelations. In the claustrophobic funhouse Taylor has orchestrated, his narrator blithely tells us things as if telling a conventional story, the author withholding many metaphorical exclamation points of his own. This amazing tour de force, which has been much anthologized, must have gone over many of its first readers' heads like a shooting star. A bit meanderingly and imperfectly told, it's meant to read like the transcript of a spoken story. The repeated use of the conjunctions "and" and "but" to begin sentences says everything: *and* means there is a connection between things; *but* means that that connection is not absolute. Also, the story's location, the fictional town of Chatham—described by some as "geographically Northern and culturally Southern" and by others who say the reverse is true—puts us on a fault line, in troubled and troubling territory that makes everything liminal. With a historical perspective introduced only in the last pages of the story, we're made to understand that the mercenary, mercantile Dorset family opportunistically settled Chatham "right after the Revolution" and then, in the early twentieth century, abandoned it—"practically all of them except the one old bachelor and the one old maid—left it just as they had come, not caring much about what they were leaving or where they were going." The rape of the town echoes the rape Taylor has earlier alluded to in the Leda and the Swan plaque; it also keeps the suggestion of incest ambient. Heedless people. Opportunists, Taylor intends us to see—analogous to those who grasp for what serves *their* purposes to embrace.

Taylor was a Southerner whose best friend was Robert Lowell, a Boston Brahmin. It's possible that, for reasons of his own, he put a positive spin on some of Lowell's pointed needling and, ultimately, neediness. (Taylor once told an interviewer that Lowell "invented facts and stories that made his dearest friends out as clichés ... cliché Jews, cliché Southerners, cliché Englishmen. Naturally this was irksome sometimes—even mischief-making. He was fond of representing me as a Southern racist, though of course he knew better—knew it from the hours of talk we had had on the subject, as well as from my published stories.... His teasing was often rough but ... it was his way of drawing closer to his friends, rather than putting them off.") It seems equally possible that sometimes Taylor was hurt, though he always remained Lowell's loyal friend. Taylor was in some instances quite sure of his feelings: he knew, for example, that as a young man he had to stand up to his father—even if it meant refusing to attend Vanderbilt, his father's choice of university for him. (He *did* later attend Vanderbilt, but for his own reasons and on his own terms.) He knew the first time he saw Eleanor Ross that he would marry her and waited only six weeks to do so. Their long marriage lasted until his death. As for finally wearing a somewhat ironic crown, in 1987 he received the Pulitzer Prize for a novel, *A Summons to Memphis*, yet thought of himself as primarily a short story writer. Like all of us, at times he revealed more than he knew. He explained his election to the American Academy of Arts and Letters by mentioning that there were "no dues or anything like that." I love the

slight naïveté, as well as everything implied in the phrase "anything like that."

In Charlottesville, one didn't see him on the golf course or riding with the horsey set. Though he taught at a great many colleges and universities—in the East and the Midwest as well as in the South—he returned in the end not exactly to the foul rag-and-bone shop of his heart but, with fondness, to a place he thought of as a prestigious, known entity: the University of Virginia. In what might or might not be a contradiction, he taught creative writing while remaining skeptical about whether there should be a creative writing program. When he retired, he and Eleanor continued to live in town. Eleanor, herself an accomplished poet, liked to garden. If she'd written a poem during the day, no visitor was told. Quite a few of Peter's students and former students became his friends. Robert Wilson, the editor of *American Scholar*, accompanied him to Paris to receive the Ritz Paris Hemingway Award. Dan O'Neill, a student who later became his real estate agent, drove a rented van to Long Island to fetch Jean Stafford's settee (a wonderful Tayloresque word that has vanished from the vocabulary), which she'd willed to Peter and Eleanor. (Only after her husband's death did Eleanor say she didn't much like it.) A former student routinely drove the couple to Florida in the winter. They bought a house in Gainesville near Eleanor's sister, Jean, who had married the poet Donald Justice; earlier, they'd lived in Key West. Oddly—or maybe significantly—while wild tales of Tennessee Williams and, more recently, the bons mots of James Merrill are as essential to the residents of Key West as the literary air they breathe,

there is no historic plaque on the Pine Street house where the Taylors lived, nor is there any Peter Taylor lore.

Peter and Eleanor were real estate enthusiasts. They bought and sold and repurchased a house, only to later sell it again. They came for dinner and if you were renting asked if you knew whether the house was for sale. Taylor showed pictures of properties they were considering when Eleanor left the room. Eleanor, in the kitchen, would earlier have laid out photographs on the breakfast table of her own recent house fascinations. They rented Faulkner's house in Charlottesville but, unable to buy it, bought the house next door. Later, they moved a bit closer to the university. But I don't believe they ever owned only one house, even when curtailed to one location after Taylor's heart trouble worsened.

Their preoccupation with houses was surprising and somewhat eccentric, but houses and their home-obsessed inhabitants are everywhere in his fiction. Never props, houses (apartments and hotels, as well), along with their furnishings, are given the stature of characters. The characters are an outgrowth of the life lived within, as well as the houses' being significant because of where they're located, how they're used, and what details have been described in such highly visual terms that they convey indelible meaning throughout the story. The houses are as integral as a shell is to a turtle. And, like a turtle, they suggest that no one's going anywhere fast. In spite of life's flux, houses give the impression of being constant.

Taylor isn't Hawthorne or Poe (he admired them, but their pyrotechnics didn't reflect his sensibility; if they were

the fireworks, his stories would be the just-struck match). He did have the ability to create his own sort of visceral scariness—one that rarely had anything directly to do with obvious projection or personification ("Je Suis Perdu" is an exception that proves the rule).

Here is Peter Taylor, talking to an interviewer in 1985:

> I like to do landscaping. On the last place I had I built three ponds, one spilling into the other—18th-century style. And that's what I've done to this place. It's got great boulders on the side of the hill, rocks as big as this room. And it's very beautiful. I was even building an imitation graveyard, a topiary graveyard with carvings and shrubbery. It was pure folly. And Eleanor's planted acres of trees. Then there are a lot of blackberries, persimmons to be gathered and that sort of thing.

Of course, his saying this, and making the "folly" we'll never see so vivid, reminds me of how important his dreams were to him, how Freudian the implications of some of his stories are, as well as of his own use of allegory. It's almost astonishing, how easily we can read into his words and understand that he is speaking simultaneously about a literal and a symbolic landscape (as in dreams). When he described his property, he was already suffering from heart problems. He doesn't reflect on his statement or in any way let on that he knows what he's said, but it's easy to see that the topiary graveyard conveys both his concern with mortality and the careful artistry, the pruning-writing that he undertakes; landscaping is a metaphor

by which, in creating an ideal world, he wishes to prove he's powerful—still alive.

To read a great number of his stories is to sense an invincibility about Taylor's dwellings that makes them a force to be reckoned with. Within these houses—as within all of us—must be secrets, areas of disrepair, covert demands exerted. One of his major considerations as a writer is the clash of past and present, the old order versus the changing world, Nashville versus Memphis. This evolution asks important questions about who we are, where we belong (and whether we can ever really leave those places), and what meaning to ascribe to exteriors, compared to (psychological) interiors. In the stories, we sometimes hear angry words from a character, a roar, occasionally hysteria—though no reader would typify his material by these outbursts. When things go out of control, in life or in fiction, they rarely devolve into complete chaos (war zones excepted), though it's true that Taylor tends to play in quieter territory.

Has he not had the reputation he's so long deserved because it takes awhile for his subtle, disturbing stories that gestate below the surface to settle in? Was his magic act of now-you-see-it, now-you-don't a bit too successful, a ruse that ultimately became counterproductive? His proclivity toward selecting narrators who have a cordial, confiding tone was trickery, but may have misled some readers into thinking that he was a nice Southern gentleman, indistinguishable from his fictional creations.

It's also possible that his reputation is a rare case of a short story writer's being eclipsed by the poets of his gen-

eration, Lowell foremost among a group that also included Randall Jarrell and the now iconic Elizabeth Bishop. Another factor may be that southern writers, with such notable exceptions as William Faulkner and William Styron, were once considered regional writers whose voices did not rise to universal truths. This is not the case today, if it ever was, so it can be easy to forget that there was a time when the term "regional writing" carried negative associations, and things southern were thought a bit unsophisticated. In some ways, Taylor's discursive, chatty stories played into a stereotype about pawky storytellers whose horizons were obscured by the hills of home. During Taylor's last years, it was Eudora Welty and Flannery O'Connor who were celebrated as examples of the quintessential Southern short story. Meanwhile, Taylor struggled to get his stories and books into print (in any case, he was never prolific), and his critical reputation became wobbly; had it not been for the admiration of such distinguished writers as Anne Tyler and Joyce Carol Oates, his reputation might have dipped further.

It's rarely easy to find and keep an audience when a writer is publishing only intermittently, especially when that writer is not easily categorized: Taylor alternated between genres; he composed stories in verse (some of his rough drafts—in fact, every story in *In the Miro District*—initially took this form); he did not write essays and seldom reviewed books. He did not live in New York City, and time has proven that the *New Yorker*, which never exactly stopped publishing him, should have been more amenable to more of what he wrote.

Taylor advised writers to find a teaching job that would allow them time to write—conservative, no doubt practical advice, though having done that, he himself moved from job to job. He valued as the greatest compliment having the admiration of his peers, which he certainly did have. He thought small literary magazines were where a beginning writer could attract an audience and be encouraged as one built a reputation. Now, with so few commercial magazines printing fiction and *Kenyon Review* and *Southern Review* (among other magazines where he first published) still going strong, he turns out to be right. Taylor once remarked:

> Flaubert says, "Madame Bovary, *c'est moi.*" How can you write fiction if you can't imagine it? And how can you imagine it if you don't link your psychology to your characters? Writing starts with events and experiences that worry me, and I put them together. You write a story in which you are the protagonist, but you have to change him for the theme's sake.

As always, he's very clear about what he believes. It is the reader's good luck that he worried. His best stories rise to the level of transcendent worry. He's capable of making us—when we finish reading one of his more complex works—look upward from planet Earth, and from the South in particular, to a blue sky, or a dark sky, just waiting to be projected upon.

Alice Munro's Amazingly Ordinary World

The Globe and Mail, 2001

THE NINE STORIES of Alice Munro's *Hateship, Friendship, Courtship, Loveship, Marriage* register so strongly and seduce you so quickly that, as with any great work of art, you are tempted to believe them available to description or summation because they are so vivid and so well wrought. But they are not paraphraseable precisely because they are so complex: The whole is greater than the sum of the parts, so that enumerating characters, details, events, and curiosities will not really give a very accurate sense of them.

Our sympathies are aroused, but then they shift: Do you begin describing the story from that moment of understanding or do you try to narrate chronologically, though the author herself has little interest in chronological time? You might start by describing some detail, or with some unexpected moment—though, even then you may find that to explain fully, you must digress to de-

scribe another moment. It brings writers no joy to have their work paraphrased, and more than most, Munro has a Houdini-like ability to snare you in your own net of description, while the fullness of her story slips away and makes its miraculous escape.

The stories are sometimes astoundingly vivid, brilliantly detailed, presenting eloquently described landscapes at once external and internal. T. S. Eliot built with allusion. Munro alludes to little that is not right in front of our eyes, but, then, she has an eye for seemingly inconspicuous places and for moments that might veer into sentimentality under the observation of a lesser writer (looking at the stars; huddling in an unexpected rain). The stories are illuminated by her simultaneously nonjudgmental, shrewd insight and by the luminosity of her prose. Her selectivity and her ability to transform something mundane into metaphor are truly astonishing.

Flannery O'Connor has said: "The first and most obvious characteristic of fiction is that it deals with reality through what can be seen, heard, smelt, tasted, and touched." An Alice Munro story is always a tactile experience, in the smallest details as well as in the most densely descriptive passages. In "Nettles" we have "sour cheese" socks; "the gravel pits were simply for leaping into, with the shouts of animals leaping on their prey"; even ketchup on bread becomes (if not at first, then through repeated mention) indelible.

This author can hypnotize us with the color and texture of something as banal as ketchup; her accomplishment—in fact, one feels she can't resist—is to make the ordinary

magical: tree limbs, rocks, and water almost alarm us by their viscerally tactile quality. Under her delicate touch, they are transformed; as we connect, we are drawn in to deeper meanings, as in a fairy tale: The rock takes on different connotations, transforms; stones, personified, cling together "in a more mean-spirited way." At story's end, what at first seems to be a rather arch botanical correction is so acutely descriptive that we, too, feel pierced by the plants that have caused the character's pain.

Munro is not a writer who observes nature in order to facilitate a convenient transition. Nor is she a strident nature-nik: It's just that her characters cannot help but be animated amid the world's natural beauty (we become nostalgic the more fleeting we realize it is), as well as by nature's current golf-course-accommodating depredations. In "Nettles," the words *waste* and *meadow*, paired, are deliberately discordant. In "Post and Beam," the architectural philosophy of building a house that fits into the landscape—a house meant to disappear into its setting, at the same time it paradoxically reveals itself—serves as the refrain to the fragile scaffolding that keeps the characters' relationships operative.

As Alice Munro demonstrates throughout the collection, what goes unsaid has the potential to bring the house down. Her focus is on the accommodations people effect or their sometimes painful fine tunings, their heartbreakingly revelatory stories that express so much more than the story they wish to tell.

In "Post and Beam," the married Lorna, talking to a young married man with whom she is somewhat smitten,

tells him about a memory she has of her dead mother. It is recounted as a story that refers, in turn, to another story: She and her mother once failed to listen to a favorite soap opera. "She felt a deep concern, not because of missing the story but because she wondered what would happen to the people in the story, with the radio not turned on, and her mother and herself not listening. It was more than concern she felt, it was horror, to think of the way things could be lost, could not happen, through some casual absence or chance." This fear, which might torture Bishop Berkeley and which could be called irrational, is very rational in the context of this story about missed opportunities. It is a misgiving that manifests itself in different permutations in other stories throughout the collection. It is also, of course, a comment on the artistic process that suggests that artist and audience must be complicitous: The audience has an obligation, not only the creator.

In "Nettles," a couple are bound together by the accidental death of their child. "It could happen to anybody," the narrator thinks, when she hears the husband's story after the fact (until then, she has considered the possibility of reuniting with him). But beware the convenient cliché in the world of Alice Munro: It is there to be banished. The next lines read: "Yes. But it doesn't seem that way. It seems as if it happens to this one, that one, picked out specially here and there, one at a time." How something seems, how it feels, can be more real than a fact. These are feeling characters, but they are thinking characters as well. They are not foolish (though some impulsiveness is unavoidable, and displacement may provide some conso-

lation)—it is just that sometimes the unspoken resonates more than the stated, listening to words confuses the heart and, in "Post and Beam," the more dire imaginings provide an informative, painful perspective not mitigated by the way things are.

Who among us understands the way things are? The boy from the past may reappear, rendered unobtainable by fate ("Nettles"); one may search for a missing person only to realize that the person is a sort of escape artist from her own life, eluding herself as well as the pursuer ("Queenie"). Even furniture seems to have great mobility and to serve the same function as a character in many of these stories (the collection's wonderful title story, "Family Furnishings"; "Queenie"). Furniture, for heaven's sake: It's larger than life and can't be cast off! It would be funny, except that it carries the weight—is the weight—of the present-determining past.

In a short review, I cannot do justice to the particularity of Munro's words, to the expansiveness of her vision, to the precision of the writing, and to the lyrical passages that ultimately belie any belief that there are easy epiphanies to be had. In "Post and Beam," we are asked to consider "a scene so ordinary and amazing, come about as if by magic. Everybody happy." Munro herself has a dowser's ability to locate hidden currents: She is drawn to what is amazing within the ordinary, though this almost guarantees that everyone will be not happy. Her stories are far from fairy tales (though she may conjure them up), and part of their magic resides in her ability to provide constructions that enlarge and shrink images—that are selective and subjective—while they appear to be regular mirrors.

Audaciously, Munro begins a number of these stories with a vignette. It is at once direct, clear, but may either stop us because we are presented with an obviously significant observation ("Family Furnishings") or may end lightly, so that the section seems to dissipate with a joke ("What Is Remembered"). It's a tease: a little something seen too soon that sharpens our senses and increases our anticipation. We've been recruited as spies: We've peered through a keyhole, overheard a conversation. But then comes the moment when we must take a giant step, through white space, to the story proper—the information we've heard echoing, cueing us to look for things that might reappear, creating a mystery about the future, though what we've been offered has not been inherently mysterious.

Munro orients the reader toward realizing that a story is composed of pieces and shows us that shards, as well as neat slices, are necessary to complete the puzzle. Like the reader, the characters see things in the moment; they, too, need to fill in the blanks (or make sure they don't); they lack the larger picture (and may emphatically not want it).

Throughout, the author has an uncanny ability to shape recognizable people who are revealed to be too impermeable, too inward, to be understood as ordinary. Their jobs may be humble, their days may be limited, their prospects may hold little exciting potential, but somehow, from some defamiliarized terrain we discover may be fertile territory, they have internalized a resolute courage, a steadfastness, that offers them the blessing of a life lived outside the context of cliché.

Andre Dubus's Spotlights

Introduction to
We Don't Live Here Anymore, 2018

ANDRE DUBUS AND I were once on book tour together. Because he was wheelchair-bound by this time, we were transported by hired car. Outside Boston, actually not so close to Boston, the car broke down. Do I remember correctly that this happened on a holiday weekend or am I still trying to make sense of it? We sat in the back seat. Andre's friend Jack was in the seat next to the driver. There were numerous phone calls, many moments when we had, or lost, hope. We reached our publisher's voice mail. Nobody responded—well, there was *talk*, but no one did anything, as time passed and time passed. Finally, we tried to get a car by calling 1-800-RENTACAR, but that didn't work, either. A cop car pulled into the breakdown lane, assessed the situation, and raced off, light blinking. That was the end of that. Hours into this, my husband and his best friend fetched me. Andre and

Jack insisted: I must go. I'd be seeing him soon, Andre said; one of the group had finally managed to summon help: a tow truck, another rental car, I don't remember. I left amid cries of "Good sport!" and "See you next week!" feeling that I should stay. (Yes, I should have.)

During this debacle I doubt I had reason to reflect on the fact that Andre and I were writers. What would that matter? If you're busted flat in Baton Rouge, who cares that it's a double entendre? Off I went. My pal and I would rendezvous soon in Portland, Maine.

As it turned out, Andre didn't make it to Portland. In a coffee shop there, I overheard a young guy trying to convince a pretty woman he'd just met to go to the library reading. "He's a kind of a Raymond Carver character," he said. "And I've never heard of her." Off *her* went, to do a solo.

When I think of Andre, an image of us in the back seat inevitably returns: the world whizzing by, everyone's bright ideas totally ineffective, the distracting and effective bleak humor that soon set in, how strange it was that a car belonging to a big company had broken down and there was no one to help us. The oddity of the situation became the prevailing reality. This isn't my segue into comparing life to fiction, then launching into a discussion of one of the best American short story writers ever. It's just noting something in words, imagining that if there's an afterlife, Andre will be happy that I spread perplexity to readers who know (pax "The New Criticism") not to confuse the author's life with his work. We do our best, and in Andre's case, he watched keenly when he was mobile, and no less keenly when he was

afflicted. He took things in straight on, and also saw from an aerial perspective. Writers or not, we're mortal, trapped in a car or trapped somewhere more spacious.

IT'S SORT OF thrilling—and maybe a bit dangerous—to have a fictional character stand alone, though this isn't an unfamiliar state to any of us; numerous works of literature focus closely, unwaveringly, on one character. We've all been alone, during an exhilarating walk down a woodland path, meditating, or when everyone else has fallen asleep. We have sometimes been alone when waiting for a bus. But unless we've walked off to have a private moment, we also tend to notice that we're the only one on the street (or, in Andre Dubus's world, the last woman cleaning up the kitchen), so where is everyone else who means to board the bus? What I'm trying to get at is the surprising way Dubus does the equivalent of spotlighting a character, though his subtlety makes what he does more analogous to being in church and lighting a candle.

Once we've seen Dubus's characters alone or close up, that impression lingers. But do the characters glow (so to speak), because of inner light or external lighting? Only when we get some distance from them, and their often indelible first moments—only as the story progresses—do we get some indication. Writers usually want to find ways to animate their characters from within *and* externally, allowing us to know their private thoughts or revealing them through their interaction with others. Dubus was Catholic. It was an integral part of his identity; he often

addressed the subject directly. So perhaps those private moments are analogous to the split second before a character on stage speaks, or perhaps, more aptly, analogous to a petitioner approaching a religious icon. What if we're observing a silent prayer that establishes an unspoken interaction with an unnamed force? If so, at least sometimes, might that force not be called spiritual?

Dubus's story "Over the Hill" begins: "Her hand was tiny. He held it gently, protectively, resting in her lap, the brocaded silk of her kimono against the back of his hand, the smooth flesh gentle and tender against his palm." We sense the prose's movement—it, too, can be characterized as gentle—that guides us, as the still hand seduces us into this story. After reading the opening sentences, I remained fixated on the visuals. This might be called a devotional moment. We imagine the story will either go one way or the other, but nothing in between: it will evolve mesmerically, through our senses (feel that brocade sleeve), or reverse the reader's expectations with violence.

But neither happens. Or both, as it turns out.

Whereas the prose comes close to freezing time and forcing the scene to vibrate through our senses, the dialogue, once spoken, is of another sort—it's not beautiful, but clipped, Hemingway-esque, flat-footed, sentences that don't even aspire to be cryptic. Things change quickly, in the bar where sailors sit with Japanese women who come with a price. The main character is an unhappy man named Gale (the name carries connotations of a storm). When the woman's hand is relinquished, Gale goes to the bathroom, where there are drawings of ships, some with

scrawled "obscenities," along with factual information. The image of the hand returns, conflated with hands of a different sort. Out goes the tactile, thrilling silky kimono; in comes the toilet. Along with this information: There is a "she," Gale's young wife, who—like the American girl at the end of the war in Hemingway's "Cat in the Rain"—is petulant and wants the Japanese equivalent of the good life. Here, it has been transmuted from Hemingway to Dubus to become "china and glassware and silk and wool and cashmere sweaters and a transistor radio." *Those* desires end with a thud—as does the litany in Hemingway's story, unless we particularly like wet kittens.

Without giving a summary of this quintessentially sad story, the violence that is the flip-side of the gentle, tranquil moment with which the story begins (we accept that love and hate are not necessarily polarities) becomes, surprisingly, something Gale directs toward himself, in a moment reminiscent of Hemingway's "Indian Camp." At the end of both stories comes a moment of awareness—every new conclusion is not an epiphany—in which the reader learns the character's thoughts about mortality. Granted, one is a child and one has just left any vestiges of childhood behind. We read both writers' stories, though, in context with what we know about the ways of the world. We also take in Dubus's story with a keen awareness of how Hemingway changed the story form by making sure information subtly accrued that was at odds with things stated and observed. Post-Hemingway, a reader's attention functions like a dowsing rod, searching for subtext that reveals what's precious in proportion to how deeply it's buried.

The uneasy tension between stasis and a person's resolve to act, whether or not such action ultimately comes to pass in a Dubus story, carries an implied question of what one should or might do versus the accommodations inherent in what one does. Dubus's stories question the status quo. Actually, they catch it and break its neck, even those times they ostensibly put it back together. Everything looks the same, but if you were to lift it, you'd feel the inherent flaw.

This might be the moment to remark on Dubus's writerly largesse. It's easy for writers to corner their characters—one way is by stacking the deck against them—yet sometimes (like being mugged in an alley) the story seems to have its own uncontainable energy and trajectory; it declares the inevitability of letting bad things happen.

Peter, the main character in "Going Under," has lost his wife. His children have moved away with her. He has relationships with younger women—some too young to finish their martinis. Ever. Here's a typical moment in which Peter, who seems neither terribly imperiled nor highly functional, has a perception that in a lesser writer's story would seem forced, probably compounded by the problem that the prose would be written in loftier language than his/her character's perceptions: "Jo was good to be with, better than eating alone; but she has not laughed since dinner, her smile is forced, and in her voice and dark eyes her ache is bitter, it is defiant; and he feels they are not at a hearth but are huddled at a campfire in a dangerous forest." What at quick glance might seem condescending—or at least Peter's tendency to only like

young women depending on how they affect *him*—isn't, on closer examination, so easy to categorize. We can't just dismiss this jerk. The word *bitter*—even if it's invoked as *he* would perceive it, retaining the emphasis on him—is a word from a different realm: the realm of adult experience. Furthermore, she is "defiant." She has volition. The language changes: Peter no longer interprets as if his perceptions are interchangeable with facts; "he feels," and what he feels suggests (as the story established earlier) a tentativeness on his part, a shift in potential power. When we hear about the "hearth"—a word almost onomatopoetic; to say it aloud suggests breadth and warmth, even heat—we take cold comfort. This hearth carries connotations of a fairy tale. Peter would like to feel powerful; perhaps he'd like to express his condescension toward the rather random young woman, but the potential of something frightening happening enters with the allusion to a fairy tale. *Hearth* is like so many words spoken to children about a largely vanished past: gone, and therefore intended to have magical associations. The characters are "huddled" (a religious posture that is of course also symbolic). He and she are metaphorically in "a dangerous forest"—an apt analogy for life itself. Who or what is destabilized here? First, the status quo. The language also produces a visceral effect; the reader would prefer the warm hearth to the unknown forest. There's no going back, though: we've been transported, propelled into new territory. Dubus's stories are so often deceptively familiar until the moment they're revealed to be a consideration of something else.

Reading "Going Under," I was initially perplexed by Peter's histrionics: raving, in dialogue. Yet early in the story we learn (casually, in passing) that he started out as an actor. This cued me to another way of reading: his first failure was in acting (later appearing on radio). When the reader meets him, he's engaged in repetition compulsion, locked into performing—and performing badly. (No, I'm not kidding.) Here, "an Andre Dubus story" (yes, they're recognizable, and not to their detriment) deliberately teeters on farce. Wow. What a risky, admirably perverse thing for a writer to do: to give his character bad lines, and lots of them; to present moments interchangeable with your worst Broadway nightmare of having to sit still and be subjected to bombastic overacting ("Come with me, Miranda. You love me. We'll make it. Come now, baby, come now. . . ."). Other than the reader, the audience for this is Peter's passive, not-quite-girlfriend, Miranda, who's also involved with another man and won't make a commitment. ("I'm too young," she says sensibly, undercutting all his over-the-top, ostensible passion with three simple words.) She remains a nearly mute audience as he ups the ante, imploring her to see things his way. Gosh—ever met anyone like that?

This story also re-creates, subtly cueing us through action as well as words, a potentially dangerous downside of storytelling: writers who try to hammer others (listeners; interpreters) into submission. When you get used to a writer's territory, you have certain expectations, even if they're unstated, to see those expectations reversed; this can happen even when readers are made very happy. As

Flannery O'Connor pointed out about one of her stories, "Anyone is happy to see someone's wooden leg stolen."

Finally, I read "Going Under" as a serious story, though it runs the risk of being misread, in part because we identify neither with the silent, stricken Miranda, nor the bombastic, self-dramatizing Peter. Peter is desperate. "Desperate. Yes." What more information can Dubus be expected to provide? Well, this: that when Peter can't sleep, he sets out for his other girlfriend's house in the middle of the night, whistling "Summertime," George Gershwin's song from *Porgy and Bess*. Anyone familiar with the opera's lyrics knows they're sung by a man who wants to *persuade* the woman he loves to see things his way. (In retrospect, Peter's importuning "Come on" dialogue sounds similar to "You an' me can live dat high life in New York/ Come wid me ..." from the same show.) Dubus is appropriating, displacing, re-creating, making comedy butt up against a serious matter: this man has no sense of self. In his conflict and stasis—in his inability to move that is so often the metaphorical straitjacket restraining free movement—Peter seems doomed to a Dante-esque ring of his own hell: "If he reaches the sidewalk, he will go around the corner of the building, to the garage in back. To reach this sidewalk he must simply traverse the lawn, walking on a shoveled walk between low white banks of snow. But he cannot go down the walk. He stands on the porch looking at the two steps and then at the T formed by the two sidewalks and at the smooth hard snow of the lawn. He starts to step onto the first step, his leg moves, it reaches the step, the other leg follows, he is standing

on the step but Peter himself is not really there, whoever Peter is has been driven in panic back into the warm and lighted apartment; he is not even on the steps." This has, indeed, been a story about a person unsure of his identity, unmoored. Many writers would have concluded here, when the themes have been brought together to produce a triumphantly disheartening resolution. Dubus does not end here. Read on. The soundtrack is provided, and the writing's as sure-footed as your own fears stalking you.

Dubus's female characters are very well conceived, and it may be more unusual than I realize that he so consistently created and stayed so close to his female characters. But I don't want to simply assert that Dubus gives women equal time and equal potential power as men, but rather that he lets us watch fairly conventional power struggles between men and women work out unexpectedly, because there is always the inclusion of fate. Dubus's second collection, *Adultery & Other Choices*, contains two examples of this: "The Fat Girl" is almost a fairy tale, but one gone very wrong; "Andromache" is almost a prototypical tale of how military life is for the men serving and their wives, but the military, ultimately, offers no clearer ability for one to triumph than engaging in something overtly reckless.

Reading "The Fat Girl," one of my favorite stories, feels as if we're spying and seeing the private moments that ruin what might go right in the life of the title character, Louise, and her relationships with her parents, college roommate, and husband. Very quickly, the reader has to take sides. And since Louise's nice roommate, Carrie, is willing to help her, it would be inhumane not to take

that side—so readers think, "Yes, yes, I should be affiliated with the roommate, with the voice of reason." But that dynamic (covertly) is a love affair played out not sexually, but through one person being vigilant about what is best for another. It is as much about power as Louise's earlier struggle with her mother. But there's real affection between the roommates, and, arguably, it trumps the relationship Louise has later with her husband.

In Louise's marriage, we observe that she can get only so far with her attempts at weight loss, and then she begins to regress: "He truly believed they were arguing about her weight. She knew better: She knew that beneath the argument lay the question of who Richard was." This might seem astute—she wants it to appear that way—but I don't think we can take this as an epiphany. It makes her sound good, but is it verifiable? In the end, we see that Louise grows into a woman who wants to be alone, that she is more than willing to have her husband simply gone.

In "Andromache," Dubus focuses not on Marine officer Joe Forrest, who has died unexpectedly, but on his widow, Ellen. Dubus gives us the story's end—the outcome—at the very beginning, so there's no surprise (surprise as in *unexpected revelation*) when what happens. This is a good writerly advantage: to be able to let the reader know more than the characters, because the writer can take liberties with chronology, while the plot transpires as it does. It is a sneaky story: we know from the outset that Joe has died, then move backwards into another time period when we uncomfortably observe him "living." Ellen is left with the burden, but so is the reader, who has also always known.

I can see thinking of Ellen as accepting of the difficulties of being newly widowed and suddenly finding herself a civilian with two young children to fend for (she does identify them as difficulties; she's not obtuse or in denial), yet she seems to have no fail-safe in the face of life's variables. But the story becomes more of a comment on military life that asks all characters to be withholding than a story about a particular marriage. Joe and Ellen are being dictated to by the military—Joe has his role to play and Ellen has her role to play, also. But there are cracks long before Joe's death: Ellen feels condescended to; she feels slighted by the circumstances of the party; she has her confidantes, but they're too immersed in the same dynamic to really help. The story is more about "This Kind of Life" than about individuals.

Dubus goes out of his way to show us the cracks in the facades, and to show us that while two strong-willed people are behaving *appropriately*, that is no guarantee about what curve life might throw them. So I see Ellen and Joe as equal, in a way, but also as limited by context and a bit numbed by time. They're evenly matched, but Ellen is right: the survivors are the ones who are going to have to find a way to go on living.

I think Dubus gave his men and women comparable power because it's not about who "wins," but rather it is a reality that the struggle is undertaken again and again. The stories are about how people must make accommodations once they find out there's no winning. The external world, as Dubus sees it, is very grim—even with male and female characters who are articulate and who think they know what it is they want.

DUBUS IS SUCH a master that even those times he in-
vokes *Sturm und Drang*, he simultaneously casts the
drama into invisible ironic quotation marks. Even when
Dubus says something with his fingers crossed behind
his back, his jokes are terribly serious, the stakes high,
the final moments often transcendent not merely be-
cause of his prose, but because rather than expressing
hopelessness, the stories lift out of moments of personal
pain, sometimes to reveal imaginary, rather than real,
constrictions. What Dubus observes, he clearly does
not endorse. His fictional world—though the reader
comes to feel that if he wanted to, Andre Dubus, like
Puck, could race around the earth—rooted his fiction
in working-class life; really, the struggle to have a life,
since poverty interrupts good intentions, liquor is cheap,
women were not then (are they now?) given a fair shake,
and people are fallible. In these stories, the divorce rate
is high, and the rate of loneliness higher. No writer
has the obligation to save us from grimness (bring on
Zola), but his endeavor—apparent from his first story
collection—reveals a complex writer who has digested
enough unhappiness that he could easily regurgitate,
and of that mess—because of his wizard's ability with
words—make something beautiful. There are certainly
moments, lyrical moments, moments that genuinely
transport the reader by simile or metaphor, but it is his
ability to undercut his own talent in order to keep us in
the real world that dazzles me.

What is Dubus doing, anyway, calling one story "The Fat Girl" and another story from the same book, which alludes to a very different mythical woman, "Andromache"? He's looking straight ahead *and* from an aerial perspective, and not flinching at what's there. He's spiritually (okay, at least celestially) inclined, while knowing that his sharp eye and ear are not enough to take him where he wants to go, where he wants us to join him.

Borderlines,
Real and Imaginary:
Elizabeth Spencer's
"The Runaways"

Narrative Magazine, 2022

ELIZABETH SPENCER'S "THE Runaways" is, like all her writing, a wonder, with everything present and off the page contributing to our impression of her characters as people in the process of revealing as they conceal. This story eventually lets us hear a stunning admission made by Joclyn that we infer has been withheld, in part because she wishes to conceal it from herself. While omitted, it's obliquely alluded to—though since this is a story by Elizabeth Spencer, the surprise is only part of the story. How interesting, this self-activated jack-in-the-box that also speaks its one significant line, how significant the man who's arrived to receive the information.

The story focuses on Joclyn (her name missing the conventional *e*) and Edward, the rather mysterious Southerner, a recurring character in Spencer's stories. As we read, we learn about people displaced, on the run from

various things, including, it goes without saying, themselves. They're temporarily in one of those San Miguel de Allende sort of places, composed equally of dust and gates. But that's the wrong analogy, because they easily enter the terrain of mountains and valleys in this new community, conveniently also arranged for single living. ("Efficiencies," indeed; Edward hates the term).

The basic situation is immediately, and sadly, comprehensible; it makes it easy for the reader to extrapolate the wider implications, since any story about mortality extends to all of us. The characters are, by choice, in a kind of limbo in a faraway land—though others, we feel, would be just the same at home. Still, it's hard to read without realizing that some of them, if they were more courageous, would walk out on themselves.

But wait: they have! At least, they've tried. They're those pesky expats who can try to see how they play in a new environment, to a new audience. Yet in literature, the audience also inevitably comprises readers, and readers delight in failure. And, of course, we're all familiar with the adage about travelers' baggage always including themselves.

The story is filled with borderlines, demarcations, limits, invisible as well as overt. The apparent ones are, well, apparent. Some can be chosen, literally as well as metaphorically. (Joclyn chooses "a long winding path", Edward chooses "the sharp climb.") Unseen lines are drawn, sometimes to be ignored, as with the obnoxious Gail Loftis, who does enter like a gale. The lofty part of her surname hints at her self-regard. She actually goes in through

a window to trespass on Edward's space. That's one sort of transgression, but of course Spencer is more interested in the unspoken, invisible barriers: as the narrative voice is filtered through Joclyn's perceptions, we learn that Edward has a "slurred way he spoke, Southern obviously, that made irony seem like sarcasm and even contempt." That stunning characterization is obviously particular to the character—it helps create the character—yet I pause at the interjection of "Southern obviously." That's the pronouncement of a character familiar with the dynamic, so that she too is subtly linked with him (takes one to know one) and both are defined by her knowledge. Southerners cross lines others don't—at least, not in exactly this way—but that's because they recognize them. Some of the story's other invisible demarcations have to do with manners, or the lack of them, and things alluded to whose meaning remains unclear, as with the reference to San Francisco. Who, exactly, is Joclyn waiting to hear from? Will it be business or something more personal—what might the letter say? Then one day Edward, who, at Joclyn's request, often gets her mail at the post office—she's written a note (manners) authorizing him to pick it up—is eventually handed her mail unquestioningly. (It's a small community; the post office employee is simply using common sense.) Then he briefly forgets to give it to her (upsetting her sense of what's expected), though when he does hand it over, it's clear he's planned to arrive at drinks time.

As Joclyn sees it, the post office has crossed a line, and he has crossed another, "forgetting." She is, appreciably, losing control. Though in a more profound way, we'll soon

understand, she's already lost control, or her illusion of it. Earlier, we learned that "she had not been well"—a mannerly euphemism, or circumlocution. Then, during their private conversation, she abruptly tells Edward she's dying. This has been hinted at, underscored by her thinness and lack of energy, but when she bluntly speaks, the subtext of everything is exposed. What do we think of her now? We no doubt experience a jumble of emotions, even if we've suspected that something dire might have been at stake that has only been crystallized by words. I ask about the reader's reaction, rather than Edward's, because his reaction speaks for itself. The surprise for us must be that Joclyn's statement doesn't surprise him.

But here's where things get interesting. Before this revelation, he's made one of his own: he killed his wife. He's described the unlikely murder weapon (when we visualize the green Venetian glass, it's strange enough, and vivid enough, that for many readers, it will be convincing exactly because of its unusualness: the "perfect" detail because it is so imperfect), but we'll soon find out that Joclyn doesn't believe him. She contradicts his story. The two of them really are in sync: he's known, or at least has essentially understood, all along, what Jocelyn hasn't verbalized about her condition, just as Joclyn disbelieves his lie. There are many possibilities about how this feels to them, separately and collectively, but as I read it, they see through each other; they're equals, paired.

But let me go backward, to notice the way Spencer writes this story. The language is conditional, hectic. (Spencer might approve of my comma splice.) From the

first paragraph, it's a story intended to call assertions into question by immediately instilling doubt.

From the first, notice the many quibbles and qualifications whose cumulative effect is tediously frustrating: "not really"; "but rather"; "perhaps"; "no one knew for sure"; "the feeling was that." The maundering is excessive, and it's there to destabilize anything we try to hold onto: Well, it's like this, but not really; maybe, maybe not; I was wrong the first time, so let me try this other way of saying it; people talk, and this is what they say, but I'm not stating an opinion, only saying what I've heard. Wouldn't you want to grab the shoulders of anyone speaking this way, to say, Just tell me what you actually think? So why would Elizabeth Spencer begin this way, with a lavish display of doubletalk?

Because that's what her story is going to be about. Even when the numerous irritating examples cease, the noise resonates in our heads. We're sensitized; we're going to hear all that nonsense talk, in the same way Edward makes us conjure up the unlikely green murder weapon so that we see it. Of course, Edward also emphasizes its particular, entirely extraneous history. We're being put through the motions of registering, with some degree of irritation, exactly what the two main characters are separately and jointly up against: the pain of knowing themselves and admitting to the impossibility of exerting control over their own lives.

Notice, also, descriptive writing that poses as mere notes—as in notes to oneself—for example, in the cryptic description "up here on the ridge, cool nights, temperate

afternoons." Notes, as opposed to eloquent writing, aren't to be judged; they're just jotted down. Their fragmentary form can whiz the reader right along, in contrast to the first paragraph's zigzagging prevarications. Yet such tersely expressed moments don't contribute to the fluidity of a story; they're observations sent out, like skipping stones across water. They jump across the surface, taking the reader on a bouncy little ride. This method also makes the lulls feel even more like sink weights.

Often, for these characters, time weighs heavily and passes slowly. One waits for the mail. One walks a bit, then rests. The clock ticks toward drinks time. Somewhere, elsewhere, these people had or have other lives. Yes, the mountains look a particular way. The sky's color is described. We're simultaneously speeded up and slowed down. Viscerally, we no doubt register that something is being withheld.

I would say this about Elizabeth Spencer: she's more interested in the humidity than the temperature.

Along with this, there's Joclyn's occupation, though little is made of it. She's an illustrator. Though these drawings aren't described, illustrators make selections so that the text is visually illuminated. (Interestingly, Edward's "heavy piece of green Venetian glass" shows that he shares with Joclyn the ability to make a story come alive through its visual details.) Whatever Joclyn's illustrations, they seem to me somewhat analogous to notes that include recognizable adjectives ("cool nights, temperate afternoons"). I think the story tells us that we're propelled forward (we live our lives) in speeded-up time that registers in blips,

or moments, but of course we can't control the larger picture—even if we change the backdrop.

More than midway through the story, Edward sits talking to another "runaway," the writer Mr. Rotovsky, in what poses as a casual moment. Edward's question is plaintive—it's really a life-or-death question. His diction speaks to the implied question of the larger story. Is he trying to toss off "go existential" as colloquial or is he unaware of his wish to deemphasize the onus that comes with the word *existential*, thus revealing his vulnerability? (I don't know, though elsewhere, when assessing his wife, he appropriates a regional expression that says everything brilliantly, in four words: "She had taking ways.")

Edward says to Rotovsky: "But if you go existential, you plunge toward something new, and then how're you to know you'll wind up any better than at first?" Rotovsky's direct yet slightly syntactically jarring reply: "Well, then you must feel so strongly that you plunge anyway. There is no time for the questions of this nature." (Similarly, the extraneous "the" gives us a hint: is he effete, or is English not his native language?) Joclyn overhears Edward and Rotovsky's conversation as she passes by. I note that she says nothing. She's on her way to pick wildflowers, because there are rules about not picking the flowers by the walkways.

So what is the depth of feeling between Joclyn and Edward? Those words won't be written in this story. Spencer isn't being evasive, she's being emphatic. She doesn't think (at least here) that words are the best, or only, communicators. There are force fields. People express

themselves through gestures. Little things—inhibitions, slipups, contradictions—reveal and betray us. At story's end, Joclyn's head rests on Edward's knee. Certainly that's intimacy. But let's get down to basics, since her story and my thoughts have almost concluded: Is this a love story or not?

(For me, it's a kind of love story. One off the page, in the heart.)

Craig Nova Casts a Line

Foreword to *Brook Trout and the Writing Life*, 2011

THIS AMAZING BOOK is a memoir in miniature, equally suited to being read from behind the pulpit or tucked into the pocket of a fishing shirt. It's like coming upon a footbridge just when you need to cross the river. The water below, sometimes shallow, sometimes deep, always holds possibilities that are right there in front of you, while—in the hands of this magician writer—simultaneously escaping on the current of metaphor.

Brook Trout and the Writing Life is three books in one—a beautifully tied, totally convincing fly of a book woven from several strands: marriage and fatherhood; being a writer; being a fisherman. I don't fish and I'm not a parent; I love words for their ability to allow the writer to describe one thing while conjuring up other levels of awareness. How precisely and evocatively language serves the writer's cosmos of associations here: what he wants

us to sense on the surface and what information is conveyed deeper down. Writing about fishing: "The line made a lovely shape in the air, at once serpentine and hopeful." We are reading about the fishing line, but it's also a pun: Stories proceed by the extension of lines.

The combination of unexpectedly paired words (*serpentine* and *hopeful*) is obviously disjunctive. The reader conjures up the serpent in the Garden of Eden, with all that connotes; the person who loves paradox will delight in the idea that something snakelike can also bring hope. In spite of our tendency to recoil from a snake, this one is projected upon and humanized into being "hopeful." Read the sentence as expressing the possibility that the snake itself is hopeful; read it, also, as a personal observation: Although my fishing line is like a snake, I, the perceiver, am hopeful. Either way, it's an amazing sentence that expresses many possibilities using so few words.

Midway through his beautiful and often quoted poem "Epilogue," Robert Lowell interrupts his eloquently stated thoughts and invokes some skepticism about himself: "Yet why not say what happened?" speaks to writers' frustration at what they strive to do. (Even dystopian visions, their creators would fairly maintain, are "what happened.") It comes so unexpectedly, though; it seems that in the moment of creating, Lowell could not in good conscience continue. When we read, we usually assume we are receiving—or about to receive—a revelation about something, not that that thing is being obscured or disguised. Yet what writer isn't aware that poetry or prose is a mask: In bedazzling, the aesthetic veneer can also con-

veniently hide the writer. Writers do write to reveal, but also—subconsciously, sometimes—to protect themselves. Think of how many writers have said that if not for the act of writing, they would not have discovered—often, at considerable personal expense—previously unarticulated, sometimes painful truths. It seems to me that Craig Nova, one of the most distinctive voices and visionaries in American fiction, works close to the bone, but never forgets to see things from afar. When he describes his process of tying a fly, our own fingers cramp with tension; when he casts his line, we become that line, flying over the water's uncertain surface.

There is a lot of physicality about fishing, but lest fishing become fetishized, the writer tells us: "One of the things you learn is that some materials, like rabbit fur, when wet, have a movement that is lifelike and suggests anxiety, or at least the desire to get its business done quickly." The writing is so immediate, activates so many of our senses, that smiling as we read the concluding words of the sentence comes as a bonus: Wait a minute: this guy's got a sense of humor!

One of my favorite small stories within the text is about Craig's awareness that as he's fishing, a woman sits on her porch, without expression, shelling peas, involved in her own precise activity; eventually other people arrive and depart, fooled by Craig's fishing a predictably bounteous stream with no bait; aware that he's being observed, he doesn't want them to discover his sure-thing fishing spot. It's only when the ruse works, and they leave, that the woman waves to him.

That moment is so nice: It isn't elaborated upon; no dialogue follows. She communicates by a signal, nonverbal shorthand for a lot of things she's observed that have been going on. She becomes, in effect, interchangeable with a writer: This is exactly what writers do, when they come up with the perfect gesture to define or explain their character. In nonfiction, Joan Didion is one of the real masters. In fiction, Hemingway. We are so rarely solitary, even trekking through the woods, even fishing, let alone near enough to civilization that someone might acknowledge us, in her own good time, in her own equally valid reality, with a wave.

Still, privacy remains an integral part of Americans' self-definition, in spite of the fact that we spend so much of our lives among others, whether it be in airport transport vans or in the crowded pleasure-dome cafés of New York's Upper West Side. Along with all the frantic markers for Having a Good Time, though, comes a predictable ebb tide that is the impulse toward solitude. From Natty Bumppo through *Easy Rider*, our guides slip the knot of acceptance that binds them to a notion of what a person is supposed to do. The romantic ideal of escaping society's constraints is represented by Dennis Hopper and Peter Fonda, speeding through all that empty land; we go on "retreats" to rethink our priorities; we visualize—and when we do, how often do we imagine joining some official or unofficial parade, as opposed to partaking of something more placid, such as sitting on the beach at sunset?

William James: "The intellectual life of man consists almost wholly in his substituting a conceptual order for

the perceptual order in which his experience originally comes." We write our own stories, retrospectively substituting intentionality for chance. When Craig Nova observes mountain peaks that have "a color like the tip of a soldering iron," the description instantly sears our senses: vision, touch. We register pain. As with the snake, we draw back from danger, though this moment eventually devolves into a more neutral view. Yet once we've been branded, we know those peaks' power, as well as their usual/unusual postcard colorfulness.

This way of making us observe says something about the way Craig Nova sees the world, and about the way he wishes to reveal it: At its most extreme, and also at its most lovely, the two states exist in constant tension with each other. As a writer, to have the dual impulse to stand back and consider the unexpected nimbus that surrounds the ordinary, as well as to transform that seemingly unremarkable observation convincingly through words and their qualities of ambiguity, allusion, and inherent poetry, is an amazing—even daring—accomplishment.

First, Let's Kill the Lawyer

Review of Elmore Leonard's *Mr. Paradise*
The New York Times, 2004

PEOPLE SAY IT all the time: open the newspaper and read stranger stuff than you could invent. Fiction writers have (you choose) got it easy or they've been trumped by reality. This is true only if you believe what you read in the paper and believe in "reality." Elmore Leonard's fortieth book, *Mr. Paradise*, is filled with ironic quotation marks, though he doesn't put them on the page. Tone is everything. How, exactly, can you be sure what the tone is? Well, you can't. Leonard addresses those who think they hear the same music he does but are open to questioning the familiar, to listening carefully and seeing when something has a different emphasis.

Flannery O'Connor wrote that good fiction comes at you through the senses, and in Elmore Leonard your sense of hearing is much called upon. What happens in this book is—perhaps more than usual—very much about

language, the decline of the language: not just its warpings or its variables or its much talked about imprecision. Class figures into it: those in power often benefit by adopting a particular vocabulary; those without power use language to exclude as well. And everyone knows language can seduce—which can be very enjoyable but also problematic.

When Kelly, a model who is present when a murder takes place, describes her father, she points out: "He's a semiretired barber. Not a hair stylist, a barber." Hair stylist is in invisible ironic quotation marks. When Frank Delsa, the homicide detective investigating the murder, questions someone he suspects and is told "This nigga busts in and shoots 'em," he rephrases the statement: "This home invader." Delsa's description is also in ironic quotes. They continue to punctuate, sharp as an ice pick, throughout the novel.

Elmore Leonard's previous work has demonstrated he's got a sense of humor. He's hip and has the ability to keep readers involved, even if some miss an "in" joke or have no idea there's a literary allusion. You will love this excellent book even if you make nothing of the fact that the victim, surname Paradiso, is known as Mr. Paradise. If you want to, though, you can let your mind wander to "Paradise Lost" in Book One, where we find one of Milton's famous lines (which happens to be spoken by a fallen archangel): "The mind is its own place, and in itself / Can make a heav'n of hell, a hell of heav'n." Leonard is chronicling a struggle between good and evil. The Christian reader would certainly nod: man has fallen from grace. A heathen would hardly be prohibited from understanding

that our world has become a violent, sad place—though there are those among us who would speak of it euphemistically, hoping the veneer of language could soothe the hurt within.

Yet reality oozes out of the cracks, and Leonard is there to swirl it around. Victoria's Secret catalogs are not inherently subversive, but do we doubt that they advertise something other than underwear? Cargo pants serve one function when worn by the military, another when worn by a model who pairs them with a cashmere sweater, yet another when worn by a criminal. Fashions or fetishes are appropriated, but their connotations change, they mess with our minds, when they make the jump from function to arbitrary style. Our society has sunk deep into the quicksand of style, it seems, and looking around, Leonard selects well: the flotsam and jetsam we might think is harmless rises to the surface to support larger acts (the subjects of his books) that involve good versus evil. If we can flirt and posture, laugh ironically about ghastly things and accept any discordant detail about how people look and what they seem to say, as opposed to what they are and what they really mean, we're cheerleaders (as is one of the murder victims—though a rather unconventional cheerleader) for a corruption in our society whose taproot is anchored in the soil of a malaise that can become murderous.

Mr. Paradise is about deception. People deceive through false identity (appropriating, dissembling), just as they themselves have been deceived—whether by the implied promise of collapsed dot-coms or by positive, false assumptions about family.

Mr. Paradise's employees are self-justifying and treacherous. Beware those who repeat the cant that your life is the story you tell yourself. Two former convicts, employees of Anthony Paradiso, the elderly lawyer who has "saved" them (sorry: you might mistake my irony if I didn't punctuate), arrange, or are complicitous in, his murder; a former prostitute who has gone with her friend to entertain Mr. Paradise is killed when a psychopathic Marx Brother–gone–way–way–wrong criminal decides he must shoot her to ensure her silence.

Enter the homicide detective Frank Delsa (and his colleagues), who must sort it out. He does, somewhat inadvertently, converging with the two maniacal hit men hired by Montez Taylor (aka Chops) in the very house where the murder was committed, presided over by Satan, in the guise of a merely totally corrupt lawyer named Avern Cohn. There are numerous lessons to be learned, among them that dissing people can result in deadly retribution, and that "stupid" people (who appear throughout the book as minor characters, usually off-camera, like a woman who calls the police to turn in her brother when she is displeased that he opened her can of beans) often determine the outcome of important matters.

Ironic—right? But Leonard is no simple moralist. Rather, he brilliantly involves himself in playing the same game he is exposing. His details are so well chosen, so recognizable that we initially feel an amused sense of false security about their presence. His characters feel such a sense of entitlement that the reader sometimes loses sight of the truth.

To a suspect who expresses surprise that Delsa is going to let him smoke in a nonsmoking building, Delsa reveals himself in the guise of explaining: it's a problem "only if you get caught." It's a minor matter, surely; the reader is amused. Yet the word *smoke* transmogrifies into slang with negative connotations elsewhere. When we turn our heads from one matter, we become vulnerable to turning our heads from the next matter, and the next.

There's a frightening sort of refrain in the book: "It's what you do" (Chloe, a prostitute turned mistress); "That's what you do, isn't it?" (Mr. Paradise, condescendingly instructing his servant about his duties); a drug dealer is said to stash drugs at his mother's, "like they do." Ah, yes: the way things are. The status quo of the previously unthinkable, now the world as any sophisticated person must know it. We are made to consider the banality of evil, the evil of banality (signaled by Leonard in all that ostensibly makes us more comfortable: nicknames, acronyms, metonymy).

In Elmore Leonard's universe, we need to stop laughing. Metaphorically, we are dead and buried if we have learned nothing from history and have fallen so far we fail to understand that our actions have moral consequences: if we cannot see our ubiquitous disregard for our fellow man as (ironic quotes or not) "evil."

In "Flotsam,"
Nancy Hale Tells It Slant

Narrative, 2019

IS THIS AN old-fashioned story? One that doesn't really, you know, pertain anymore? No requisite zeitgeist, a foreigner (Da Silva) whose perceived character taps into ethnic assumptions . . . and how sexy is a grandmother as the main character, anyway?

Ah, but this is a well-crafted and crafty story, and things are not what they seem to be. Its title points us in the right direction: these characters have been discarded, set adrift. The writer is interested in revealing the fractures in their characters and therefore in their beliefs. As the story starts to send out flashes of awareness for the reader, we look beyond appearances to assess everyone's inconsistencies, flaws, and vulnerabilities rather than float on the story's surface. Everyone is more or less in a state of suspension, whether it be the mother pursuing her divorce, the boatman who needs customers at season's end,

the child who wants excitement, while—simultaneously, like all other children—he also wants the status quo.

It is never to return. In fact, did it ever have any credibility?

When the story begins, the excitement is over or, as I've suggested, never really happened or, at least, is recounted in an idealized way: Carolyn, the grandmother, will not again attend splendid dances; Carolyn's daughter, Mary, has left her son, Marcus, in Carolyn's care while she's away finalizing divorce papers. The boatman who approaches them about a ride (his business card reads more like a perverse little poem than a self-advertisement) is contending with New England's off-season—factually, as well as metaphorically. Over all these situations floats a cumulus cloud (so to speak), further threatening the stability of daily life. Ever so slightly, we're even reminded that the United States is separated from England. Though the references are fleeting and subtle, England is symbolized by a heraldic red-painted dragon on a toy the child remembers fondly. (By the time he finishes his account of his earlier happiness, the reader is wide-eyed.) The child's father is in England.

Carolyn walks through Rockport with her grandson on a summer day, while his mother pursues her divorce—an undertaking that required time, and even one's physical presence elsewhere, in those days. The child is fixated on the fact that he's with his grandmother, not his mother. He's seven. He does not yet know that having your facts straight won't make life clear and protect you. The grandmother is fixated on alcohol; she wants a drink. The reader

intuits that the Stereotypical Stranger, Da Silva, is up to something when he unexpectedly appears. We too are reluctant to board his boat, though of course the child very much wants that to happen; if we could advise the grandmother, we'd caution her the same way we'd address a potential victim in a fairy tale: *Don't get on that boat.*

The boat proves irresistible. They climb aboard. We learn that the grandmother has been thwarted in her plan to get a drink (first, a bottle "forgotten" by her daughter—no doubt precisely because she doesn't want her mother to drink). The town is dry; Carolyn can't buy liquor. She decides to go elsewhere, so important is this drink. That plan also gets thwarted. Except that Da Silva, who compliments Carolyn's youthful appearance (possibly, he's simply saying what he thinks when he won't be disabused of the notion that she's the boy's mother; if not, we read it as flirting), has a bottle on board. After a moment of conflict, Grandma holds it to her mouth and drinks. He knows her, knows how to insinuate himself.

Men—even little boys—don't come off so well in this story, yet the reader's bias against them isn't quite fair, as they're either elsewhere or our assumptions spring from generalizations about foreigners or husbands or from the reader's skepticism about fairy-tale-like fantasy-creature men who were always good dancers, even if those "dances" didn't ultimately work out.

Grandma's own husband died in a car accident because of speeding—or, at least, she ascribes his death to speeding. She uses this story as a cautionary tale, yet we later find out that she herself used to speed into the com-

muter lot. Alive but absent is the boy's father (Grandma liked him; he was a drinker). At first, in the presentation of Da Silva, we're made to be suspicious of the boatman (we might sympathize: these things are complicated; he needs the money—this isn't his idea of a great afternoon, either). Ultimately, he's Carolyn's moral compass, albeit a rather indifferent one. Most interesting, though, is Carolyn's late husband. Notice the way she expresses her romantic memory of him (one we have to see as somewhat, if not profoundly, silly), but she rather quickly elides her ostensibly wonderful memories with the word *suicide,* as she remembers him speeding (and dying) in his car. Once said, that word can't be unsaid, in the reader's mind. I think, though, that the reader is meant to be suspicious of *all* the absent men, but this story is also a study of Carolyn, and we come to question, almost immediately, the inherent power she ascribes to males. The more Carolyn voices her romantic conceptions, the more unknowable these men become. We know she looks elsewhere when it benefits her not to look straight ahead (which is almost every moment)—though near story's end there is a shift, and she seems totally, abruptly honest, in her reply to Da Silva when she assures him (more accurately, she finally hears herself admit) that, yes, she really *does* like alcohol.

Readers are propelled toward a different interpretation of everything we've envisioned (as opposed to heard) once we're on the boat. The boat itself is personified, as if it's another person: "It seemed a relief when Da Silva started the engine to hear it burst at once into a loud, sputtering roar. The boat wheeled, took direction, moved out with

purpose toward the cut in the granite breakwater and the ocean lying outside of it."

I must digress and say something about Ms. Hale's insidiously effective choice of words. The word *roar* was deliberately selected because throughout the story, turning around us like the opaque images cast by a magic lantern, we have a now-you-see-it/now-you-don't version of the writer's jungle or, because the animals are domesticated, a zoo. A zoo containing, for example, "stags" at the dance parties, which the grandmother explains to her grandson is a way of referring to men brought in specifically so there would be more than enough partners for the women. Reconsider the toy Marcus tells his grandmother about, and, as well as the male deer (pun), we have a lion ("It was a fire engine and two lions, and one of the lions was red.") These men, these animals, as named and imagined, are creatures of the natural world of planet Earth. Around them swirl women who romanticize them (though clearly the message is that we should not)—women who are more analogous to sprites, or air creatures, in their gauzy dresses, than strong and recognizable. How, exactly, does one group (female) interact with a different group (male)? One answer: in a *story*.

If we listen carefully to what's not said (Carolyn's account of her youth; Marcus's story about his happy Christmas), the importance of what's omitted is almost like a slap in the face. As the boy first boards the boat, Da Silva hands him an oilskin jacket—one for everyone; unisex!—but this jacket also works on a metaphoric level. For me, it conjures up the image of a seal (thus expanding

our zoo): "'Look at me!' Marcus cried, dancing about. He looked from Carolyn's face to Da Silva's, and flapped his arms. 'I haven't any hands!'" Sure—a child being cute. But he's powerless . . . he can't touch anything, right? And if you don't touch, you're not the one to blame if something, or someone, is harmed.

Ostensibly, "Flotsam" is about inclusion, but the stories within turn out to be about divisiveness, from what the reader will understand was, at best, an imperfect Christmas, to Grandma's long-ago magical evenings. Something's inherently wrong in every relationship, or even those times men only intermingle with women. Nancy Hale—who had such an eye and ear for formalities and social manners that we might at first imagine she was dazzled by them—was herself an astute, sneaky, radical writer who carefully seamed her garment to fit perfectly, then tore out the stitches as we looked away. This story could hardly be more subversive. It's also interesting to note that Mary (a significant name), the child's mother, was thought of by her own father, Carolyn's late husband, as having looked masculine (therefore, powerful); and Carolyn tells Marcus his grandfather had always wanted a boy. Yet even after his death, *she* continues to ascribe maleness to her daughter, whom her husband used to call "his little Daniel, when she'd plant herself in front of him—that fat-legged little girl—looking so worried, and tell him he shouldn't smoke so much." When Marcus is confused by the reference, his grandmother mentions the Bible. Of course. The reader will already have registered the allusion, then remembered the story of Daniel in the lion's den (borrowing, again,

from our hypothetical animal kingdom), and to Daniel's faith, which protected him from harm.

Being on a boat doesn't make you helpless, but it does make you vulnerable. Anyone who knows the sea will tell you that. So, removed from *dry* land (where lions and tigers prowl), Nancy Hale invites us aboard with the trio, as Da Silva maneuvers "between the high gates that the breakwater made." Soon thereafter, Marcus makes a comment: "'Seems like old times,' he said cozily. 'When my father was home.'" This too-adult remark provokes a laugh from Da Silva, the temporary father figure. Nancy Hale writes: "Da Silva laughed, altering their course so that, instead of heading straight out, they ran at an angle to the land. 'Where *is* Papa?' he asked." Read this symbolically: obviously, it's a hypothetical question—perhaps even a reference, as well, to that great Papa in the sky. In any case, the security the vanished father might have provided (but he did and does not) is nonexistent, and the person in control of the boat at first follows the contours of the land, though at the end of the story the reader's visual image is of the vast, unknown, potentially treacherous sea.

Wow. Then the boat is again personified: "The boat drove southward, engine muttering, and left a neat triangle [remember our threesome] of wake in the darkening water [I'll say; also, *wake* works as a pun]. Back on shore a white church tower thrusts its verdigris dome up [Freud would be smiling: how could we not envision female/male anatomy in the *triangle* and the *dome* rising above?]." The paragraph continues. The writer must have been pleased with herself for writing it in the 1950s.

We end with Marcus's perceptions, as he imagines going "maybe toward England," where of course his father (or Father) is. This idea causes the reader to experience a pang of regret too: Though our adult perceptions differ from his, we too intuit that something is missing. We suspect that those aboard are imperiled, maybe not so much because of the ocean's strength but rather because of the human tendency to try to hug the shore of our own lives, in a state of dread commensurate with our desire.

That's one reading. There are others.

Fire and Fireworks:
Richard Bausch's "Consolation"

Why I Like This Story, 2019

"CONSOLATION" IS THE sequel to Richard Bausch's exhilaratingly depressing story "The Fireman's Wife," though it stands on its own and reverberates with enough shock waves that you need not have read part one in order to be stunned by part two. "Consolation" is deliberately not a proper sequel, in which we would meet all the main characters again, but rather a kind of sidebar—a reminder that there are always more characters on the sidelines, and that they, too, have their stories, which inevitably impinge on the stories of the characters we know and, by implication, those we might yet meet. His stories are not exactly a one-two punch—Bausch is too adeptly persuasive a writer, too compassionate (a word George Garrett has aptly applied to Bausch's writing), ultimately, to hit you only in the gut—so although there are extremely painful moments in "The Fireman's Wife," "Consolation"

is more concerned with phantom pain. Of course, that kind of pain is more insidious, and dealing with phantom pain means that the writer has to haunt the reader—along with the character—with what is not, rather than with what is. It's easy to jump out of a closet and scare someone. It is more difficult to make the reader imagine a closet where one doesn't exist, and for the dramatic jump to have transpired long before your story begins. Eudora Welty has dealt with ephemeral, missed moments that can nevertheless be brilliantly conjured up, through the pace of the story and through the writer's language, in "No Place For You, My Love," in which her heated eloquence out-*Gatsby*s Fitzgerald. Reynolds Price also comes to mind, with his long, brilliant story about grief, "Walking Lessons." Actually, there's quite a bit of American literature that is about afterwards. Maybe it figures, because our country's identity is the identity of afterward.

"Consolation" is about a trip a widowed woman takes with her sister to visit her dead husband's parents so they can meet their grandson. Bausch's story does not have an ironic title. Though his characters may be caught up in ironies, he presents the stories straightforwardly—or as logically as such complex lives can be revealed in chronological time. They are usually presented simply, in the recounting of moment-to-moment events, though they become complex as you begin to sense the structure. What was a realistic painting suddenly becomes a hologram, so convincing, so three-dimensional, that you cannot possibly think the depth is an illusion, and, concomitantly, a surreal quality begins to emerge: the unspoken begins to

take on a life of its own. Like other of his stories, "Consolation" does not tell you that everything is okay, but it does tell you that the world is still there. From first story to second, the details permutate; they are different in their specifics, but not in their ability to be disquieting. Gone are the party tiki lights of "The Fireman's Wife," replaced—such as they are—by equally sad exotica: They drink tropical punch from cans.

The "they" are Milly Harmon, new mother and recent widow, and her (chronologically) older sister, Meg, who has accompanied her to Philadelphia so Milly's in-laws can meet the child born after their son's death. Aside from introducing us to the characters, the first things described for the reader are a boy who is swimming and a fat woman lying poolside. Active and passive, they express Milly's internal conflict: movement is essential; movement may take her, essentially, nowhere. Which, for a while, looks like the real danger: her in-laws seem distant, perhaps even uncaring; her sister, who we sense might do just about anything because she's so desperate and so good at rationalizing, seems a parody of movement as progress. Though Milly has decided that after her husband's death she must go on, Meg—who has suffered no such tragedy—is so conflicted over the collapse of her own marriage that we have the impression she's essentially along for the ride; this one, or almost any other, might offer equal consolation. Meg is not a simple character, though: she's wise about some things—even if the wisdom has the super-sharp edge of cynicism—and immature and/or irresponsible about her approach to other important matters. Still, Meg is our

oracle—or as likely an authority figure as we're going to get in this story. If Milly's panic is imploding, her sister is exploding—or always about to. Possible dichotomies are conjured up for us: the active swimmer or the passive sunbather. Milly sets a trajectory for herself and her sister, struggling like a creature caught in a spider's web, desperate to believe in the next big breeze.

We are reminded of and haunted by Milly's husband Wally's death even those times when that isn't the overt subject—perhaps most of all when it's not. We learn that Wally's troubled father leaves the table when "his dinner was still steaming on his plate." Later, in a brilliant description that links the new baby to the dead father, there are "fleecy clouds that look like filaments of steam." The story is much concerned with things that have—so to speak—gone up in smoke: Meg's marriage, on the verge of collapse (she hears about people who have more or less reconciled whom she cynically considers "Tied to each other on a rock in space"); Milly, of course, has lost Wally to fire, and Meg's estranged husband may even reclaim his wife, leaving Milly abandoned a second time. Steam might be a fine metaphor in any number of stories, but it works so well in Bausch's because it subtly directs our attention upward; as we watch it dissipate, we remember the fire (though we weren't present), at the same time we gaze upward, anticipating the eventual fireworks display at story's end (which also doesn't get staged for us). Much happens off-camera in the story just as it does in real life, but because aspects of the tragedy permutate as they are evoked, they come to seem hyper-real. There is the fact of Wally's death, inherently dramatic, but

it is in the softer, more diffuse, ghostly vaporous steam that we repeatedly sense his absence. One moment, in effect, repeats and masquerades as another ... which leads me to another observation:

Throughout the story, people are in costume: Larry, Meg's husband, in his discordant clothing, is described by that very word. But Meg, too, has a costume; she wears a kimono, which she artfully arranges to attract attention. The baby, too, is masquerading: named after his father, he is instead nicknamed "Zeke." Mr. Harmon, who has brought in an enormous stuffed bear for his grandson (we can't help but think of his dead son, of course, when he "has it over his shoulder, like a man lugging a body"), is said to stand in an "intentionally ramrod-stiff way ... the stance, he would say, of an old military man, which happens to be exactly what he is." Harmon reverts to the posture, as if it will be some help to him, just as Larry, in his odd bohemian getup, tries to emulate a safe but scintillating stereotype of the artist, to get what he wants. Only Milly, whose childhood nickname was "Stick," seems unconcerned with how she appears physically and indifferent to appearances in general, though she is nevertheless concerned with what people think of her. (So much of her own life seems somehow duplicitous to her, as if the wish to please others and to be well thought of somehow dulled the edges of her identity and left her with nothing but a set of received impressions.) One way or another, all the characters are acting, and as they do, Bausch reveals to the reader more than the characters are consciously aware of. Larry is not only foolishly dressed; he displays his emotional wound when his turtle-

neck is described, "its dark colors bleeding into each other across the front." The masquerades are troubling and troublingly transparent. When Mr. Harmon speaks of the past, he invokes it at first nostalgically ("There used to be a big field out this way—") with regret for what has passed, but in wanting to placate his wife, who remembers her dead son's boyhood in connection with those fields, he insists—hardly to the point, but characteristic of his love of the status quo—that (speaking of the fireworks), "They still put on a good show." Which is what they all strive to do, as Meg announces earlier in the first outright mention of a performance ("Hey," Meg says. "It's your show.").

Near the end, everyone's personal drama is played against the backdrop of the Fourth of July, the anticipated fireworks conjuring up not only war (Mr. Harmon's connection to the military; Larry's chest-wound shirt; even Meg, as she describes herself in a moment of despair: "Good lord, I look like war."), but the explosive fire in which Wally died, as well. Literally, Meg has said more than she knows when she announces, early on, that the Harmons' odd behavior is the result of "the war" ("I think the war got them. That whole generation."). No doubt, but as Bausch demonstrates, there are different kinds of war, and one of them might be the battle you have to wage with yourself to stay sane. When Milly shudders, remembering Wally, Meg calls it right again: "You looked like something hurt you . . . you were thinking about Wally."

No psychic abilities required. Of course Wally's death has been the subtext for everything in the story, and that undertow—through image and language and analogy—

turns us repeatedly back to the past, even as the story marches relentlessly forward. We have Meg to thank for her words of wisdom, and Meg to pity for the pain her awareness has brought her. An ostensible celebration becomes for her—and therefore, for us—something quite different: "All these years of independence," Meg says, "so people like us can have these wonderful private lives." It's difficult not to expel a cynical snort of agreement after that observation, but she's speaking not only to assert what she believes (or fears), but also to restate an important element of the story, which is how often the private becomes public. On one level, that's what all stories are about, because what a storyteller does is expose people's lives—but thematically, within the world of this particular story, the smoke never quite clears: it's as if we squint and strain to hear, just as the characters do, hoping for clarification, as they also fear it. Even Meg's husband's ludicrously bad poetry is concerned with his frustrated attempt to see. Things take their course, whether those things be fires or fireworks displays, and the challenging question—the one that has so often interested Bausch—becomes how one copes.

Certainly, in the larger sense, independence has guaranteed us nothing, but a certain independence of spirit—a reaching out that can result in a firmer bond with another person, rather than separateness—seems to be an idea. When Milly at last hands her child to its grandmother (we do not fail to notice that this is the baby she was never willing to relinquish to wounded, cynical Meg), something has come full circle. For a moment, everyone has

suspended thoughts of separateness and independence. Instead, they've become interdependent, and in that way—like buddies in battle—they can best go forward.

David Markson's
Visions and Revisions

Introduction to
This Is Not a Novel & Other Novels, 2016

Introductions, when read at all, might sometimes be considered as an afterthought to the reader's own impressions after finishing the book. There's nothing wrong with guarding one's capacity for surprise when encountering the work of an author who's new to you, nothing wrong with reading the review after seeing the movie. So, perhaps perversely, I hope you'll read these three novels and form your own impression, and if my remarks suggest other things, or verify or call into question certain feelings, they're only that: an appreciative reader's observations.

But they're fond remarks. What I have to say teeters between David's having been my friend and my awe and continued amazement at his work and what he achieved. Since now there will be no new work, I can only reread—which might elicit the same responses, because of familiarity. Yet every time I pick up one of his books,

I find it more exceptional than it seemed at first. I'm not alone in this response: it's appreciated and discussed and is often spoken of as representing a leap forward for American literature. I'm still troubled that it wasn't more appreciated in his lifetime, but I'm less sure that matters—except, obviously, for a writer being able to make a living, and for reinforcing the writer's sense of self-esteem, which are not minor matters. "Rediscoveries" are more and more a part of literary culture: Edith Pearlman; the reissues in the wonderful *New York Review of Books* Classics series (don't miss *The Pilgrim Hawk*, by Glenway Wescott, if *The Great Gatsby* initially gave you snow blindness). We've always had Counterpoint to thank for bringing forth unexpected texts, radical books for astute readers. That doesn't mean you have to be an expert to enjoy them.

I knew David in the early eighties in New York. He lived in Greenwich Village, I lived in Chelsea. We had a few mutual friends. When we were introduced, I hadn't read his work, but I did know that Douglas Day, who'd also written about Malcolm Lowry, had the greatest respect for David's book, *Malcolm Lowry's Volcano*. I eventually read a couple of David's early books, liked them but wasn't over the moon, and as we got to know each other a bit better, he asked if I'd read a manuscript he'd just finished called *Wittgenstein's Mistress*. As I write, four extra copies are on my bookshelf, in case someone wants to read it. I took the manuscript home with me and read all night. I was speechless. Whatever I finally managed to say on the phone let him know how astonished I was at what

he'd done. In the back of my mind, I had feared reading a manuscript that would call on my nonexistent knowledge of Wittgenstein. And, as writers always fear, if they don't like what they read, they have to figure out how honest to be in their response. I'm sure I fell all over myself, but he did understand that I thought it was one of the most moving, surprising books I'd ever read. And I'm sticking to that. The character in that novel is either the last person on Earth or she believes she is.

Absence throbs in the text. The last page is heartbreaking. And while that earlier book is quite distinct from these three, the idea of a solitary thinker, an artist (she is a painter) without reinforcement but with many memories and confusions, going toward she knows not what, provides a kind of thematic undertow to *This Is Not a Novel*, *Vanishing Point*, and *The Last Novel*.

There is no possibility that David Markson would have thought of being fashionable. But without any calculation, his writing has come to be considered very of-the-moment. I bring this up because for readers who've heard of him only recently, perhaps in online magazines or various blogs and literary sites, or because his books have been embraced in the academic world, his categorization as "postmodern" might come to mind. I can't argue with that, though it was not the categorization that led David Foster Wallace to write him a fan letter. For Wallace, as for many other writers, it was for his unique mining of a territory that didn't much exist—at least in the United States—until David asserted its presence. First he discovered the turf. Then he stood on it.

You have in front of you his last three books, which have often been discussed in terms of collage. We, in these fragmented times, with our reputed short attention spans and our belief that with enough intellectual coaxing anything can be made to fit with everything, react positively to "collage." People love to compare writing to visual art, though I don't think his work has much to do with collage. I think he was his own perfect team of Eliot and Pound, a poet who displaced and projected emotions onto an opaque, little-peopled landscape that, after being rearranged and judiciously edited, revealed the bones of a skeleton we knew existed, though not in this exact, surprising form. So, okay: I'd have it that he was a brilliant paleontologist as well as a fiction writer with the deft touch of a poet. Teamed with himself, he was absolutely brilliant. He really shuffled those cards: a quote from Diogenes; a little-known fact about Baudelaire ("Baudelaire wore rouge"). (They really were cards; his notes were kept on index cards. Many, many.) So in some ways he was a collector, and metaphorically speaking I suppose he had to eventually glue his sentences down in what he considered the best possible order. But they are *all words*, the images conjured up but off the page, the collage—if it's even an appropriate comparison—assembled horizontally, for the eye to scan from left to right.

Try to *stop* reading one of these three novels. Meanings accrue; mysteries arise; you laugh when you least expect it; a character (or characters) is indelibly created (though in the Beckettian manner, he uses as few as possible). It's often observed that when you compile a list,

what is revealed transcends the individual notations. Write a play—in which you are primarily restricted to dialogue—and the problem is often that the dialogue takes on *too much* meaning. A writer as aware and purposeful as David would have been highly sensitized to that. By the time he finished, he knew what the books were. And then, I'd guess, he went on to write a second book in the same manner, because he also knew what the books were not. I'm not the one to say how many books by a writer are enough, too few, or too many. They'd have to all exist, to have a dialogue. There would have had to be many more in this series (how I wish they existed; he was working on another when he died) to know if they'd stretch all the way to the horizon line that existed, way in the distance, sometimes obscured by fog, as a definition of what the twentieth century was. He worried about doing the same old thing—but any serious writer becomes inhibited and nervous about that. He was a man of habits, who took increasingly short walks (hey: he got old and wasn't in perfect health. Also, his beloved Strand was nearby). But he read assiduously (who cares if he didn't keep up with contemporary fiction? Even his own admission of deficiency seems half-hearted), and developed his book's trajectories subtly but deliberately, working both on the level of the sentence and keeping in mind the book's arc. Some sentences are inverted; many present the observation or statement, then fill us in on who said it ("'He who writes for fools will always find a large audience,' said Schopenhauer"). And then, when we are used to this system of presentation, he drops in a simple declarative sentence

("Marco Polo died three years after Dante"). Among the questions David implies is this: Does it matter who said what, or that the thing was said? For me, what's stated, usually tersely, is like a balloon whose string dangles the name of the person being quoted. Interesting questions are raised: of the spoken word vs. the personality of the speaker; how one statement inadvertently continues or calls into question another. And throughout, a fictional persona coexists with these usually famous artists and philosophers and musicians—a bare-bones sort of person sunk sometimes in a self-pity that seems simultaneously funny, or wandering *alone* through a maze of concepts that do and don't have anything to do with his banal day, his banal (but human/therefore human) desires. What we have is fiction, consisting of fact and hearsay and words already written, whether transcribed exactly or not, repeated by David in a different order, appropriated for the purpose of making a new creation.

If at times that might have looked to the writer like a words-only version of Exquisite Corpse (the old-fashioned game of two players drawing parts of a figure, then folding the page over so the next person must continue drawing what they've never seen), that's no different from the way a lot of other writers work. Even writers who proceed from an outline often remark that as they wrote, something surprised them, or derailed them, or that only as they got close to the end of the first draft did they realize the larger meaning of what they were doing. I don't mean to either disappear beneath the mask of metaphor or make an exact analogy, but David was a solitary man

who read and wrote and lived alone (though he certainly missed the good old days at his favorite bar, the Lion's Head). He could continue drawing his own invented figure (so to speak), but in juggling the contradictions, textures, and clashing philosophies of what he was creating, he must, at times, have had to resist forcing something into shape just because it was under his control. (Pound and Eliot hardly had the same sensibility.) You don't live almost your whole life in New York City and not believe in chance.

To quote myself (he'd smile at the indulgence) with something I said when I introduced him for his reading at the 92nd Street Y: "We know that literature is always in dialogue with other literature, but it is our good fortune that David Markson has acted as a facilitator, the good host, introducing all the right people to the right people, while being puckish enough to introduce all the right people to the wrong people, as well. In-jokes appear sometimes as little grace-notes. The works and the remarks of visual artists and philosophers also figure in, as do characters who may not be fictional. In David Markson, backward motion is as important as forward motion." So this doesn't become abstract, let me make a few comments about a short sequence of paragraphs from *Vanishing Point*:

> Scholars who are convinced that Shakespeare must certainly have been a military man. Or a lawyer. Or closely associated with royalty. Or even a Jew.
>
> To which Ellen Terry: Or surely a woman.

Yup; the jury's out. But the passage tells us so much more than the fact that Shakespeare remains a mystery. It mimics gossip. It addresses the serious issue of identity, and other people's claim on it. The word *even* is certainly revealing about someone's attitude. We are (I assume) made uncomfortable by the distinction being drawn. The following paragraph ("To which Ellen Terry: Or surely a woman") does several interesting things: the speculation resumes (and therefore, by extension, this determines a manner of speech and typifies a conversational mode), but we can't quite recover from *"even* a Jew," although Ms. Terry's remark—because we do not know her—might be read any number of ways: that she thinks Jews and women are both problematic; that she is a woman who reflexively mentions oft-forgotten women; that she truly believes that Shakespeare might have been female. These are just a few things to notice among many possibilities. But then we drop off into white space. The next paragraph concerns a painter. Since we have no other transition to the first word of the next paragraph (Michelangelo), we hear something discordant: the lingering voice of the last person to speak (Ellen Terry) butting up against Michelangelo. We don't move from famous writer (Shakespeare) to famous painter (Michelangelo) and feel the coherence of the arts, though; rather, we hear that ambiguous pronouncement of the suddenly vanished Ellen Terry making a remark that might have been fatuous, or perhaps mocking, perhaps an announcement of a personal belief . . . and a sort of echo chamber is set up, in which a voice doesn't entirely vanish, but is supplanted instead. This happens in

music all the time. I would suspect, though, that for those who care to hear it, there is Eliot's line from *Prufrock*: "In the room the women come and go, / talking of Michelangelo." I'm only guessing, but the world-weariness of Eliot's famous line seems to bond invisibly to the fact that between paragraphs, a breath has been taken (seen as white space and with no suggestion of a direct way to make the transition), so that we are surprised, yet not surprised, to suddenly be considering Michelangelo.

> Michelangelo once criticized the fact that Raphael was unfailingly accompanied by an entourage of pupils and admirers, saying he went parading about like a general—
> To which Raphael: And you go about alone like a hangman.

We smile at Raphael's one-upmanship. It's one of those moments of quick riposte we so often wish we were capable of; someone does get the last, clever word. Add that to our Exquisite Corpse as it's been shaping up, and the accordion (turn it on its side; then my analogy works!) lengthens so we see that Shakespeare and Ellen Terry have been conjured up, to be followed by another eminence, who gets a put-down from yet another eminent painter. Here, we can laugh—even if a bit ruefully. But rarely does a conversation conclude with someone offering a *bon mot*. In dialogue, it's never believable, because it seems like the writer is being too witty, or artificially ending on a high note. (We might get off a witty remark,

but then fate seems to decree that the fire alarm goes off, or our belt breaks and our pants fall down.)

But now here, *here* David Markson intervenes, with his character Author:

> Not that rearranging his notes means that Author has any real idea where the book is headed, on the other hand.
>
> Ideally, in fact, it will wind up someplace that will surprise even Author himself.

There's the preemptive strike, in case we wondered where the book was going. Ah, Author does not know! That's understandable, and part of the fun of writing is in the unexpected discoveries. Who'd begrudge someone that little treat? Author is self-deprecating, willing to confess to potential worries or inadequacies; Author is just like us ... except that Markson has interjected Author deliberately, for a little cameo that will grow into a larger role, later. We know that we are not supposed to be so unsophisticated as to believe that Philip Roth the character is Philip Roth the writer, or that the fictional Kathy Acker is Kathy Acker. Got it. Yet if some little part of our brain does conflate the two (privately, silently, as if with a flashlight beneath the sheets), the fictional character inevitably takes on more credibility and meaning because we see the superimposition: it's a funhouse mirror that distorts and also allows us to see right through it. Here, Author is released like a genie, and since what is supposedly "real" in fiction really makes us perk up, the writer can have it both ways. Author is David Markson, but Author is also just

some guy. Author brings us back to earth, in a departure that deliberately pricks the balloon that's been sent up to ask us to consider The Great Men. Yet when we return to basics, when we touch base with an individual who is, after all, something of a guide, even if not an authority figure, earth has become somewhat defamiliarized. It's slightly destabilized, a place not so much of sunrise and sunset, trees and bees, but a life of the mind, floated in white space for our perusal and contemplation, a concept accruing like a cloud. It's suspended above us whether we see it or not, though if that cloud is cumulus, it's rather reassuring that it was formed by one layer forming above another, all parts working together to give the impression of density, the flat surface from which it forms very much like the flatness of a book.

My Regards to Leo Lerman

Review of *The Grand Surprise*
Paris Review Daily, 2013

LIKE EVERY OTHER person in school, I hated footnotes. That was what you'd be quizzed on and lose out, having watched the soaring bird while forgetting the gnat. They were a trap. Boring. Even the texts were boring (I thought then, along with my teachers being bizarre). I'm not kidding about this: to avoid classroom giggling (or worse), my high school English teacher referred to Melville's novel as "Moby Richard."

Of course, now I'm a convert. Recently, there's been a trend for writers to footnote fiction (Nicholson Baker; Tim O'Brien)—it's the idea of footnotes as a continuation of the text or, sometimes, perhaps a preemptive strike, using the gnat-gems to discourage academic pedants.

I've just finished reading (belatedly—it was published in 2007) a book I love, *The Grand Surprise: The Journals of Leo Lerman*, that wouldn't be the same book without the footnotes, though they are not Lerman's, but made by his for-

mer assistant, Stephen Pascal (apparently with help from Lerman's nearest and dearest, Richard Hunter and Gray Foy), when Pascal put the book together posthumously. In a certain world (primarily New York), at a certain time (from the forties on through 1993), there was hardly anyone Leo didn't know, or know of, and that is in large part why he had the career he did, at *Vogue, Mademoiselle,* etc., which were not then the magazines they've become. Here, I must digress and say that along with a new enthusiasm for footnotes, I also love the use of brackets. Consider this, from Lerman's book (brackets added by Pascal), about a once much discussed writer whose reputation *always* existed in anecdote, so what the hell: "[Writer Harold] Brodkey came to Diana Trilling bringing [his] forty-page manuscript written in 'defense' of her, against critics of her *Mrs. Harris.* He insisted she read this; she retaliated with the first chapter of her memoir. Harold then told Diana that she had no taste, she lived with 'mail-order' furniture, and a collection of 'cheap' third-rate drawings and Japanese woodcuts typical of academe house furnishings. He ended, as he left, saying out of nowhere, 'Give my love to Leo Lerman!'" A footnote identifies Mrs Harris: "Diana Trilling's book *Mrs. Harris: The Death of the Scarsdale Diet Doctor* (1981) depicted the trial and conviction of headmistress Jean Harris for the murder of Dr. Herman Tarnover." (Alas, *sic:* Tarnower.) Since I remember this incident well, I doubted the footnote would contain anything essential to continuing my riveted reading of this excellent book, so I delayed receiving further information until I reached the end of the page, though I'd read the previous foot-

notes as I came to them. Somehow, as a group of four, the footnotes seemed to tell in microcosm little stories that echoed the expansive, main trajectory of the book: many people, almost all of a certain social class (or aspiring to it), quite mix-n-match, except that Lerman's consciousness united them. The first footnote: "Romance novelist Judith Krantz's 1978 book, *Scruples*, had been a huge seller." Next footnote, about Lerman's longtime companion: "Tiffany and Co. annually invited guests to style tabletops displaying its wares. Gray had done one that year." (From Leo, we know it was "A pre-Hibernation Tea for Bears—Grizzly Delights.") The mind boggles. Wouldn't you *love* to have wandered into Tiffany's and seen this? But the footnotes continue: "Sylvia Townsend Warner (1893–1978) was a British novelist, poet, and short-story writer." Well, she *was*, but here I had to pause and remember how very many stories she'd published in the *New Yorker*, and really, what a surprise that she'd been born in 1893, making her a literary contemporary of Mrs. Wharton, for heaven's sake (also: the brilliant *The Age of Innocence*, which won the Pulitzer in 1921, was published only five years before *Gatsby* and wow, are those depictions of life in New York and its environs worlds apart!). Then follows the footnote about Diana Trilling that, with its pitch-perfect use of the word *depicted* rather than the more usual "about" makes you *envision* whatever this trial was, while the omission of the name of the school where "headmistress" (what a concept!) Harris was employed shows you there's got to be some limit to the facts of these footnotes, though independently, as well as collectively, they create their own

momentarily cohesive, yet ironic world. (Digression: don't fail to look at the index of first lines of James Wright's *Collected Poems*. Successively, any half dozen or so make a poem of their own.)

Sure, some footnotes merely offer information, telling us that a town is in the northwest of Ireland (ho-hum; bring on the GPS). But others stun with information as sharp as a bee sting: you find out the people whose romantic wedding you've just read about *divorced*; that everything you just read was *denied by authorities*; that someone was one of *nine* children! In Richard Nixon's *Six Crises*, which is rarely footnoted because he thinks he's so thorough and so inevitably right, we read in the main text that after the riots that happened when Nixon went to Caracas, he and his wife were "applauded by spectators in hotel lobbies," though what really bothers him is that newspaper columnists "sitting at their desks in Washington, wrote their 'interpretations' of what the South American trip meant. One wrote that the riots were directed against me as an individual ... the attempts to stir up trouble against the United States could not be blamed on the Communists." Here we get one of the rare footnotes: "Not all the rioters, of course, were Communists. But this misses the major point: there can be no doubt that the riots were Communist-planned, Communist-led, and Communist-controlled. Fresh evidence of this fact keeps turning up. Just a few months ago ... two Peruvian students—self-confessed former Communists—told of Communist organizations of the San Marcos riots in Lima and also publicly apologized to me for their own part in these demonstra-

tions." So, *you see?* Nixon was and *is* correct. Do you believe it now, since it's even in the *footnotes?*

In so many cases mysteries prevail, even in footnotes, or the footnotes raise little mysteries. In his impressive biography *Koestler*, Michael Scammell offers this chapter two footnote (quoted in part): "Although Koestler doesn't say so, both he and Bihalji-Merin went to Switzerland for Maria's funeral. According to the Swiss writer Werner Mittenzwei, who was also there, Maria had divided her estate among the poor émigré writers who had been her guests. Németh was one of the beneficiaries, but Koestler apparently wasn't. See Tvertoda, 176–8, and Mittenzwei, 269." Here is an author who could add much to the text, if so inclined, and who wants you to take notice of the complexity of some matters.

Today I sent an account of last night's dinner with friends to another friend. I cooked; I got praised for it; I had a good time. I knew the friend receiving the note would understand the context about which I wrote, quickly get the tenor of the evening (there aren't *that* many tones at Camp Beattie-Perry), that I could communicate some funny things by shorthand. But having read with intense pleasure Leo Lerman's cogent assessments much of the day, I was mentally footnoting at the same time I was writing my email. To be honest, I'd started composing imaginary footnotes during dinner, thinking just how funny they might be, explaining my insecurity, my husband's withheld thoughts (he insists on putting a positive spin on three weeks of rain on our recent Italian vacation). But don't we all deal with what's said and what's unsaid? If I wrote au-

tobiographically, should I be the one to write the footnotes, or should they be left to someone else? Of our guests last night, someone might footnote "A well-known painter whose subject was often the marshes in Maine," though mine would read, "The painter's wife asked him to consider two things when getting a dog: not a large dog, not a white dog. Their dog is very large and white." Leo Lerman was himself so astonishingly astute (read him on Susan Sontag), but the footnote pas de deux with Stephen Pascal or others who contributed to this book is perfect: a mixture of information, implied amusement, judicious word choices that subtly convey commentary. It's the book I'll read aloud to houseguests, sparing them the audio of Mel Gibson's phone call to his ex-girlfriend Oksana that we taped from the internet before access to it quickly disappeared. (If you know what I'm talking about, imagine the footnote to the next generation for that one.)

P.S. "Acknowledgments" can be *most* informative, as in Levi Johnston's (no, I'm not going to footnote him) *Deer in the Headlights*. From Levi: "The Cowans had seen me out there on TV, read about me—and thought I was getting the shaft. I already knew I had to do something before I was suffocated by half-truths and outright lies." From the Cowans: "This book was researched, organized, and written on a tight schedule."

Oh, but that tragedy/comedy is all so . . . *last summer*. Move on immediately to *The Grand Surprise*, which was written over a lifetime by a keen observer and world-class self-doubter who took Proust as his model, a book beautifully edited, assembled, and produced.

Watching Screwball Comedies
with Harry Mathews

Paris Review Daily, 2018

HARRY MATHEWS, WHO died on January 25, 2017, was born on Valentine's Day. This is the first time his friends (including those in Key West, who, during the winter, often got to see Harry and his beloved wife, Marie) have had to be without him. About the time he turned eighty, maybe a bit earlier, he had to stop bicycling. He did this grudgingly, berating some of us for our concern (expressed as he was about to cycle off after certain ... let's just say *wine-centric* dinners). His good friend James Merrill was the person who'd urged the Mathewses to leave wintry New York and come enjoy the sun in Key West. (Merrill, on his own bicycle, was always a delightful sight as he sped toward you wearing his shirt, shorts, argyle socks, and sandals.) Not that Harry needed to imitate Merrill or his other close friend, John Ashbery, at all: his sense of style was singular, as was Harry. But how did I become

dear friends with a person who had specially sewn compartments in his shirt pockets for his cigars? How did my husband and I appear, year after year, on New Year's Eve to be poured as much champagne as we wished (forget that "wishing upon a star" nonsense; this was excellent champagne) and to watch a screwball comedy that would be midway through at midnight? He shushed us if we so much as whispered to the person sitting next to us. In the background, we'd hear fireworks, the screams, the ubiquitous unmuffled motorcycles, more piercing screams, and soon, very soon, the sirens, as the TV volume was adjusted upward to a near-deafening level. In Key West, certain individuals get the idea that they might, say, blow up a pier to celebrate the New Year. (Or, at the very least, set their neighbor's garbage can on fire.)

But I don't want to suggest that we were strangely dressed, hedonistic, alcohol-dowsing creatures with no more imagination than to mark the end of the old, in with the new by watching Rudy Vallee. Harry was all imagination. Imagination and detail. He swung between those personal polarities like a watch used to hypnotize, and in a way he did hypnotize you. Let me say right away that he knew a lot. Please just google *Oulipo* to get a general sense of the society he belonged to, in which, almost until his death, he remained the *only* American member. He knew about everything from poetic form to opera to Byzantine coins—though if you brought up those coins, he'd suspect you were about to turn ironic and would question you: When and how did you become interested in Byzantine coins? He knew the Latin name of the plant you liked

in his garden. He once stunned Rust Hills by instantly answering one of Rust's many questions. As the carful of people was returning from a lower key to Key West, a beautiful sunset spread across the sky. Harry exclaimed, "Oh, it's like coming into Venice!" And my husband said, "More like coming into Mestre." Somehow the word *propaganda* was used—you think I was keenly focusing on this?—and Rust, who loved information and specialized in mumbling questions to himself, asked, "Where does that word, *propaganda*, come from?" Harry said, "It originates with the Uffici per la Propagazione della Fede, which was set up by the Vatican under the Counter-Reformation to propagate the faith. It still occupies a building in Rome designed by Borromini." Harry might also have known how to change a tire—he loved process, and when he cooked certain things, he wore an enormous ticking timer on a string around his neck—but I don't know about that. Though, after his mother's death, he drove her truly enormous car through the narrow streets of Key West until the car itself died. There's one stretch of Simonton Street I never pass without thinking of the sight my husband and I saw one night, after we'd parted from Harry and his wife and friends: that enormous car, that cruise-ship-size car, coming down the opposite side of the street with the interior light on, the faces of Harry and John Ashbery, a second's bright hologram flash of merriment. And then they were gone.

At this point, Harry might wonder why I've been mentioning vehicles: cars, bicycles, motorcycles. Is this what someone would be thinking about when remembering

Harry Mathews? But I mention earth, the vehicles of earth, only as a point of departure to the air. What about all those planes—the big airlines, the private jets, the Navy test planes that fly over Key West with such bursts of sound that everyone knows to simply stop speaking until they pass (though sometimes the first words of the over-eager person who had the floor get garbled in the plane's fading roar)? Harry would simply raise a finger and every-one would stop speaking. (He studied music at Harvard, so it's probably fine to think of the obvious: Harry as a conductor.) I don't think he originated the raised finger, but he did it better than anyone. And his facial expression was so clear. It didn't involve the conventional eye roll; the obnoxious noise was too usual to surprise anyone. His expression never varied. It said, Wait, this will pass. It suggested that he was in control. The ever so slightly raised eyebrows let *you* know that *he* knew the conversation could pick up right where it left off. Being reasonable wasn't always optimal, but in some cases, well, what can you do? His expression sort of metaphorically replaced a period with an exclamation point. Whereas I think his amazing fiction often implied just the opposite.

Happy birthday, Harry, from those of us here on the ground, looking upward.

John Updike's
Sense of Wonder

The John Updike Review, 2011

THE WORD ELEGANT is often used to describe John Updike's
writing, which articulately, with often incandescent lan-
guage, presents an imperfect, messy world created not by
people's best—or even most ordinary—thoughts, but by
the urgency of their desires. His characters are smart—
thinking people—but they are nevertheless tortured by
the gap between words and what's really *wanted*; those
times they are silent, sadness oozes into what's unsaid.
His characters are mortal, created by a writer whose pa-
rameters stretch very high and very deep: Updike is as
familiar with religion and mythology as he is with psy-
chology. The characters may themselves be "elegant" at
times, with their talk of lobsters and champagne, but John

*These remarks were delivered as the keynote address at the First Biennial John
Updike Society Conference in Reading, Pennsylvania, on October 1, 2010.*

Updike has one eye on beauty, sensual pleasure, physical passion, and another eye on the predictable, the banal, the loftiest imaginings slamming into the highest brick wall. The natural world is always present: vivid, even radiant, though Updike's characters are set apart from it. It provides the backdrop for his characters' folly; it becomes the scene-stealer for a sentence or two, before we are denied any more views out the window or authorially manipulated transitions or time changes that pivot on an invocation of the world's inherent radiance. The world is just beautiful—yet this is the way we act.

It is well known that Updike began as a visual artist, though language became his medium. His work is highly visual—something that's usually implied, I think, by calling a thing elegant. Nature is the foreground, but he insists that we look at it instead of tracking words on a page, trying to understand the character and his or her story. We all know that the sight of an oak tree in autumn can make our little accomplishments pale in comparison, and of course Updike sometimes evokes such images to temper or to undercut his characters' getting and spending. Writing that is hermetically sealed runs the risk of seeming contrived: characters get to speak without the annoyance of the phone ringing, without a bird flying into a window; they get to speak—as we do not—to a conversational partner who is not distracted and who is allowed to give his or her undivided attention. That oak tree is a brass band, once you catch sight of it. Everything that happens, simultaneously or thereafter, is tinged by the context it provides: its otherness; its immediacy; its inevitability.

Another quality of elegance is judiciousness. Updike's eye doesn't race through the forest, but locates some detail or single entity to focus on in the natural world and, usually in a sentence or with a brief allusion, sweeps his writerly paintbrush to pair it with his character. An example of such an allusion is from the story "I Will Not Let Thee Go, Except Thou Bless Me," when a series of thoughts occurs to the main character, a man who has broken up with his lover and will soon be moving with his wife and children to Texas, though he does not want to go: the marriage is unraveling, and we know that his wife dreams that she and the children might go without him.

> And Tom, hurriedly tying up loose ends in the city, lunching one day with his old employers and the next day with representatives of his new, returning each evening to an emptier house and increasingly apprehensive children, slept badly also. The familiar lulling noises— car horn and dog bark, the late commuter train's slither and the main drag's murmur—had become irritants; the town had unravelled into tugging threads of love.

The noises are indeed familiar, but the suggestion that the train "slithers" makes the reader conjure up a snake, and the snake of course reminds us of trouble in the Garden of Eden; it is the prototype of what is happening here in microcosm. So work and love, domestic life, are being played for higher stakes—not unusual in the world of John Updike. He sees to it that they also become diminished in cosmic importance by their banality: the powerful, mythic

snake becomes a commuter train. Either reading, or both readings, add to the story: the writer is conscious of both implications. To reenact the Fall of Man in suburbia is slightly absurd. Also, the move to Texas—not Updike's usual territory—is envisioned as "a desert of strangers; barbecues on parched lawns." The narrator's physical passion has resulted in his sentence to a kind of hell, with everything that will be taken in as food, and also found externally in the surroundings, burned.

In fairness to the many allusive patterns Updike weaves in the story, there is the more obvious mention of threads, with the husband, Tom, "tying up loose ends in the city" and the town "unravelled into tugging threads of love." These bits, these threads, materialize in the clothes worn to the couple's farewell party, so expressive of the times ("Bugs Leonard had gone Mod—turquoise shirt, wide pink tie"), but especially in the dress worn by Tom's former mistress. She is simultaneously ascendant, as an angel, and absurd in her costume of a dress: "Maggie Aldridge . . . swung down the hall in a white dress with astonishingly wide sleeves." The dress is seen repeatedly as the story progresses: all white, it is of course a wedding dress for the marriage that will not take place, but it is also the way an apparition would be attired (will Tom be haunted by her?). She has come to the party although she has a cold and—literally and metaphorically—a fever. Could she be the phoenix rising from the ashes? "Softly fighting to be free, Maggie felt to him, with her great sleeves, like a sumptuous heavy bird that has evolved into innocence on an island, and can be seized by any passing sailor, and will shortly become

extinct." In this scenario, Tom takes his place as just one of many "sailors," though it is because of him, because of men, that she "will shortly become extinct."

Yet, in the moment, they dance. And while they do, they have a strange conversation in which she tells him, "five years ago you were my life and my death, and now ..." The ellipsis picks up several lines later, when she continues: "... you're just nothing." In the next sentence we are told that "the music flowed on, out of some infinitely remote USO where doomed sailors swayed with their clinging girls." As this author sees it, the sexes are often at war. Here, though, the men have been deflated: they are not sailors who can drive a woman into extinction, but lonely guys at a dance, no more powerful than men usually are in such a situation. Later, Tom observes that Bugs (hardly an impressive nickname) and Maggie "danced close, in wide confident circles that lifted her sleeves like true wings." "*True wings*": like them, but not the real thing. Again, the writer directs us to see it both ways, in terms of potential and in terms of potential unfulfilled. One of the truly interesting and puzzling moments of the story comes when Tom and his wife, Lou, are alone at party's end:

> Safely on the road, Lou asked, "Did Maggie kiss you goodbye?"
> "No. She was quite unfriendly."
> "Why shouldn't she be?"

His wife's question lets us know at almost the last minute that she is aware of the affair. Then, Lou—the nickname

is masculine; it was explained early on that it is short for Louise—reveals that for a moment, she became Maggie's pseudolover: the woman kissed her on the lips. Sexual, yes, but perhaps also a strange benediction, a serious kiss, rather than Lou and Tom's "peck" of a kiss bestowed on Maggie earlier, continuing the bird imagery and reminding us that birds are symbolic of the spirit. Again, possibility is conjured up in order for it not to happen. Everyone is "very tired." Texas awaits.

In this story, Updike giveth and Updike taketh away; he inflates and deflates, yet the unease lingers in a series of visual images, small moments, and an inability to easily paraphrase what the emotional experience of the story has been. Though the "threads" that underlie the story transform the characters and also have their own interior logic as the story's scaffolding, the end of the story is wrapped up more in language and in interwoven visual patterns than in point of fact. It is as if the surface of a lake has suddenly stopped shimmering, and the mysterious shadows and unrecognizable bits of bark or stone or even sunken tennis shoes are revealed to be only what they are. What we have at story's end may be both the mystery retained, because of Updike's imagistic patterns based on visual images that carry recognizable connotations, and a literal ending that suggests that even the characters are tired of the expenditure of energy inherent in their folly.

In "Separating," Updike's insistence on the quality of the moment, instantly recognizable to readers of contemporary fiction, appears as past-tense, cryptic stage directions: "The day was fair. Brilliant." The scene is set,

sketched in indelible Updike shorthand that requires certainty on the part of the narrator, and an open-endedness that asks for a subjective response from the reader. The word *fair*, understood in this context as indicating beauty, also carries ethical connotations; the word *brilliant*, too, has many associative meanings and is rather anachronistic (except in England)—it can be used to describe someone's mental abilities as well as the light that comes off an object.

This is a story, not unusual in America and not unusual in the author's work, about divorce. The separating couple has decided to tell their children, each separately—though the husband can't keep to the script. Early in the story we are given the thoughts of Richard Maple (his last name connects him inextricably to the natural world) as he considers the tennis court on their property, remembering when "canary-yellow bulldozers churned a grassy, daisy-dotted knoll into a muddy plateau." Two things that might have been: nature, undisturbed; his dream of a tennis court that has now more or less gone to ruin. Again, an idea—a lovely idea—almost materialized, but is quickly demystified and made ugly, somewhat analogous to a bandage: "the barren tennis court—its net and tapes still rolled in the barn—an environment congruous with his mood of purposeful desolation." As happens so often in Updike, the best laid plans go astray, though we have no doubt about what they are, and we see them intensely, as the characters do. For the length of a sentence, or illuminated by the descriptive quality of a perfect adjective, they are indelible; we do not need Thomas Kinkade, "Painter

of Light," to understand that those very common daisies (think also: Fitzgerald) are vivid and could not be more clearly seen if we had a painting in front of us. And yet. The specific, even gilded prose seems to make the sentences lift off the page, while the reality—what happens on the nonverbal level—deflates the ideal. Updike's images have puncture wounds. I don't see it merely as a matter of sending something up in order to shoot it down. The interplay between the external world and a character's internal state is a convention of writing. We are familiar with the pathetic fallacy; the mimetic echo of a character's psychological state explained by projection onto nature; the clarifying, expansive analogy that devolves, finally, when we break it down into its components, into suddenly suspicious words.

Writers distrust words, and no doubt some distrust them in proportion to how great their talent is for manipulating them. Some writers, such as William Gaddis, visually link their text into one snug woven entity, the longest kite cord ever made, then let us watch it unfurl until the body of the kite is out of view—after which the cord continues to unravel and we have only that to look at, the head having disappeared. Gaddis, though, unlike Updike, depends heavily on dialogue, which he runs together by omitting quotation marks. We must do the work of hearing differently, learning slowly, in Gaddis. With Updike, his amazing gift for using language to make a thing stand apart and shine is also just the talent he, personally, won't settle for. He does not aspire to be a Romantic poet; he attempts to do two things almost simultaneously—to give

and to take away, to mystify and to demystify—and, as background intermingles with plot, or foreground, our seeming advantage of having been presented with the transcendent ideal haunts us with possibility gone awry.

Dialogue in Updike, while often clever, is only so many words. What happens happens beneath the surface, which may be why he wants us to see the surface as being so dazzling: it is the entryway, the beginning of the process required of the reader to delve beneath it. The very affecting ending of "Separating" gives us only one word, but a word we had no reason to suspect would be uttered, as the character does not. Midway through the story, Richard leads his younger son "to the spot in the field where the view was best, of the metallic blue river, the emerald marsh, the scattered islands velvety with shadow in the low light, the white bits of beach far away. 'See,' he said. 'It goes on being beautiful. It'll be here tomorrow'." The appreciated landscape, the usual but nevertheless vivid adjectives, the whole idea provides some sort of reassurance—of course it does—but this is not the end of the story. That comes when his elder son suddenly blurts out the subtext, verbalizes what Richard has asked himself, and tried not to ask himself: The Question. "*Why?*" is the one word his son utters, and with it the boy punctures the balloon. Or, to use another analogy, he metaphorically opens the lock that his father has literally been trying to repair since the story began. It is written this way, as Richard echoes that stop-time word: "*Why*. It was a whistle of wind in a crack, a knife thrust, a window thrown open on emptiness." So his son has the key, and he does not. Both

expanding upon his feelings and, by using any analogies at all, trying to distance himself from them, we have the metaphoric "whistle of wind," extra nice because it alliterates—it has a pattern, a sound that forms its own little logic. More violently, it is the knife that Richard has already turned inward on himself, now only "a knife thrust," not even connecting with its target, but still "a knife," as if it can be objectified. And finally, "a window thrown open on emptiness."

It would be the rare author who could give a character this line of dialogue without irony, or ominousness: "It'll be here tomorrow." If writers believed that, they would also write the story "tomorrow," but as we know, writers' delaying tactics and their ability to take avoidance to a high art are fanatically cultivated. My husband, a painter, says that he "likes to paint." He has observed, and I agree, that writers "like to have written." I can't speak for John Updike, but I wonder at his sense of wonder. It seems so integral, yet, in rereading his stories, I am struck by how often—true from the beginning of his writing career—he undercuts his own facility. How often he seems to wish that what we see is the story, not its figures of speech, not its clever and astute literary contrivances. I am in awe of what he can conjure up with a sentence or, at other times, with a word—often, a word repeated so that it takes on more weight, vibrates, registering subtly or subconsciously, alerting the reader, who will rarely stop reading to figure out what's going on at so microscopic a level, to an imagistic pattern meant to express a level of the story that can be pointed to, but the meaning of which always exceeds

its boundaries and therefore cannot be caught, or more clearly expressed.

"A window thrown open on emptiness." It would be odd to think of the world as empty except that this is Updike, and one's inner state is being projected. (It is a nice touch that the couple plan to tell their eldest daughter about the separation on "the bridge across the salt creek"; at the end of the story, when their oldest son cries while asking "*Why?*" the literal creek becomes a metaphor internalized, a huge thing absorbed, constricting to the small, quite ordinary child's tears.) The italicized word *Why*, first asked as a question, is repeated by the father without a question mark. And the answer? The text rushes in like the tide and gives us instant metaphors ("It was a whistle of wind in a crack," etc.) that, while clever, are also transparently an avoidance. What a thing is like, when the thing speaks for itself, is unimportant. Which Updike knows, but he is showing us the fatal tendency of being half in love with easeful words. Does their descriptive quality really make you look more closely at the moment, or look away from it? I think the reaction elicited is the latter. You might be seduced; you might not forget what the words point toward, but in certain contexts—this being one of them—they can bedazzle while being powerless. Writers don't trust words. There are many possible readings of this story, but one would have to do with the fact that however beautifully descriptive it is, language also is a habit, a thing that can protect us, or allow us, if nothing else, whether we are speaking or listening, to bide time. Writers come up with some of their best sentences because there is always

the story they are writing, as well as the buried story—the story they do not want to tell. This is why, when questioned, writers often seem so ignorant about their own material, even after originating and carefully editing it. You know, but you don't know; the same words that dazzle the reader may, for the writer, be a form of desperation: a distracting tactic; a beautiful smoke screen; a way to say something at one remove from the stunning truth the writer flirts with but does not want to acknowledge. Words are also a way to bide time; the writer risks writing a painful sentence because, when cornered, at least it is not the *most* painful sentence. Yet the freeze-frame of this story, as it concludes, gives us a tableau—really, resides in a visual image that is not directly expressed through analogies—that aims for nothing beyond its simple, almost unbearable, existence. It stands alone, to be highlighted by human pain: "*Why.* It was a whistle of wind in a crack; a knife thrust; a window thrown open on emptiness. The white face was gone, the darkness was featureless. Richard had forgotten why."

Updike trusts visual moments: the bodies pressed together dancing; the moon shining on the field; a father sitting on his son's bed—all nonverbal forms of communication. In his essay "Why Write?" he mentions receiving a letter asking him to explain one of his stories and uses this as a point of departure to ask himself, in the same exasperated way he has addressed the person making the request:

[H]ow dare one confess that the absence of a swiftly expressible message is, often, *the* message; that reticence is

as important a tool to the writer as expression; that the hasty filling out of a questionnaire is not merely irrelevant but *inimical* to the writer's proper activity; that this activity is rather curiously private and finicking, a matter of exorcism and manufacture rather than of toplofty proclamation; that what he makes is ideally as ambiguous and opaque as life itself; that, to be blunt, the social usefulness of writing matters to him primarily in that it somehow creates a few job opportunities . . .

At the end of Joyce's "The Dead," what exactly—since he is an articulate man who now has much clearer insight about himself and his situation—might Gabriel Conroy *say*, as opposed to going into a sort of fugue state in which his thoughts silently intermingle with the world outside his hotel? His epiphany is beautifully expressed, but when all the thinking is done, his wife, Gretta, sleeps on the bed and Gabriel stands alone at the window. At the end of Richard Ford's story "Rock Springs," the narrator, Earl, about to be left by his girlfriend, his daughter again solely in his care, out of money and out of luck, wanders—not in his mind, but in point of fact—into a motel parking lot, where he seems to bifurcate, taking an aerial view of himself. Cleverly—Earl is a con man, after all—Ford implicates the reader:

And I wondered, because it seemed funny, what would you think a man was doing if you saw him in the middle of the night looking in the windows of cars in the parking lot of the Ramada Inn? Would you think he was

trying to get his head cleared? Would you think he was trying to get ready for a day when trouble would come down on him? Would you think his girlfriend was leaving him? Would you think he had a daughter? Would you think he was anybody like you?

Ford drops the lure and reels us in, until we are caught too firmly to escape. The question answers itself. The writer implicitly asks, Who could feel otherwise? But in this story, the writer performs a sort of visible/invisible magic act: a clever act of conflation, suggesting that the reader stand first here, then a bit more behind the main character—oh, we're spying, of course, but it's just our little game—and then suddenly the torch is lit and we are welded to a character who takes on more dimension, as do we, because, unlikely as it might seem, we have become a new entity, seared into Earl. Gabriel Conroy wanders in his mind, sensing stepping-stones—the snowflakes outside his window—as guides toward perceiving unity; Earl distances himself from himself and asks an unexpected final question that contains its answer but also requires the reader's mind to wander. While I don't think Updike was inordinately under the spell of Joyce, and while I do not see Richard Ford as rooted in Updike, I do notice— among these defining, now famous moments of fiction— that instead of physical action, there is internal action. In Joyce and Ford, to look outward is to see inward. The way Updike writes, the sensibility presiding over the piece— let's be honest: that is *the writer*—colors the material from the first, much the way a landscape painter looks at life,

then builds layers of paint on a canvas. But, interestingly, with Updike it is as if the highlights were put in first, over forms that have not yet emerged; the piece begins with something small and inherently eye-catching illuminated, in a few seconds' time made particular and distinct. It is as if the composition were detailed from its inception, as if the quality of light and the textures and color, alone, inspired—and even constituted—the story.

Ah, but think of Updike's respect for opacity. The bright sentences seem to determine things, but ultimately do not—the emotional weight they carry and the characters' precarious movement toward something unknown is not always in sync, and is often at odds. Think of Rabbit's run toward the end of *Rabbit, Run*. We sense the loneliness in the gap between the character and the external world—a negative space, a place of estrangement, for which there are vivid examples, yet no words. I mentioned Joyce and Ford because the gracefulness of their sentences, the way the sentences build to suggest a depth that is ultimately psychological, seems rooted in their strong visual acuity. Flannery O'Connor, in one of her essays, says that literature has to come at us through our senses, and in these writers it certainly does. Perhaps Updike was the shy boy, the class poet, the writer with so much power to wow that he became (his word) finicking in his restraint: sketch; highlight; make it indelible; wow 'em with your power of language, then show that that—or any power—contains its opposite, powerlessness. To continue my painting metaphor, the frame in Updike should not go unremarked upon. It is mortality. Each image he dazzles us with daz-

zles in its own space, for its own moment or moments, but the constant awareness, the borders on the expansive language, are what contains us for that moment—meaning, the moment of the story—but which are not there just for our edification and admiration. They are inventive, beautifully expressed, the world as we rarely see it, but as we recognize it immediately, yet they fail to sustain us—our efforts in the world build no better world. These intense visual realities desert us—and properly so, as I think Updike would feel—by moving on, by running as Rabbit does from what he thinks of as impossible complacency with the real, until we, too, eventually—in the restricted and in the ultimate sense—move on.

These are the two concluding paragraphs from John Updike's very short story "Archangel," which I had never read until recently, and which comes as close as a story can to becoming a beam of light. I won't emphasize my own points and interests about what the writer observes, and why. What we hear, reading this story, are words directed to oneself, in a private moment overheard: more shorthand, words that point to visual images that cannot themselves be decoded by finding the exact words to describe them. Updike's interest is in what underlies the fabric and texture of daily life, and the ebb tide that is the inevitability of death. Along the way, he makes a little joke by alluding to the title of his first novel, then reverts to his customary humility when writing about the "microscopic glitter in the ink of the letters of words that are your own." He loves his words; he loves their appearance as well as what they denote or connote; he loves the process, as does

any happy fanatic. There is also the ability of his eye—a cold eye, sometimes; other times, a poet's evaluative eye, directed toward minutiae that need not be stretched very far to embody the power of metaphor. He is a sensualist who attempts to compare what he sees with what he intuits—pretty grimly—about the largest, least understood, cosmic questions. He isolates narcissism, yet sees its potential not only for self-deception but as a rallying call for transcendence. This makes him a writer who, at his quite often best, is impossible to paraphrase, one who escapes us on the currents of his words as they lift lightly off the page and become airborne. It's a great disappearing act, because when something is powerfully articulated, you experience the presence of the person speaking so strongly, he remains present: we're all in this together.

Where, then, has your life been touched? My pleasures are as specific as they are everlasting. The sliced edges of a fresh ream of laid paper, cream, stiff, rag-rich. The freckles on the closed eyelids of a woman attentive in the first white blush of morning. The ball diminishing well down the broad green throat of the first at Cape Ann. The good catch, a candy sun slatting the bleachers. The fair at the vanished poorhouse. The white arms of girls dancing, taffeta, white arms violet in the hollows music its contours praise the white wrists of praise the white arms and the white paper trimmed the Euclidean proof of Pythagoras' theorem its tightening beauty the iridescence of an old copper found in the salt sand. The microscopic glitter in the ink of the letters of words that

are your own. Certain moments, remembered or imagined, of childhood. The cave in the box hedge. The Hershey bar chilled to brittleness. Three-handed pinochle by the brown glow of the stained-glass lampshade, your parents out of their godliness silently wishing you to win. The Brancusi room, silent. *Pines and Rocks*, by Cézanne; and *The Lace-Maker* in the Louvre, hardly bigger than your spread hand.

Such glimmers I shall widen to rivers; nothing will be lost, not the least grain of remembered dust, and the multiplication shall be a thousand thousand fold; love me. Embrace me; come, touch my side, where honey flows. Do not be afraid. Why should my promises be vain? Jade and cinnamon: do you deny that such things exist? Why do you turn away? Is not my song a stream of balm? My arms are heaped with apples and ancient books; there is no harm in me; no. Stay. Praise me. Your praise of me is praise of yourself; wait. Listen. I will begin again.

My Life in Bingo

Kapnick Lecture, University of Virginia, 2019

WHEN I WAS a child—though not so young that I might scream—my parents insisted I go with them when they played bingo. This took place on Sunday nights—then and now, my least favorite time of the week—in some town in Maryland.

My father drove my mother, my uncle, and me to an ugly building that sat on acres of farmland that wasn't used for agriculture. Rockville? In any case, now it must be accessible by metro and filled with high-rises. I exited our car into a world much more boring than the one I already inhabited (suburbia), that radiated emptiness except for the long, low building that stretched between nothing and nothing. I knew what awaited me inside: cigarette smoke, boredom, and bingo.

In the middle of the enormous space, a man sat at a long table behind a big, transparent cube with air jets

blowing inside, sending white Ping-Pong balls bonking around. A microphone sat beside the machine. The man moved slowly and always allowed lots of time to create suspense. He stuck his hand through a closed flap—like a nurse reaching toward a baby in an incubator, I did not think at the time—to solemnly extract one ball, which he would scrutinize with a slight, skeptical squint, then sonorously pronounce, "G-3."

Now, I think differently about that ceremony held amid clouds of smoke. It was a game; there must have been a prize, though I don't remember what (maybe a carton of cigarettes?). The evening must have concluded somehow, with smoke drifting out through the opened doors to mingle with the clouds, hanging low above the fallow land . . . but that would be writing fiction. I coughed my way to the car, I hope planning my future, and fell asleep on the way home, for all good reason. But that transparent cube—we could see the excitement inside! And that hand, always the same hand, reaching in, a bit distorted by the overhead lights shining on the box. The hand caught something in the air and drew it out.

This is more or less what it's like to write fiction: you reach for the word and often—as many writers acknowledge—see that you've placed that word in a sentence that bears little or no resemblance to the ideal sentence inside your head—the one you intended to write, and that with dedicated effort surely you can write on the second attempt. Nevertheless, there the intruder remains, still legible under your cross-out, trying to trick you into reinstating it. Can't you come up with a word substitution?

A different adjective? That sentence might well remain in military formation even after the cadets around it have fainted in the strong sunlight. To be honest, it's often better to see where your initial sentence might take you, unless you find following intolerable.

Such is the writer's lot: you carefully construct your sentence, yet it emerges as if it's been hijacked by an impostor, a pretender to the throne that's aggressively inserted itself. It refuses to budge. It has plunked down, so that's that. You become confused: *You're the writer, right?* Just reach back—farther back than you thought, with every second that passes—and retrieve that ideal thought and put it back. Except that even if you do, it's predictable that it won't sound quite as inevitable, perfect, and useful. Too much time will have passed. You'll come to doubt the sentence's initial perfection. How ridiculous that you thought you'd composed the perfect sentence! How could you have been deluded, as it now appears that there are infinite possibilities, and every now and then a new one swaggers out to assert itself, seeming mercifully *right*, worth waiting for—though in writing, that, too, disappoints you.

Try to explain this to someone who isn't a writer. Try to explain not just your inability to get it right, but also your lack of confidence, your frustration as you record the shape-changers, one after another. Your carpenter will tell you that "well, no, two-by-fours don't really behave that way, and really, they're not even two-by-fours."

But to cheer myself up, let me say that sometimes, not often, almost never, I really have been saved by the perfect

word when I haven't had to struggle to find it. I'm sure this is because stories are composed in our subconscious as well as conscious mind. One little word can just suddenly jump, like a flea. (Or—I can't resist—a Ping-Pong ball.) Here is my flea, from "Missed Calls," a story about things unsaid. In a way, my story is flirtatious, which seemed appropriate to the theme of flirtation. In it, a young girl, the goddaughter of one of the characters, acts oddly, though since young people are no different from anyone else, they do act oddly. The revelation about what's been going on appears covertly, near the end, where I give my secret wink to the reader, who has either already come to understand what hasn't been articulated, not understood at all, or—more likely—who might feel discomfited, suspecting, though they can't be sure. In the story, a man has come to visit an elderly lady to interview her about her late husband, a painter. His troubled goddaughter is on the trip with him, and, of course, causes trouble. At one point, the interviewer calls her, in the presence of the interviewee:

> The expression on his face as the phone rang and rang—turned off? Or was she willfully not answering?—was dolorous, filled with intense sorrow in the second before he remembered where he was and raised his eyes and shrugged his feigned dismissal.

"Feigned dismissal" tells the reader that he's insincere. But it was a single word that made the story come into focus—at least, in terms of having its meaning emerge in the reader's subconscious: *Dolorous* sounds like Dolores

Haze, from Nabokov's *Lolita*. It's not a word in my writerly vocabulary. Selecting it was an homage, and also acknowledged the story's blueprint.

A story's smudges and stains, its subtext hinted at with words that float like drifting perfume, are meant to escape readers, at the same time they suspect they're catching a whiff of something. Think of the Shroud of Turin (now discredited, though you really can't discredit a metaphor). Or the faint scribbles rising underneath the page of an Emily Dickinson poem to hazily (I guess I'm still thinking of *Lolita*) become part of it. If you remember the old days of blackboards, think how intriguing it was to try to guess what, among the partial erasures or sentence fragments that remained before class began, gave you some knowledge of what the previous lesson might have been. Robert Rauschenberg once made his own artwork by asking his friend Willem de Kooning for one of his drawings, then erasing it.

If all this sounds like game-playing, that's exactly right. Artists like games. And of course games can be played for high stakes. They can be informative about matters that extend beyond, say, the Monopoly board: *What was your opponent's body language? Should you be worried about how much they wanted Park Place? Have other people played this game before (sure), and if so, should you allude to them?*

WHEN POLAROID CAMERAS were newly manufactured—the vertical, boxy ones, not those cool, shoot-'em-out SX70s—there were adjustment buttons you slid before

you took the photograph. You had to justify the image, which meant merging and precisely overlaying one adjacent double image atop the other, so that, for example, the figure of your mother existed singly.

I liked doing that because it was a mechanical skill I could master, and also because it was a variation on something I believe as a writer, which is that underlying whatever we see lies something related, that forces us to squint, even if we have excellent vision, to really hone in on the surface. The way text and subtext play out can be complicated because what underlies a character's psychology and actions will rarely, if ever, duplicate what has been apparent on the surface. If it does, you probably have no subject matter—though, as a writer, you have to find a way to address one thing and let the other, often more important thing infuse it.

How many times have you heard writers say they don't know what they think until they write it? That they discover what they think in the act of writing? In her essay "Why I Write," Joan Didion lets the reader know she's acquainted with uncertainty and open-endedness. She mentions textbooks that show pictures of cats, drawn by patients in various states of schizophrenia. Here's a long quote from the essay:

> Look hard enough, and you can't miss the shimmer . . . You just lie low and let them develop. You stay quiet. You don't talk to many people and you keep your nervous system from shorting out and you try to locate the cat in the shimmer, the grammar in the picture.

Just as I meant "shimmer" literally I mean "grammar" literally. Grammar is a piano I play by ear . . . All I know about grammar is its infinite power. To shift the structure of a sentence alters the meaning of that sentence, as definitely and inflexibly as the position of a camera alters the meaning of the object photographed. Many people know about camera angles now, but not so many know about sentences. The arrangement of the words matters, and the arrangement you want can be found in the picture in your mind. The picture dictates the arrangement. The picture dictates whether this will be a sentence with or without clauses, a sentence that ends hard or a dying-fall sentence, long or short, active or passive. The picture tells you how to arrange the words and the arrangement of the words tells you, or tells me, what's going on in the picture. *Nota bene*:

It tells you.

You don't tell it.

Didion's last two sentences are placed individually, which draws our attention to the page. She does this for emphasis. The content is unambiguous; both sentences are (to her) statements of fact. The power resides in the first assertion ("It tells you"), in which she conveys the writer's *lack of power*. Both are declarative sentences, but the first is a "yes" sentence, the second a "no" sentence. In keeping with her thought process, what would be different if she reversed the order?

I'll try to answer. "It tells you" acknowledges an un-named yet knowable force that contains inherent author-

ity. "You don't tell it" sounds like the hectoring voice of an authority figure, or maybe your alter ago, who wants to get the last word. To my ear, it's accusatory, positing a "you" that's inevitably tempted to do the wrong thing. But she's talking only about writers, and by positioning her sentence as she does—dangling there in white space, I should also mention, because elsewhere she's written about the importance of white space—she's speaking to herself here, when she writes, "You don't tell it," and by extension cautioning other writers to do away with preconceived notions and not overwhelm or over-determine the material. Reasonably, she comes out in favor of serving the greater good by admitting humility rather than unassailability—though she implies that skill and/or experience is necessary to remain receptive.

To play devil's advocate: What if the writer looks at the shimmer, waits, and no cat appears, nothing is revealed? What if the picture not only fails to tell you anything, but is also replaced by items you need to add to your grocery list? Surely a writer's openness and alert receptivity could prompt a very funny Roz Chast cartoon. Actually, the unworkability of this hoped-for symbiotic relationship is so routine—the failure to have a revelation arise organically, clearly, from within the work—that writers rarely mention it, any more than they wear a KICK ME T-shirt. Nevertheless, it probably explains why so much of what we read seems predictable. What the writer writes isn't *wrong*, it's just *not right enough*—it hasn't been perfectly envisioned and executed. With novels, in particular, it's understandable. What writer wants to abandon hundreds

of pages? So writers often simply continue, sometimes trying to fool themselves by adopting the late painter Thomas Kinkade's technique of trying to both attract and distract the viewer with obvious highlighting (alas, the painting ultimately remains only what it is). What can feel like the painter's or the writer's forced march has too often begun as the writer's.

It's a dilemma, though. Why limit yourself when you're writing a rough draft, if you can later discard what's not useful? Some recycle their writing. If the writer plods through the material and comes to things late, the story's revelations, its specifics, can feel artificial—*trompe l'oeil*, rather than a genuine outgrowth of the material. My local fishmonger is getting rich, I'm convinced, because he came up with a process for pressing fish skin he'd otherwise discard into bits as thin as communion wafers. He realized that dogs respond to them as if they're crack.

There's no saying how long the writer is expected to tolerate being lost in a thicket. Who's to say how long is long enough to wait? (This really wouldn't be a good question for Miss Manners.) How many not-wonderful sentences will the writer have the patience to elucidate or revise? Was there ever a moment when, for someone else, some other writer, the sentence "See Spot run" emerged effortlessly?

As I write this, I think of Flannery O'Connor's of ten quoted statement about things that surprise the reader also having surprised the writer. Like Joan Didion, O'Connor believed that a certain amount of waiting

is necessary for the writer to be educated and informed by the material, though with Didion, I think, this waiting game verges on sensuality. I doubt anyone would think of O'Connor as sensual. Didion is, though: in her self-exposure, in her articulation of bodily and spiritual aches, she sometimes writes as if she's the projection of her actual body, not merely her brain. In so many ways, her early writing was startling because while she was insisting that she wasn't resilient, she *did* have stamina, as well as good instincts; she still stayed to observe, and in those things she saw through migraines and dust storms and exhaustion—and made us see—she certainly turned out to be prescient. In locating and naming the previously unnamed—because it was invisible, or assumed to be inconsequential before she took it in—she colored it so that it became identifiable.

In Flannery O'Connor's essay "Writing Short Stories," she says: "If you start with a real personality, a real character, then something is bound to happen, and you don't have to know what before you begin. In fact it may be better if you don't know what before you begin. You ought to be able to discover something from your stories. If you don't, probably no one else will." She is a writer for whom character precedes plot; the events of the story are very much an outgrowth of character. It's wonderful, those times when you've picked well as a writer, either while imagining a fictional character or with a person you've cherry-picked from life to interject into fiction, to set them waltzing and whooping through your story. But as writers will also tell you, the most magical-seeming in-

dividuals often, in spite of Henderson the Rain King and Zorba the Greek, collapse into flatness in a story as soon as words are applied to them. It's similar to one's knowing someone whose face is always animated, though their features appear oddly flat in every picture taken of them. This is often explained in terms that make my eyes glaze over—the requisite talk about the way light falls, and mention of "good bone structure." I've known compelling, dynamic people with memorable expressions whose prominent cheekbones habitually disappear when they're photographed, just as their springy ringlets meld together until they become indistinguishable. Certain cultures fear photography because of the belief that the image steals the soul. This same vanishing act can happen to a writer who has a character in mid-creation. Sometimes this works in inverse proportion to how conspicuously easy that person seemed as a subject. Characters will outthink you, though. They'll give you the slip while a minor character strides forward and, if you're lucky, reveals themself to have hidden depths.

Is this unpredictability some cosmic lesson in humility? Or do the eye and the imagination sometimes more successfully fill in information, skipping over contradictions and flaws so that a fictional creation has a coherence absent in a real person? Or another factor might be that such people transformed into characters have a way, in life and on the page, of determining how things will go—no different from the way extroverts overwhelm introverts. The only problem is that, ultimately, their ideas might not be as good at the ones fabricated by the writer. Beattie's

maxim: *Writers have to take care not to be overly influenced by or indebted to their characters.*

I LOVE TO read the concise, often amusing notes the photographer John Loengard, who was picture editor of *Life* from 1978 to 1987, made about his photographs. It's interesting how much he accepts (and isn't really at odds with) the limitations of photographers and the situations in which they work, including the room in which a photograph will be taken. I knew him, and I wouldn't say John Loengard was a casual sort of guy, but he really trusted his hunches and his reflexes and—like Joan Didion—was indefatigable. He had his own inherent powerfulness, however polite he remained. His 1991 photograph of Philip Roth is a revelation. Loengard writes:

> He had been photographed so often that the chance one picture would describe him to posterity seemed slim. I asked him to sit at his desk and write. He did, facing the window and looking self-conscious, as one might expect. I started to take pictures and told him he looked splendid. I hoped something might happen. A writer with me asked a question. Roth snapped about, instantly oblivious to the camera. He had the look of a querulous pheasant, just flushed and ready for flight.

Thank you, writer, for asking that question. It enabled Loengard to take the "shot" of the "pheasant." The analogy to writing is that those times a voice from elsewhere

interrupts are most often very helpful. (Music playing in another room can influence, or also get included in, what a writer is working on. So can trash trucks, of course.) Obviously, the photographer has to have super-sharp reflexes to record the moment, and it's the same way in writing, though you are the only animating force there; you're the one obliged to keep things in motion. It's a problem if you're too persuasive because the lazy reader, once habituated to your character, might not remain alert and stay with the text. Any time you raise the ante, it simply becomes, for the reader, the new status quo. Of course, writers don't have to raise the stakes to ludicrous heights, but as writers face forward, staring at the computer screen (or possibly the writing pad), they have to be attentive to things in their peripheral vision. That, or they can be holding the exact right card—I don't want to give the impression that all we need look for or receive is *Surprise!*— though because writers have time to revise, they have the advantage of being able to think longer before they react than John Loengard did. Or to revise.

AN EXAMPLE OF rather brilliantly informing the reader by intruding oneself into the material, either by name or, more often, by the writer's timing (the technique is used often; writers are pleased to have the reader go over a cliff), is Mary Robison's very short story "Yours," which initially appeared in its entirety on one page of *The New Yorker*. What power, as Robison knows, to simply insert a break in the text, and move the story

elsewhere. Joan Didion would heartily approve. Reading, we're suddenly told by one simple, blunt statement that the wife in the story, who has been carving pumpkins, is going to die. In my mind, this rivals the news of Mrs. Ramsay's death in Virginia Woolf's *To the Lighthouse*, presented to the reader in brackets. In both cases, the factual statement is shocking, overpowering, and the writer knows it is. Similarly, Alice Munro sometimes reads her character's mind so credibly that the reader believes that he or she knows everything, every true, intimate thought the character has, at which point Munro changes course and de-emphasizes the character's inner monologue to let us know, instead, how things feel, experientially.

Here's a passage from Munro's "Nettles," in which a woman who has never forgotten the boy she loved in childhood is unexpectedly reunited with the man much later in life. He fills her in about his life, letting the reader and the woman know, simultaneously, that even now, belatedly, they will never have a life together:

> I knew now that he was a person who had hit rock bottom. A person who knew—as I did not know, did not even come near knowing—exactly what rock bottom was like. He and his wife knew that together and it bound them, as something like that would either break you apart or bind you, for life. Not that they would live at rock bottom. But they would share a knowledge of it— that cool, empty, locked, and central space.
>
> It could happen to anybody.

Yes. But it doesn't seem that way. It seems as if it happens to this one, that one, picked out specially here and there, one at a time.

This is so obviously good writing—moving, on so many levels. First we're swept into believing information presented with restrained elegance (I can't help but think of Marvell's poem "To His Coy Mistress"—"The grave's a fine and private place / But none, I think, do there embrace"—when I read about the "cool, empty, locked, and central space"). Another writer might have left off with "It could happen to anybody" and let that knowledge haunt us *at the same time that it's a cliché.* What I most like, though, among the repeated words that (like a mantra) lull us into believing that what's being narrated is "logical," is Munro's reminding us that just because there's a capable narrator in a story, we can't be lulled into complacency. We have to hear "bound them," "bind them," and the word *locked.* This is what the story won't—can't—refute. It's as though the words themselves stand as the ultimate barrier to the couple's free will. Even if writers are magicians, as Munro clearly is, we can't be *too* receptive; we have to resist passively nodding our heads while the writer, like a skipping stone thrown across water, eloquently does all the work, on the surface, attempting to be persuasive through repetition and the judicious selection of strong words. The first time we hear about "rock bottom" (Munro knows it's a cliché; she invokes it to play with it, like a cat with a ball of twine) is much different from the final time those rocks are invoked. It's amazing, Munro's ability to have us move into a trap—a

trap that is other people's lives—and not to realize where we are until it's too late: this isn't the writer's eloquence; this is the clash between reality (rock) and language (Munro *knows* she can write beautifully, and here both does that and discredits it) that's so powerful, it's disorienting. Again I'm reminded of Didion's interest in the not clearly seen cat somewhere within the "shimmer" (life). As I read it, the last voice we hear in "Nettles" is also a cry of alarm, a caution that the writer, too, must be on guard against being seduced by rationality: Munro had two voices in her head—one that could state something rationally and eloquently, another that was entirely opposed ("Yes. But it doesn't seem that way"). How it seems matters. No one, including the writer, should be seduced by mere eloquence.

As a writer, however powerful you are or aspire to be, it's difficult—and probably not something most writers even want—to be so sure, so sealed off by what you intend to write that your manuscript becomes exactly what you'd imagined. I've read a lot of *Paris Review* interviews, and I don't remember any fiction writer saying such a thing.

Consider another form of seduction, which is what I see as the theme, as well as the method, of Raymond Carver's astonishing story "Neighbors," in which a husband and wife look after their friend's apartment across the hall, in their absence, and become fascinated by what it contains ("Kitty" gets marginalized). It's a creepy story, as Carver intended. It also engages our daydreams, or our envy, or whatever might be operative in our notion of the life not lived. The characters' going into the other apartment—the parallel reality to their own—excites them

sexually. The wife discovers dirty pictures she wants to show her husband. Though the reader registers the after-effects of the couple's having gone separately into their neighbor's apartment, Carver is too good a writer to waste time by letting us spy on their actual acts (which, even if surprising, would almost certainly be mundane). It's an interesting strategy: We're forced to use our imaginations, which are overlaid (to make a bad pun) with the husband's and wife's separate but mutual arousal.

Carver isn't at all subtle as he presents what we must understand. He does this with his timing, and by forcing our eye to certain details. He telegraphs these ostensible throw-aways—a thought blurted out, for example. Being the sneaky writer he is, he focuses not on what happens inside the apartment, but on the shadows the experience casts on the wall, so to speak, and on how those shadows overlap, in private and mutual desire. Then he does something interesting, which happens as abruptly as Mrs. Ramsay dies. It's as terse as the announcement of Mary Robison's character's death sentence. He locks his characters out: the key to the apartment mistakenly gets locked inside. It's as if the writer is playing Russian roulette with himself. Even though I've read this story many times, I still expect that the next time might be different, because the air that surrounds the characters is so persuasively combustible. But of course, things won't blow up; Carver is the master of implosions. The husband and wife remain exiled—though it's a very paltry, diminished kingdom from which they've been cast out:

He tried the knob. It was locked. Then she tried the lock. It would not turn. Her lips were parted, and her breathing was hard, expectant. He opened his arms and she moved into them.

"Don't worry," he said into her ear. "For God's sake, don't worry."

They stayed there. They held each other. They leaned into the door as if against a wind, and braced themselves.

End of story. The prose is understated, though nudgingly particular (even the word *expectant* is loaded. We can read "For God's sake" literally, as well as knowing it's a lazy expression). The last image of them we see verges on, or maybe steps right into, the muddy puddle of cliché, as the husband envelops his complicit, silent wife. This excessiveness can only be intentional, over the top; it needs to be read both in and out of context, as if Carver is using ironic quotation marks. The visual scene is overemphasized, with Carver's "as if." "As if" nothing. He intends for us to think just what he wants us to think, with the conjured-up wind becoming metaphoric as it blows. We've become voyeurs to voyeurs; then we find ourselves out in the cold with them, in a dreary apartment hallway. We're with the orphans huddled in the storm. We think of Odysseus tied to the mast to avoid the seductive calls of the Sirens. It's a riff on that, and it could also be looked at as a riff on Drama, in general. Carver is working within well-known tropes, but it's his intention to *reveal* that he knows that. It's as if all the allusions are an ironic backboard against which these actors—so very different from their prototypes—act. Carver orchestrates a

final moment that's both intense and "intense." I think a case can be made for this story as a demonstration of the highly dramatic at an ironic remove from its literary precedents. It can also be seen as metafictional, as writers are always capable of being inside the door (they *created* the door). But here, daringly, Carver's locked *himself* out—to his advantage. We already know (and knew) the inside story, but now we're left to consider another one, since we, too, are locked out and can only move imaginatively.

SOMETIMES, THOSE TIMES I can get on another writer's wavelength, I can point to a sentence, or an individual word, and identify the writer's turning point, say exactly where they decided not to tell the story—to make it one story, versus another. This isn't a unique skill. Writing an alternate story doesn't make it better or worse than the one unwritten. But sometimes the writer doesn't realize that they're hiding in plain sight, or that they've failed to smooth things over enough that they're entirely convincing; they might be dressed well, but the hem is showing. I feel Freud's spirit hovering as I say that. It's also possible that, until it's pointed out, the writer doesn't "see" what's there.

Neither is true of two other writers I want to mention briefly, though both have decided to reveal what's at stake, or what most matters, early in their stories—not to hide it at all, but to draw attention to it. It's amazing that when this happens, the reader registers it but keeps on reading—only to find that what was always there returns in an unexpected way, familiar yet different, because

of the story that's developed between its revelation and the story's end. Russell Banks, in "Sarah Cole: A Type of Love Story," creates a first-person narrator who states an important fact early in the story, though by the time that information reappears, he also reveals that the confession has been a ruse. In Frank Conroy's "Midair," an essential traumatic scene is enacted, but the character himself forgets, repressing it. Then, at story's end, provoked by what were related yet random occurrences, the memory is recovered. The cracks in the sidewalk that were first seen by the young son whose father endangered him (and his sister) by crazily taking them out on a ledge high above the pavement, from which they looked down, are seen again at story's end, but this time they mean something different (as so many things do that we see in childhood, then later as adults); the cracks now also exist the way cracks do in stories—so that among the ending's many levels of meaning, it reminds the reader that *stories* are artifice at the same time they intend to be simultaneously real. In Conroy's story, tension exists between the readers' knowledge that leads to their understanding of the character, while the character goes through his life knowing less than we do, existing at a distance from himself. It's become such a convention for writers to invoke unreliable narrators that the reader can be surprised if the narrator is reliable—but Banks's story and Conroy's are doing something different, and in a way, the reader becomes the third side of the triangle, implicated (as we become exiled bystanders in Carver's story "Neighbors") but powerless. In "Sarah Cole" and "Midair," the characters wish to be in

control, they *pass* for being in control; it's easy to imagine they might answer any question—they might even turn their pockets inside out to show you the lint, and in so doing suggest that they have nothing to hide—but the power in these stories accrues in part because of the reader's proximity to the truth (Banks's narrator deceives us *and* confesses; Conroy's character is in hiding from himself, not us; he doesn't know what he might tell us until he's overwhelmed by seeing the justified image at story's end). Characters exist to be challenged, and if no one confronts or provokes them, eventually they have no recourse but to provoke themselves.

Peter Taylor's creepily vivid story "Venus, Cupid, Folly and Time" centers on a brother and sister. It is, in more than one sense, a costume drama (Taylor sets the story on Halloween). The subtext is incest. First published in 1958, it's possible, though not probable, that a reader would read the story—its length alone provides wonderful obfuscation—and not realize what the situation is, though certainly the "goings-on" (as Taylor might have said) are odd, even for the South. But try to explain to a nonwriter why a writer would choose to invent characters whose actions are never named, least of all by them—characters who reflexively know and hide from certain truths. As mentioned earlier, this is true of Munro's characters in "Nettles," though even the "nettles" (the outside world) attack them, as if punishing them doubly for their self-denial. *Characters!* They exist to be betrayed, though those betrayals often take an unexpected form (late in Munro's story, the outside world becomes so animated and causes so much misery, including

physical pain, that it seems like punishment from an angry god that would please a Puritan minister). Obviously, it's not just in stories that we understand things through inference or based on of our own experiences. But how to articulate something that remains only a feeling, or a hunch? And if the character has misled us (or tried to), would it be unfair to be angry or unhappy about that? Some of the stories I've mentioned, such as "Neighbors" and "Venus, Cupid, Folly and Time," have an operatic quality; we undergo an intentional immersion in excess, even if (as in Taylor) the events of the story are a displacement of the characters' inner state, or express their paradoxically contained turmoil. Language always surrounds the characters in a story; that's part of the difference between a story and real life: one is narrated and the other—at least, moment by moment—is not. The structure of the story and the language the writer chooses, even if attributed to the characters, is deliberate and can be revised, refined, loaded. In writing about Louisa and Alfred Dorset, Taylor describes their ruined house this way: "They had the south wing pulled down and had sealed the scars not with matching brick but with a speckled stucco that looked raw and naked." No different from the way dogs understand tone of voice, and know enough to compute what they hear because they know the buzzwords that matter to them, the reader also reads that passage and stops at—has a visceral response to—the word *scars*, then to "raw and naked." I don't need to belabor the point; Taylor is writing about more than architecture. In this displacement, he's telling us generally, if we don't yet know the specifics, about the damaged people within the

altered, damaged house. Later, he alludes to Poe and to Tennessee Williams (provocative writers, hardly random choices). He's intentionally set up a funhouse mirror. The title alludes to a sixteenth-century Bronzino painting in London's National Gallery, and therein lies an essential clue. I think both artist and author would have been much amused by this helpful note on Wikipedia: "Scholars do not know for certain what the painting depicts."

WHILE WRITING THIS, I was interrupted by a friend who's made my husband and me a lush flower garden at our house in Maine. Every year it expands, seeding itself so that parts of the garden have to be dug out and replanted elsewhere, forming other gardens. Here's hoping the phlox take root in the field across the lane. Also, because of the amount of rain this year, we had a mini-jungle. When friends visit, I immediately make a disclaimer: *Yes, it's gorgeous, but I have nothing to do with it; Michael's the gardener.*

Here's what happened: Michael hollered up to me on the second floor to say that he had to stop work early and leave immediately. This got my attention. Quickly, though not as quickly as he delivered the rest of the information, I went to the top of the staircase and listened attentively to what he was saying. At first, I stood at the top of the stairs, then—as a cold wind blew through the door, to which he was oblivious—I sat on the landing. *He had to leave.* (*Right: Got it.*) It was important that he get to another house before dark because the husband had simply never watered any of the plants in the enormous planters sur-

rounding the swimming pool all summer. Michael, who is tall and has long limbs, threw open his arms, leaning into the gesture; big pool area, clearly. *Nothing had been watered! Everything dead!* Of course they'd all died but the thing was, the wife was about to return—as I write, whatever happened has taken place or, for all I know, there was a happy outcome—and Michael didn't want her to see the dead plants. He'd be back first thing in the morning: "Keep the water on the vinca. Tell Lincoln to turn it off before he goes to bed." Into his truck he hopped, his dog (the one who loves wafer-thin fish skin) and his young assistant already inside. Then Michael was struck with another thought, which he called over his shoulder, "Well, it's fall, so she'll just think I've cleaned everything up."

I went down to close the door. Channeling the husband's voice, inspired by my memory of *Gaslight*, I called out, "Clothes all over the floor? What clothes? Oh, maybe someone else threw a party."

Michael turned, smiling. "That's what we need, a sense of humor. That's what makes life worth living," he said, and away he went, with me thinking, *I wonder if, yet again, he forgot his straw hat. Was he wearing the hat?* And then I thought about Michael writing the story of the couple and their untended garden-in-pots, and how it was quite possible that until moments before, even the husband had not realized every plant was dead, as he awakened from a summer long sleep to find that his wife was returning from who-knew-where. If Michael was a writer, what would he have done to humanize these people? Or did that belong to the world of John Cheever, and was that

world a little . . . what would the word be? *Remote?* (And, unlike the two of us, might Cheever at that very moment have been enjoying a cocktail in heaven?)

Michael's truck had vanished.

My silent questions had not.

What were the names of the plants, the ignored, dried-out plants? I wondered. I conjured them up in my imagination. What had they been? So often, what you wanted was already perfectly named. Were they rue? (Okay, it's an herb, not something planted around swimming pools.) My wheels were spinning: *What was the story, what was going on with these careless people. Where would you begin to tell the story? What could you reach out for and touch that might be a partial clue?* It would be like reaching for a Ping-Pong ball—"B-3"—that, once grasped, might be just what was needed, exactly what you were missing.

I might have enjoyed my moment of speculation—admittedly, stories can be more interesting than working on an essay—but it was Michael to the rescue. I was only walking back upstairs. But I kept thinking about what he'd implied: that the wife might never know a minor tragedy had taken place; the plants' disappearance could be attributed to the changing season, which of course can't be orchestrated by anyone.

MORE TO SAY:
ON PHOTOGRAPHERS & OTHER ARTISTS

Placing Lincoln

Lincoln Perry's Charlottesville, 2006

IN TRANSIENT AMERICA, we are fascinated by place. We are inundated with special issues of magazines devoted to people's memories of the places where they grew up, the places they love above all others. Place has been deified, and with deification come certain expectations: we must travel to more-and-more remote spots; we must move forward, yet cast our Gatsbyesque eye backward. Our vacations must be adventures, our contexts global.

What does all this have to do with Lincoln Perry and his paintings of Charlottesville, Virginia? The place both disturbs and calls to him: it's a paradoxically comfortable and uncomfortable not-quite-home he has been drawn to many times for reasons he can't easily articulate. He visited Charlottesville as a young man (hitchhiking to visit a girlfriend), later lived in Charlottesville for ten years, left, and recently returned to buy a house—though he also lives else-

where and, when he can, goes to Europe to paint. Although from time to time he has taught art at the University of Virginia, he has been primarily a self-employed painter with the luxury of being able to choose where to live. He has a wanderlust that his wife (me) considers impressive. I suspect that if Charlottesville had Italy's trees and Key West's cemetery, he might spend even more time in town.

For Lincoln, no individual place has proved perfect—either for living or for painting—but when he's in town he goes out into it, repeatedly, to observe the way it changes in different seasons, or as one day elapses. On a day when a windstorm takes down a big tree on the university grounds, he pays homage as if he's attending a friend's funeral. He might know the fate of more former bushes and trees than anyone but a landscape architect, and still mourns one particular tree that provided U.Va.'s Lawn with its only deviation from the vertical.

Inevitably, as he has returned to the town during different periods of his life, he's reapproached it with changes in his own way of looking at things, and with different interests in structuring and executing paintings. He loves many things about Charlottesville, and it has served as a constant, though ever-changing, source of inspiration to someone I would not describe as a person who likes small towns, or who even prefers the United States to Europe. He could go (he does go) elsewhere. But in self-inflicted rootless times, it's a place that has retained special, personal associations: family who attended the university; our meeting; good friends; his interest in history; his love of Jefferson's architecture.

Pleasant associations and a degree of comfort are always suspect, and at best only part of the story. Artists are also motivated by discomfort, and intrigued by contradictions and complexity. If there's nothing to wrestle with, there's little depth of involvement. As anyone who lives in Charlottesville knows, the place is something of an oddity: a Democratic bubble in a Republican state; distinct groups of people (the writers; the horse people) who don't often mix. I think that Lincoln likes the town's quirkiness and its lack of uniformity. It's also a place that allows him to practice the X-ray vision so many visual people have for underpinnings: the contradictions that can be drawn upon and aesthetically dramatized; a painter's sensitivity to light, but also to sound, to growth, to loss. Obviously, some of the paintings are in a major key, others in a minor. Perhaps I'm projecting, but it occurs to me that Lincoln may be interested not so much in the much-discussed loveliness of Charlottesville as it being a place he hasn't quite settled on, a place he lives in part time that's always eluding him: in a strange way—I feel this way, at least—it's impersonal enough to project upon, and therefore possible to love. It's almost approachable, yet not. Try taking a walk in the country, and realize that you have to walk on the shoulder as trucks fly past, and that all the land is fenced. Yet other times—the most unexpected times—the Lawn at the university can be inexplicably empty, and the moon can look a certain way, and the smell of the ground, and of the magnolias, can be sweetly pungent.

The place sparks his imagination, and with his paintbrush, he sparks it, charging the air with a bit of unex-

pected—but very recognizable—light. People make much of light in paintings, and fair enough: so do painters. To someone who doesn't paint, however, the light might seem particular, yet be taken for granted. It takes someone like Lincoln, who notices the way it drifts and casts shadows that have a blue or a violet hue unlike other shadows, to make a viewer realize that in part *because of* the light he or she can identify the location. For whatever reasons, Lincoln is willing to be vulnerable to the place: a conduit for its changes, its disjunctions, its sometimes unexpectedly lovely coherence.

JUST AS REALIST painters must know the fugitive, elusive nature of reality and the level of artifice inherent in their project, painters of place are aware that their subject—in this case, Charlottesville, Virginia—has an uncontained life of its own. The unparaphrasable is what artists tend to trust, so while it's often physically beautiful and diverse, the town isn't inherently provocative or confrontational, like Las Vegas, or mind-bogglingly spectacular like the California coastline heading toward Monterey.

There is also the much-talked-about spirit of Mr. Jefferson, a presence so strong it can't be ignored. We must philosophically accommodate to an apparently inevitable expansion, while the place has continued to resonate with the ideas and ideals of the man who once looked down on it from his mountaintop. People want the land because they want privacy. They want the downtown mall (in Charlottesville, an outdoor, pedestrian-friendly zone)

because they want to be part of the public parade. People have endless good and bad ideas about the place—but almost always they assume it needs to be changed. (Well, *of course* the asbestos has to be removed. And who objects to a good wine store?) As is happening all over the nation, people are moving back downtown, buying condominiums, having their morning coffees. (There's still the lunch place where the workmen eat; you can buy bread anytime you get sick of your croissants, the argument goes.)

Though it seems rather unlikely to me, knowing that Lincoln doesn't easily filter out urban sprawl, or even members of the opposite political party, he seems endlessly able to find a personal walkway through the scaffolding and bulldozed streets and buildings in medias res to connect with the place and to tacitly acknowledge the timelessness of some of Jefferson's best thoughts and to reconsider them as they are woven into a contemporary context. There are always the implicit questions about change: How much is too much? Is this going to work? What does it mean when a certain history pervades a place, but in a layered and disjunctive way (a subject of Lincoln's paintings of mostly bewildered tourists surveying the ruins of the Roman Forum)? When I think about it, third-millennium Charlottesville exists as a daily enactment of Lincoln's internal debates about how to paint and how to live, apparently almost synonymous concerns.

AT THIS POINT, a note to the reader. This is being written by a writer who distrusts narrative, about a figurative

painter of narratives who often says he has no idea what people do. I mention this not to make you think us peculiar and deficient, but because so many introductions seem to suggest that artists know what they're doing: that they are gifted (whatever that means), and that they have a will to express themselves, and do so. I'm skeptical about how true this is, but I'll avoid sweeping generalizations and confine my remarks to myself and to Lincoln.

When the viewer looks at Lincoln's paintings, he or she may be immediately drawn to them, though it takes a while for things to sort themselves out. On first quick glance—the advantage, but also the liability, of things visual—the viewer is usually able to see, in a general sort of way, what is there. But more often than not, Lincoln offers an kaleidoscope instead of binoculars to assist in your viewing: multiple panels have a confusing, sometimes static, sometimes overwhelming, contradictory complexity that puts you on sensory overload, and then— just when you think your eye is moving quickly enough, and that your brain might catch up, the shapes shift and your perception skitters to reveal another mesmerizing shape: you try to look at it in its entirety, yet you can't, because you can't trust it not to move—especially because it's painted so as to keep the eye in motion. So perhaps you squint, to take in only an aspect of the painting, or, if it has multipanels, the primary panel, on top, or the one that seems particularly involving, on the left . . . Eventually more is revealed, which is not to say that there are not continuing complexities and ambiguities.

Lincoln is true to his sensibility. He paints not so much out of a sense of defining things but rather to reveal that there are always multiple possibilities: there are the steps to one of the pavilions seen frontally and there are the same steps seen from the side, obscured by a bush. As someone who majored in history as an undergraduate at Columbia and who began to understand for the first time that so-called historical facts had much to do with who was presenting those facts and why, and as someone who has a proclivity toward encompassing different viewpoints and resisting the idea of a representative (or inevitable) narrative, Lincoln finds multiple perspectives to be not merely an interesting diversion but a presentation of the artist's thoughts and feelings as he wrestles with unexpected moments of beauty, disharmony, or unexpected ironic juxtapositions. Clarity is not always trustworthy or even inviting; those who understand Robert Frost's "Stopping by Woods on a Snowy Evening" comprehend that even the poet wouldn't think the museum stairs less traveled by made all the difference. When Lincoln's eye takes different perspectives, you are obliged to do the same. Things shift, just as they do in life.

It's a standing joke in our house that there are three possibilities. Even when Lincoln says there are two possibilities, there end up being three. It makes things more interesting—at least to him, because it's true to his way of looking at life—though the multiple-possibilities game can get a little maddening in terms of what restaurant we go to for dinner. It also suggests that possibilities themselves are real exactly because they are multiple, and that

they need to be given their say; in his paintings, it's as if he personifies possibilities as figures. Mythical underpinnings are often used to suggest shared subliminal meaning or subtle continuity; there are homages to other painters, sometimes invoked to complicate as well as to clarify; even fond in-jokes: just what you'd expect of someone who has studied the history of art but who also has humility and an unusual sense of humor.

What artists don't often say is that it's the amusement factor that keeps them going through the rough parts. In my work, a minor character, allowed in one quick quip to compromise the other characters I've so painstakingly created, is always welcome. Autonomous, unmanageable characters give me the courage to trudge on. Your little antagonists have to be in the work, whether they're the airborne kite that won't stay still long enough to paint or characters who have clearly slipped out of your grasp. Whatever is being created—in order not to be hermetically sealed by its own artfulness—needs breathing room. The problem is how to suggest that it's there without diverting too much time and energy into invoking it, so that it doesn't distract the viewer or reader. In Lincoln's painting the history of art is real and present, and an allusion to another painter is more a collaboration of kindred spirits than an homage or an appropriation.

Lincoln is a figurative painter, at home with abstract thinking and painting. What we see becomes form and color and proportion—and yes: the painting also remains a depiction of steps you can ascend or descend. He's fond of quoting Corot and Bonnard to the effect that it all

comes down to light. In viewing his work over time, or the work of any other painter who creates a world, the cumulative effect is that it's instructional, and that when you begin to consider things in their own terms—to follow their lead—you've taken an important step toward silencing the self-referential chatter in your head: the story you tell yourself about what's good, what's bad, what's expected and what's not.

In A BOOK Lincoln likes very much, *Out of Sheer Rage*, by Geoff Dyer, the author presents an account of his failure to write his book because his subject eludes him, and this struggle becomes very funny. There is a passage about the writer's envy of artists that I find extremely informative. Dyer writes:

> Writers always envy artists, would trade places with them in a moment if they could. The painter's life seems less ascetic, less monkish, less hunched. Instead of the austere mess of the desk there is the chaos of the studio: dirty coffee cups, paint-smudged cassette decks, drawings of the artist's girlfriend, naked, on the walls.... For the painter work means a more intense physical engagement in life, it begins with carpentry (making stretchers) and ends in glazing, varnishing and framing. Even though it thereby involves labor the painter's work—or so it seems to the writer—never seems like work. In the age of the computer the writer's office or study will increasingly resemble the customer service desk of an ailing small busi-

ness. The artist's studio, though, is still what it has always been: an erotic space.

Well! Surely he speaks the truth, and the wonderful messiness is much more romantic than wads of paper thrown in a trash can. The painter is in there, doing something, touching something. (This envy has turned many writers into good cooks, by the way.)

On the rare occasions when he's painting indoors in Key West, I sometimes watch Lincoln out of the corner of my eye, and less frequently I wander into his space and sit backward on a rickety orange office chair donated by his mother. (I never, ever see Lincoln sitting in this paint-smeared chair; nevertheless, it serves as an obstacle to everyone: our approximation of an old, slumbering family dog.) With phone on the table, Bob Dylan revival in full *Whoooooooooooooah*, Lincoln stands, cocking his head, barefoot, war paint on forehead or tip of nose, paintbrush at his side pointing down, like a conductor who has decided the musicians can figure the rest of it out themselves. Once he's ascertained that I don't have yet another computer problem he has to solve, he'll continue to squint and to endlessly approach and back up from a canvas hung from a somewhat expandable masonite wall that blocks the entrance into the kitchen.

I not only look at what he's painting but also notice with envy that Lincoln can paint almost anywhere, including the landing into our small, many-windowed Florida apartment. Visitors usually don't faze him, whereas I do a body block of my computer screen if someone walks

in while I'm writing, no different than if I were hiding a fugitive. My fear (wait'll you hear this one) is that if someone sees part of the writerly equivalent of the body-in-progress—a sentence instead of a hand, or even a word instead of a finger—the rest will evaporate and I will be left with nothing. In a way, I feel that I'm writing by holding my breath, as if thereby withholding breath from my character, because it needs a life of its own that must transcend what I'm creating or there will be no finished story. If someone sees it—including me—it will disappear. But Lincoln ... moving forward, singing along with the lyrics, squinting—all of it is his enviable, odd little dance (always, always accompanied by music, whether playing loudly in the room or ... you, too, can save your marriage through headphones) that's physically interactive with his dancing partner, the painting.

Writing, I sit as silently as possible, not making a move, to better encourage or trick the character into coming out of hiding. But this is not Lincoln's method, at all. (Come to think of it, we both work the same way we converse: he has questions, I rarely do; he likes to get something going, I like to see what unfolds.) As I understand it, the visitor is part of the painting, as is the soundtrack, the art book open on the floor to a painting by Poussin or de Kooning; the phone call that comes in is part of the painting, interrupting the already interrupted momentum, thereby shaking up ideas.

When he's painting, Lincoln knows—the lucky artist gets to know, because he can touch it if he wants—that his subject matter is not going to die on him or recede into

mist or in any other way cease to exist. He might paint things out, but that's another matter. If he is in the process of painting a figure with an opaque, featureless orb on top of its neck, he can tell you which vegetable he wishes you'd buy at the store, or where he thinks the checkbook is. I am completely amazed by this, and it transcends my awe for all the reasons Geoff Dyer remarked upon; I'm jealous because he can let you look right at the mystery and still continue to perform magic. And furthermore, he doesn't think of it as magic—which is not to say that it's easy (you should see the sketches and preliminary marks); it might be insufficient, or problematic, or disappointing in any number of ways, but it won't cease to exist unless he decides some or all of it doesn't belong, whereas most writers will tell you—really—that their characters are capable of putting on their hats, leaving the room, slamming the door, and never returning, even if no one but the writer is their audience. No: Lincoln's creations are indelibly there in the faint marks of charcoal; they get clearer and clearer (if they're meant to), they are adjusted and repainted and removed and perhaps put elsewhere, but they're there because they live in his understanding of them.

But what are the figures doing? Beautifully choreographed, they might be lovers or prisoners in a road gang. And what is the story? People come up to me at openings and ask me to explain what's going on in some of his paintings. "That's our kitchen," I sometimes say dully, knowing that the answer is as insufficient as it is banal. They're not about something, they are something: prisoners are seen taking positions in a dance. In depicting them

this way, Lincoln has also taken a position: he has revealed his sensibility, his assumptions about finding beauty in unlikely places. In conversations with viewers of Lincoln's paintings I resist trying to come up with answers because I don't want to know the story. I'm drawn to the narrative precisely because I don't know it and because, by its very nature of being a painting, it has to be a different story from any story that could be put into words. If it could be told to me—paraphrased, in effect—there would be no need for the painting. (No inherent virtue in things remaining ambiguous: just a reminder that ambiguity does not exist merely to be figured out.)

When we first met, I was surprised and embarrassed when Lincoln would ask other couples, "What do you do during the day?" and "Do you talk to each other?" I thought the implication was that we did nothing of consequence and that we didn't talk to each other. Now I suspect he was covertly asking for an insufficient answer, because of course people weren't going to rattle on about doing their taxes or getting the oil changed, or express their feelings about their child's first-grade teacher. I think *Don't tell me; fail me* was what Lincoln really wanted, in spite of the ingenuous question. Because he's not an illustrator. He paints because he doesn't know, and ultimately doesn't want to know, what the story is. The story is the painting: they're synonymous, symbiotic, though neither precludes the other.

We're often drawn to Lincoln's unusual perspective, I think, because he gives things the mask of informality, and we trust that in the same way an imperfect, unposed

snapshot can be more telling than a formal portrait, or when an aside is more revealing than the lecture. In fiction, a tape recorder is useless in capturing how we process speech: people are used to tuning out what is said to them, to filling in other people's sentences. They paraphrase stories in their own minds, approximate, and express ideas as clichés, which makes "real" speech seem unnatural. Without seeing the people talking, we miss the cadences that announce seriousness or the lack of it, the gestures that undercut words. Narrative painting, itself a fiction, involves such subtextual subterfuges; we are like visitors who don't speak the language struggling to comprehend, thrown back on intuition to make sense of native behavior. The viewer must do some work, but must also have faith that the painting converses with itself with considerable intelligibility. Painters don't capture the moment, as is often said as a form of approval: they take real liberties with chronological time and do it so convincingly that you don't question the odd (and impossible) stopping of time.

BOTH THE CABELL Hall murals and the Music of Time series are about one of Lincoln's constant concerns. Simply put: the passage of time. In this case, for a student at the University of Virginia—through the seasons, with various achievements and mishaps, in symphony with others and then alone, the student matriculates and goes into the world. The rhythms and repetitions of time can be seen as a dance, though less reassuring images can intrude, as when the arrow of linear time is pulled down to

Earth by gravity. Time and overpopulation are Lincoln's preoccupation; count the figures in the Cabell murals. We all live vicariously in our creations, but I think painting the Cabell murals was an ideal challenge for Lincoln because while he had to project himself into the main figure's position and mind, he was more familiar with being on the other side, so to speak: he'd been a teacher at a place where he had not been a student; he loved Jefferson's initial concept of the university, yet had misgivings about the ways in which the university meant to expand (and also about the building his mural would be installed in: its creation cut off the view of the mountains beyond, blunting an important element of Jefferson's vision). It was a chance, then, not just to have his own dream but to honor the dream of Jefferson by illusionistically painting the panels as if the building were transparent.

As you might expect, a lot of research and planning went into the painting—this from a painter whose total immersion in planning involves, early on, the banishment of certain ghosts of ideas. Flannery O'Connor said about writing, "You have to put it there before you can take it away." It seems obvious, but it isn't—that you can't think through something or paint something in your mind: you have to physically do it, because the hand will instruct you. Artists will tell you this is true (perhaps more so the more accomplished one becomes: then, who believes in shortcuts?). The painting went through significant rethinking, and then of course it also asserted its own will. This is all I can figure out about why Lincoln selected a redhead to be the model of the young woman, then was dismayed about

the colors a redhead couldn't wear (debatable, having seen the maquette in which she wears red). The paintings are large, and as he worked, there was initially no way to see them together. Even individual paintings were so large that part of the canvas would be rolled as he worked on the rest. He could not work in Cabell Hall itself, for obvious reasons. He worked from measurements he made there, took notes on how the light came in at different times of day, figured out what other light would be needed to augment it, and finally even amused himself by adding a faux shadow beneath a figure's feet, on the real baseboard, after the panels were installed.

When people ask me to make an analogy between painting and writing, I want to say that they are not at all alike, and the day I have to maneuver the pages of a novel out my office window, I'll play the analogy game. Did he envy the clean compactness of my process from keyboard to publisher as he wrestled his rolled-up canvases, twelve feet long, out the attic window in Maine, then drove them to Charlottesville, where they were unrolled, put on the floor, cut (hold your breath), the wall painted with wet glue, the canvas rolled onto the wall (yes, with a nerve-wracking mismeasurement on the installer's part), with elements of some panels matched to the next? Most likely.

WITHOUT SPONTANEITY, THE paintings couldn't exist. Their energetic moment of conception can't disappear in their execution. Preplanned as they are, of course they

don't emerge as planned: there are constant adjustments, problems of perspective, unanticipated difficulties (anyone knows this who has tried to make even an omelet). It's all an illusion, created with paint. As stories are just constructs of words.

V. S. Pritchett has written, "Because the short story has to be succinct and has to suggest things that have been 'left out,' are, in fact, there all the time, the art calls for a mingling of the skills of the rapid reporter or traveler with an eye for incident and an ear for real speech, the instincts of the poet and ballad-maker, and the sonnet writer's concealed discipline of form." So, too, with painting: what has been left out—almost the entire world, really—has to be suggested so the painting will convince. It has to transcend its borders, extend beyond the frame, be a contained entity that lets you know that, paradoxically, it is uncontainable. It is the painter's or the author's responsibility to let the viewer or reader know that he or she is aware of what's been omitted, and that the omissions, as well as the negative spaces, count for as much, if not more, than what's there. The fifth panel in *Music of Time XX* shows us a bride at her wedding; the serpentine wall, practical and metaphoric in Jefferson's design, becomes symbolic, suggesting a serpent in Adam and Eve's garden. The curving pattern continues throughout, with the back of the chair the woman sits in, with the suggestion of a half circle made by the wedding gown's uplifted train.

Though the panel of the woman sitting in a chair is not exactly a non sequitur, it functions similarly; it appears as a random view of someone who turns out not to be

a major character, and as such, even in retrospect, it's so unexpected a depiction as to be almost out of time and place (context). I could invent a story, but why? The figure reminds us that there are other, private narratives going on while the painting sequence is itself building toward a private narrative that becomes public: a wedding. Yet the wedding isn't the expected culmination. This is a painting by Lincoln, after all. The geometry with which he began— the somewhat simplified, almost reverential recording of shapes—is returned to in the enigmatic final panel. Wedding over, the gate is open, and a shadowy figure, who no doubt has a story of his or her own, is passing by.

It would be an oversimplification to say that shape and form, abstraction, and architecture are triumphant, yet not unrealistic to say that amid the mysterious players of this story, they express coherence and a concrete reality: a kind of certainty we can't identify in the events. In conversation, non sequiturs are surprisingly indicative of a speaker's train of thought, even though the speaker may not realize what he or she has revealed. In writing and painting, though, the artist places things deliberately: there can only be the fiction that something is random when it's selected. Lincoln's unexpected inclusions—his interruptions of the trajectory, his mysteriously presented figures—function as non sequiturs, though they are intentional. They suggest that the story must be, or at least might be, much more complex. Once interrupted, the viewer has to rethink the story he or she had been putting together consciously and subconsciously. The lack of exact transitions, the inclusion of what might be called minor

characters, the lack of specificity in figures, along with the near personification of nature, force the viewers not only to participate in creating the story but also to simultaneously realize their inability to do so with any certainty. It's insidious, but fun: a sort of secret wink that collusion is required between artist and viewer, but also the tacit admission that the creator and the perceiver share a vulnerability. How, exactly, do you give the viewer or the reader the secret signal? In part, by being quick on your feet: by being Pritchett's "rapid reporter." By including yourself in the work in some way at the same time you're vanishing. By neither manhandling nor tidying up experience. By making a world that seems to have been found. The painter or writer has to communicate that somewhere inside the work a controlling consciousness exists, but that in creating the world in miniature, the creator is quite aware of the artifice, and perhaps the sacrifice, involved. That the artist is cognizant of the larger world.

I LIKE MR. Pritchett's notion of the "rapid reporter or traveler with an eye for incident." Lincoln travels often, and when he does he keeps a sort of visual diary. Many of the things he records could be considered "incidents," I suppose, if you call a bird landing on a column an incident, or—this would certainly qualify—someone victimizing a woman. More often, though, the column, alone, is recorded because of its potential use in what will be, ultimately, a fictionalized "incident," or the painter's selective eye sketches a few figures that turn on a vase while

omitting others. Envy, envy: these might be sepia ink sketches. And the ordinary looks so fresh, so surprising when simplified. Omissions change everything.

Sometimes Lincoln makes a visual note on a cocktail napkin. I can't tell you the guilt I've suffered, pulling out the wash and looking at the remains of a pen-stained, shredded napkin. We're very different: I try not to observe and not to hear, trusting (perhaps wrongly; how would I know?) that the important things stored away in the subconscious will emerge again when and if needed. I depend on that, as a working method: when I least expect it, my fortune (You have miles to go) will float up to the surface of the Magic 8 Ball, so to speak. But most things get lost, no matter how indelibly drawn, whether put down with pen and ink on a drawing pad or carefully placed in all but the final draft. My revised pages are filled with extraneous, crossed-out sentences; Lincoln fills pocket-sized drawing pads with visual or verbal notes to himself that are seldom heeded or consulted, but so what? In registering them, or recording them, they lodge in our brains and might be useful when least expected. (Lincoln is a great mimic, by the way: his talent is to have observed some tiny quirk others would overlook and to use that to define his subject.)

We both seem to filter, to mix and match, to recall in tranquility, but mostly—let's be honest—to dutifully imagine that we will eventually write or depict something, and then we forget it. Lincoln isn't a reporter: even if what he paints is familiar, he has to defamiliarize it so things can be seen as new. I think his shifting away from one

perspective—adding information, subtracting, refusing to mark each transition, fine-tuning—is first and foremost not playing to himself, not provoking just to provoke, or reassuring just to create something beautiful, to placate. He's doing what he does not in order to get an answer ("What do you talk about?") but to pose a question, which, by implication, makes the audience better able to articulate their own uncertainty. In so doing, they enter the world of the paintings.

IN HIS PAINTINGS you might be drawn to the Charlottesville you've always known. Or the place might be one element while the text and subtext offer something unexpected. In many of them, you'll probably see a place simultaneously familiar and unfamiliar—because that's the way the painter views the world: there's a necessity for the familiar to be reenergized by being defamiliarized; he sometimes does an improvisation so astute it stabilizes the original. At times he might also use complexity to get at a simple truth, or present something obvious that becomes less so when seen more clearly over time. In any case, along with being what it is, the work will also exist as a portrait of a person—a Gemini, by the way—who accepts Charlottesville's mutability as a partial definition of its familiarity, so that the unlikeliness of arrival becomes one of the painter's points of departure. Your self-questioning guide will have packed both a spyglass and a prism in the travel bag.

The Distillation of Lavender: Jayne Hinds Bidaut's Photographs

21st: A Journal of Contemporary Photography, Vol. 6, 2003

A GUILTY TRUTH about writing: if you know your subject well, you will never feel assured about where to begin; only boring subjects offer an inevitable starting point.

Of course I could begin by attempting to describe the person or the riveting and beautiful images, but to be honest, I'm so overwhelmed by admiration for both that I think I'll hedge my bets and try to present Jayne Hinds Bidaut by way of some lines from the poem "Dream On," by James Tate:

> *It's a rare species of bird*
> *that refuses to be categorized.*
> *Its song is barely audible.*
> *It is like a dragonfly in a dream—*
> *here, then there, then here again,*
> *low-flying amber-wing darting upward*
> *then out of sight.*

I see her, of course, as the dragonfly. But I see her, as well, as a sort of dreamer: someone who works with symbols, someone whose subconscious does not allow a dragonfly—or a golden silk spider, or a velvet-striped beetle—to escape her notice. Of course, whatever she presents as an image of beetle or butterfly or moth will already have escaped. Dead, it will be positioned, exposed not only to scrutiny but also to light, its portrait made.

JAYNE HINDS BIDAUT is decidedly retro, in a time when so many things aren't seen purely, but tchotchke-ized: dolphins swim not only in "Seaquariums," but, miniaturized and plasticized, rise and fall as you write with your ballpoint pen. Storybooks haven't been enough for us: now, plush animals have to be targeted at adult audiences as well as children. *Faux* animal hides are meant to amuse when stretched over butterfly chairs; plastic flamingoes are less *homage* than signs for nature's demise at the hand of pink plastic. In the prevailing ironic context, Jayne becomes the purists' purist. Her method is straightforward, though what emerges defeats any expectations we've acquired from high school biology textbooks because her process is tintype: each print emerges with variations, making it unique. Nothing she depicts is doing anything cute. Look at her book *Tintypes*: the Lepidoptera and Coleoptera are centered on the plate, facing upward, like icons. If they walked again, reborn, they would be oriented toward heaven, not toward us. Fingerprints, variables of chemi-

cals, specks of dust express the variations that emerge as the result of processing, while the orbs that brighten the area around the subject evoke the creature's growth process in maturing from egg to insect. We are reminded of the process of mitosis as we look at the speckled irregularities integral to the picture. These are not Jeff Koons's ironic animals—they're dead serious, alive in the imagination.

WHO DID I expect to meet? The Annie Dillard of photography, I guess. Someone very original, therefore almost certainly disarming. A small woman, intent upon dignifying small beings. I had her dressed in black (New York City), guarded in a deceptively conversant way (New York City). I hadn't seen anything in the images to suggest a sense of humor. Previously, she had very kindly sent me *Tintypes*, and I'd also looked at—but deliberately not read thoroughly—various press clippings. Though she was working without knowledge of what other photographers were up to, in terms of resurrecting printing methods, her work, when it emerged, occasionally came to be grouped with a small number of photographers whose common bond was that they had begun to revive various old printing processes. Their philosophies, of course, were different. In Jayne's case, it was the verge of the millennium, and she felt a protective impulse toward the old processes themselves. (Had other photographers not had similar interests, she might not have been able to find the necessary chemicals.) She was also rebelling against the digital age, and all the people who urged her to look forward, instead

of backward. She was dignifying the humble, as well: the humble tintype—quite distinct from the daguerreotype, for which people dressed up in their fancy clothes and posed for posterity—and depicting, with the procedure, things she felt had an inherently unglamorous image. I had read up on tintype, which contains no tin. (This seems to me no more or less remarkable than so many recent fictional texts appearing as memoirs.)

Enter her SoHo loft: a beautiful, almost tall woman with pale golden-red hair, a gold necklace, and a very welcoming manner. Not dressed in black. She is almost alarmed that I don't want anything to eat or drink. A turn-of-the-century English Mammoth plate camera, originally for glass plate negatives (which she uses 20 × 24) just behind the entrance area that makes me feel like a Lilliputian. Her assistant not yet present. Bamboo sprouting from a vase filled with red marbles. A fish-shaped lamp —Wow! *The very same fish lamp I have*—which leads us into a discussion of the curiosities of Vietnamese gift shops. It's not long before the two of us are bent over one of many terrariums. Insects, at first indistinguishable from their stalky natural habitat, stir when the top is raised. She sprays. Teeny, tiny (I put on my glasses) mouths open. A few extra spritzes of the wild-rose branches, for good measure (these, delivered from a grower in California, because in the winter she can't easily grow all her own food, such as raspberry and wild-rose bushes. Naturally, they come without the pesticides that would kill the inhabitants).

She's immediately engaged, half talking to herself, half talking to the creatures in the terrarium—with enough of

a sense of detachment, though, to see the humor. And all of it is very gentle, in the same way that her tintypes seem very respectful. Reverent. *Fragile* is another word that comes to mind when viewing them. Most people wouldn't like an insect crawling up their arm (Jayne would), but when she creates a tintype and puts distance between subject and viewer, we can safely examine perfection and imperfection. Mercifully, each is too detailed to tempt you to look at it as a Rorschach test: they indicate a lot about themselves, and not much about a viewer's orientation toward the world.

WHEN I HEAR a dull *clack, clack,* I assume that the heat has come on in the loft. But no: it is "Lizzie," awakened from his nap. Rescued by Jayne some time ago when he was obviously down-and-out, malnourished and ill, the iguana drops a leg casually off the windowsill. Lizzie has been sleeping on a bed warmed by two heating pads and a chenille throw (burgundy) on top, with an assortment of soft little stuffed toys to serve as pillows.

Jayne and Lizzie (sense of humor, definitely: the iguana is featured on the annual Christmas card, including a pose as a Christmas tree ornament) take road trips together. Lizzie's favorite headrest was found in a gas station in Texas.

I reflect that—as in her photographs—when you spend time with Jayne, there's a sense of surprised discovery. Things gradually reveal themselves, the way protective coloration gives way when an insect moves. Who would suspect that an iguana lay underneath a cover on the

windowsill? Other treasures are seen only when brought forth—though a little box of soil, leaves, and moss that must be some creature's plan B environment seems downright tame, if a bit mystifying. You have the feeling that while most people couldn't exist without their credit card, Jayne couldn't live without her misting bottle.

She has loved animals since they were her childhood pets. Her father, an engineer, would sometimes bring home baby bunnies that had been driven out of their natural habitat, or even "Bobwhites in a Baskin-Robbins container." He figured right when he thought his daughter would be the one to love them. "*Wild* animals," she stresses—as if those are even more precious (of course, it's clear from her art that she *does* like happy accidents). Flip forward from then to now, when she is preparing to have a show at New York City's Museum of Natural History: twenty-five of her tintypes, with accompanying insects. ("Then you can see their colors," she said excitedly. "It's great for kids *and* adults.") I feel sure that she will be there when they hang the show. Every aspect—every detail—is seen by her as part of the whole. Even the labels on the back of the framed artwork have been arranged for by Jayne, who found the Japanese paper, then located a letterpress printer who printed the typeface she chose, using her design. When questioned, she is casual about the way this came about ("Oh, I found a letterpress guy"), but it's another example of her vigilance, her sense that something is not complete until it can be observed in its entirety, front to back, with everything that pertains cohering. As with magic, if the magician lets down her guard for even a second, everything can be lost.

THE IMAGES ARE very of-the-moment and absolutely un-calculated. (Of-the-moment having to do with a close examination of the physicality of bodies—not so far away, in another kingdom, are John Coplans and Holly Wright.) But who can fake an obsession? Exhaustion would win out. The sheer number of possibilities Jayne surrounds herself with—alive and dead, hidden and lazing—makes her the real thing. She now wants to use in her photographs only plants indigenous to Connecticut (where she also lives and works), not just any pretty dried flowers or leaves. In the finishing process, the tintypes are coated with—among other substances—fragrant oil of lavender.

If she doesn't grow lavender already, wait till spring.

IN "RICHER ENTANGLEMENTS," Gregory Orr speaks of the lyric poet's heightened awareness of the body as the locus of the conditional world he wants to escape. He writes: "The more intensely the poet feels the body, the more intimately he knows it, the more he longs for that 'flight' which is born out of the body's anguish."

In a way, Jayne Hinds Bidaut is writing lyrical poems. Certainly she has examined anguish (the animalerie; the plight of her formerly abused companion Lizzie; the photographs of sad-eyed animals in pet stores). What artist doesn't hope to offer trenscendence—with image, painting, photograph, music? It's creepy to feel you've "captured" anything. The idea is to catch something only

long enough to let it go. That's why writers look blank-faced when people tell them, "You've captured my own family perfectly!"

ON FEBRUARY 3, 1847, there appeared in the *Sandwich Islands News* observations about a suddenly hugely fascinating new process that allowed one to have one's image made, inexpensively and quickly, to be kept or shared: it was like having your own playing card—the ace, of course—and the only question was how you'd play it. The daguerreotype: give it to a loved one? Keep it hidden next to your own heart? Use it as a painting reference? The publication noted: "[T]he daguerreotype movement is at present the most prevalent among us. Instead of the ordinary greetings of the day, people inquire whether you have 'been taken yet.'—questions which, in the uninitiated, have a somewhat ominous sound."

Today, a question about whether you had "been taken" would probably have to do with buying the wrong car, or waiting for the triumphant finale of a David Mamet play. I'm being only slightly facetious; of course we're on guard, more than a century later. And we have progressed (if it's a progression) from finding meaning in formal portraits to trusting less formal revelations of character (or, more accurately, we appreciate the illusion that that's what we're looking at). We're also more audacious, and find it necessary to zoom in on details, to purposefully distort in processing (to say nothing of the manipulation that can be done with the computer). The political statement is

all important. But then, how can you lose, when the new twist on narcissism is that the personal has ostensibly become political?

Of interest: Since 9/11, Jayne has been working on various projects that involve firefighters. As often becomes apparent after a deadly tragedy, there are few, if any, recent photographs of the deceased. It makes sense that Jayne, an individual who respects individuality, would want to meet the firemen at her local firehouse, and to consider them as they are, alone, but also as part of a greater system. ("They're very elusive. They all have other occupations."). They are also, of course, part of their own family, and in bringing their wives and children in front of her camera with them, she had a notion of giving them something they probably didn't have: coherence; unity; something formal but true. I think of tintypes—considered indestructible, and carried by soldiers in the Civil War: pictures of loved ones—most human, some canine. Some landscapes, I guess: beloved landscapes.

I LOOK AT small chromes of animal parts that have been discarded at the end of an outdoor market in France, now become sad still-lifes. These are in color ("My little Flemish still lifes"), never printed because she hasn't yet found the appropriate color process to match her vision of how they should be. They're shocking but oddly beautiful: "found moments," neither contrived nor rearranged. As you might expect, Jayne does not kill her subjects. She buys from "the insect guy." She has procured many, many

of them. I look at one encased in a tiny plastic tomb as if it's a Benadryl capsule.

She also gives me one to take away: a little insect in plastic, dropped in a film container for further protection. I suddenly remember that years ago, I bought film-canister salt and pepper shakers that were a great hit with my friends. I also remember, and do not mention, that thirty-some years ago, a friend gave me advice. As with much advice of any value, it was a non sequitur: "Always take the picture when everything's over, and never buy a house from anybody who's put in a stained-glass window."

THE DEVELOPMENT PROCESS results in tintypes that are both distinct and indistinct: details are there—if not missing from the original, that is—but there's also the feeling that each subject, like Lizzie, has found a very comfortable resting place—textured, perfectly imperfect, not in anyone's absolute control, including the photographer's. From what she wears to what she chooses to surround herself with, it's clear that textures and surfaces, accidents and little oddities, are integral to the desired effect.

The photographs also make us stop to wonder, as did Robert Frost, "If design govern in a thing so small." There's a spiritual element. A symbiotic relationship between photographer and subject that is palpable—to such an extent that Jayne once kept an almost infinitesimal mouse that fell out of its nest prematurely warm inside her brassiere.

At once informative, curious, suggestive, and even erotic, we view the tintypes as their own complete environment in which each specimen has its own integrity, its own selfhood. And let's face it: outside of the context of a lepidopterist's studio, once you've graduated from high school, you don't see these things. If you do, you probably smoosh them. The idea of examining them is sort of . . . strange. It's not strange to get a telescope to see the stars, but it's strange to have a microscope at home (or the photographic equivalent) to examine, say, a giant water bug. Confrontational images? Sure—but obsessive attention can transcend eccentricity, carrying us poetically into necessary fact. In demanding nothing of us, a water bug can be more like the stars than we might think.

JAYNE IS HER own model for the draped-nude Académie poses. This is because she knows exactly what she's after. As she explains, "When you photograph someone, it's a collaboration, but I knew what I wanted." She's also sensitive to the difficulties involved: "I wouldn't want to do that to anybody—make them sit still for seven minutes."

I like to imagine those 420 seconds (fiction writers find it necessary to stretch out possibilities) in which the subject is transformed. How would this happen differently in a science fiction movie? The camera could speak to her like HAL. In a children's book, every trinket in the house could become animated to help pass the time: fish lamp winking; red marbles rising out of the vase like fire roiling from a volcano.

Holding still for the present, to be seen in the future, while giving a nod to the past ... this responsibility obviously makes me nervous. Is her phone on or off? Does music play? Is anyone else there? Geoffrey Dyer, in his brilliant book *Out of Sheer Rage*, points out that, "in the age of the computer, writers' studios ... increasingly resemble the customer service desk of an ailing small business. The artist's studio, though, is still what it has always been: an erotic space. For the writer the artist's studio is, essentially, a place where women undress." So I have photographer's-studio envy, but while I'm supposed to be good at inventing (the phone *does* ring!), I'm stuck. One's thoughts upon actually disrobing, as opposed to "revealing" oneself on the page? They're too different to make anything except a specious analogy. Understanding a moth's resemblance to the female form, then adding apropriate drapery to define one by way of the other? Much harder to do that and be convincing visually, I think, when—without the malleable protection of words—a succinct image could inherently disintegrate into a joke (see the cover of *Tintypes* for proof that it does not).

Her images—whether of human, animal, or insect—are beautiful, displaying the precision of forms, the expressiveness of some essence as difficult to pinpoint as the soul. The photographer, too, has a delicacy about her: the Merchant Ivory–would–swoon upswept hair; the way she looks intently at something before touching it. When she does extend her hand, however, it is without hesitation: it would be wonderful if the spindly insect climbed onto her finger. But if it does not, she clearly still feels some-

thing of its spirit internally: look at the folds of material in the Académie photographs, her face more often obscured than not (it isn't an insect's *face* we focus on), arms-as-wings, her not fragile body that, cloaked in her compatriot's wings, nevertheless contains the energy for flight.

I HAVE JUST found out that she not only grows lavender, she also knows how to distill it.

Scott McDowell's Painterly Porcelains

House & Garden, 1990

YEARS AGO WHEN I lived in New York, in Chelsea, one of my favorite diversions was to walk to 18th Street and look through the window of Scott McDowell's tiny storefront studio. The work went on in the back, but the little display room was an amazing treasure trove of his porcelain: vases, plates, cups, and, most enticingly, a table set with one-of-a-kind dinnerware that always made me blink because it seemed he had magically invented new colors. The place settings were always beautiful and rarely lacked some whimsical touch. Even the mat underneath the table had been painted—finding a bit of dropped food would have been like searching for a strand of hair on a Jackson Pollock. The Mad Hatter would have sat happily for hours.

I invented an imaginary life for Scott McDowell: he'd been to Carnevale—that explained the multicolored con-

fetti pattern splattering his bowls; he'd been to MoMA—
that explained the Monet-like haze of color on a serving
platter; he ate at the Mexican restaurant around the cor-
ner—the green chili painted on a plate was an homage.

McDowell's pieces reminded me of the night sky. Of
seagrass. Of the inside of a conch shell. Of phosphores-
cence on the ocean. Of a sudden flash of heat lightning.
I thought that the person who created them was a poet. I
tried to join in by letting my imagination take over, inspir-
ing me to metaphors, or by trying to puzzle out the art-
ist's Rorschach splotches. I was looking at an interesting
person's preoccupations, learning from his sense of color,
seeing how much a small gesture could alter a piece. It
was difficult not to stop and examine details: some shapes
looked like cells that had absorbed dye and could be seen
clearly under the microscope; the opalescence glittered
like sun on snow. McDowell was offering an interpreta-
tion of the world.

As you would expect, I bought quite a few of his cre-
ations. I was acquiring a landscape that happened to be
the background of a dinner plate. The vase I put my tulips
in was—like its owner—placid on one side and a little cra-
zier on the other. I thought about the psychology of cer-
tain pieces. Little dramas seemed to be unfolding. Against
a neutral cream-colored background, some shapes moved
unimpeded while others were trapped or caught up in a
complex rhythm. Squiggles would be swallowed by rect-
angles in a contrasting color; a gentle brushstroke of green
paint would speed off, clearing the center of activity, head-
ing for empty space. Many of the pieces are like abstract

paintings yet allude to such archetypal images that strong personal reactions are evoked.

McDowell became interested in color in the late seventies. He began using china paints and luster glazes, he says, "to enliven the surfaces." He was also influenced by the place he lived: Venice, California. When he moved to New York, he lost access to California's glittery natural beauty, but he seems to have retained something of the colors and the feel of the place (though I suppose the state has no patent on pink and orange). His palette also includes the gray-greens and silvery-blues of Seattle, where McDowell lived and worked for three years until last month—he has just returned to New York.

"Now," he says, "the use of texture is more interesting— the way the different marks affect the forms and relate to the more subtle colorings." Increasingly, McDowell's work has taken on a sculptural quality. Regular geometric patterning has ceased to engage him very much; he seems more interested in anomalies and in the antic way certain geometric forms play on a surface. "I try to visually blow the designs to bits and see where the parts fall," says the artist. "The fun of creating the pieces is in seeing what they become rather than in executing an idea."

After slip painting (applying color to very wet clay), McDowell leaves some areas unglazed. When your eye stops at surface variations, you not only see and feel the alterations in color and texture, you notice small brushstrokes and delicate sculpting. As always, the unexpected elements tempt you to move in close, pick up the piece, respond to its inherent motion by moving your finger

around the edge. You become part of the action: yours is the smooth fingertip that touches the smoother square of gold; your eye completes a brushstroke that narrows and pales.

Of course, no one in this Freudian century would deny the intrinsic sexuality of these forms. Okay, I'll say it: one of my favorite pieces, a narrow-footed bowl, enlarges to become quite flared at the top. And there we find a tiny flagellate that has to be an improbably colored red sperm on its way to the womb.

With a commendably childlike daring, the artist has let his own incredulity show in the pieces he has created. He has put on a magic show for us—colors we wouldn't expect to be paired, surfaces that change texture, geometric additions that seem to have arrived as unexpectedly as a butterfly.

There's one more thing: what's inside those jars and bowls. Having considered the exterior, you take a bowl from the shelf to find that your own good sense of aesthetics and your ideas about consistency have enabled you to predict nothing. You will be dazzled by a sudden depth of turquoise. Peeking into the bowl, you'll see flashes of color highlighted with gold—little farewell grace notes for the curious.

McDowell's works display a painterly, impressionistic use of color combined with a sculptor's feel for releasing the inherent sensuality that will enliven the forms. The closer you examine them, the more they radiate great mystery. Which is true of beauty.

We Are Their Mirror,
They Are Ours:

Introduction to Sally Mann's *At Twelve*, 1988

I LOOK AT the eyes. It is as if we are looking at them but they are *seeing* us. Though Sally Mann may have located what seemed to be the appropriate background, asked that an adjustment be made or an object with symbolic connotations moved into the frame, there is no way she could have requested the look in their eyes.

The harder we study these photographs, the more it seems that Mann's subjects are where they should not be. Yet how can one say "should not" when this is the twelve-year-old's environment, when the behavior of the adults is beyond the girl's control, when another washday is as ordinary as the chair in which the girl sits.

Many of the girls look at the camera straight on, happy to appear in their finery or willing to participate in a picture that will be made of them in their world, all judgment aside. Mann must have communicated to the girls that she

wasn't judging them—or, at the very least, that there were no consequences. After all: artists pick up paintbrushes or cameras instead of gavels because pronouncements aren't of primary importance to them. Art is an exploration. And considering the evidence in *At Twelve*, the artist has done a lot of looking around, spent a long time contemplating her subjects. In most cases, it is obvious that the subjects were aware of the photographer and at the same time relaxed. This is quite miraculous. Because young people are great sensors of dishonesty, I have to assume that Mann gained their trust by being very forthright in the way she presented herself. It no doubt worked to her advantage that she was photographing them in their worlds, rather than in a studio. At times, it may have helped that children seem to feel that one thing is not much more important than another: a photograph is just a picture somebody wants to take.

Interpreting photographs is another matter. Anyone who has studied his or her own family snapshots will know that, quite often, some surprising revelation may be found in the studio-like picture of Aunt Mildred, sitting with her hands clasped, and that something mysterious or truly lovely may show up in the quick shot of Uncle Bobby putting the first steak on the barbecue grill. In providing us with something unexpected, twelve-year-olds are no different from adults. But when the girls are photographed, I think we register their postures, self-betrayals, and exuberance differently. While we empathize with their qualities, they are children, after all: we still feel an urge to protect them. While for them looking into a camera lens is anal-

ogous to looking into a mirror, what they mirror for the viewer, with their attitudes and their dead-on eye contact, is us. We are their mirror, they are ours.

When a girl is twelve years old, she often wants—or says she wants—less involvement with adults. It's a pretty hands-off time between parents and children, a time in which the girls yearn for freedom and adults feel their own grip on things becoming a little tenuous as they realize that they have to let their children go. The dynamic changes. But I think the fascination remains the same— the fact that, as a girl grows, the parents have to acknowledge that their little girl is becoming something (not someone) else, and that means they may become something else, too.

In Mann's remarks on the circumstances surrounding these images, we can read much between the lines about why these subjects captivated her attention, and even about how she decided what seemed true and necessary to communicate about the roles the girls are playing midway between the gropings of childhood and the rigors and regrets of adulthood. Twelve-year-old girls know what brought them to the present moment, but that's as far as they've gotten. Their guesses and desires strongly emerge in these photographs. In many, the world of childhood (or the realization that it has been left behind so abruptly) seems very apparent, in others, the girls' comportment seems humorously, or soberingly, adult. In looking so much like us, they can seem parodic or unnerving. In any case, what we see seems so real—so much as though the photographer captured them in a fishbowl—that it rep-

resents a state of awareness that will never be escaped, however it may be altered as time passes.

Most photographers will tell you that they look for significant, rather than ultimate, moments for revelations. In this collection of photographs, we view subjects who, either willingly or without suspecting, have been positioned in blatant or symbolic contexts. But whether the girls have been set in place or quickly captured, their existence retains a certain mystery that is not easily assessed. Sometimes they seem to have been caught off-guard. More often, it's their composure and dignity that seems to make them transcendent. Though standing on a ladder, the dark-haired girl photographed in front of the painting of a Civil War battle gives the illusion of moving quickly past. The photographer could not have anticipated the girl's particular emotion, although she must have been acting on a hunch about how a painting and a particular subject could reflect one another. In this case, the girl's expression seems both vulnerable and formidable. The blurriness makes her ghostlike; she is someone who is about to escape the picture frame, it seems, but she won't escape without having made a significant impression.

While the painting is in a way transformed by the girl's presence, and as a backdrop it may be revelatory of something about the girl, only the unsophisticated could see it as an explanation of her character. Likewise, the girl stretched on the hood of a car, resting behind the word DOOM scrawled in the dust, is stopped by the camera, made prisoner to her situation. Because of proximity, each is understood in terms of some nearby object—but that

painting or car hood is also understood in relation to the girls. My feeling is that rather than coming to know these people in terms of the context in which they are depicted, the context only serves to complicate our response.

In Sally Mann's photographs, everything that we see matters. The photograph of the blonde girl sitting beside the front steps is an example of a portrait changed many times by everything and everyone else included in the frame. Seated apart from the others, the girl on the left knows—or means to assert— that this is *her* portrait. And so it stays, because of and in spite of the others. Though the younger girl sitting on the steps, toes turned inward, thinks that the portrait might as well be hers, and though two others watch the photographer, our eye keeps return-ing to the person whose comportment makes it clear that she is the star of the show. If the out-of-focus leaves of the tree were a curtain that had just risen on a Broadway stage, you could be no clearer about the star, and you could make some quick assumptions about the roles the other characters would play. It's a mystery, that star's quality of straightforward involvement mixed with self-containment (hand draped over the railing, legs parted). The others all seem to be curious, as if the photographer might speak to them or give them some answer, but the girl on the left is not questioning anything. She's decided to give some-thing, and once decided upon there isn't another question to ask. Then our eye begins to observe detail. Whose shoes are they, on the pathway, that seem to have been suddenly abandoned? That person is gone: where and why? As we begin to wonder, our eye will go back repeatedly to the

center of the world we're trying to figure out: the girl on the left, who, always provocative, becomes increasingly enigmatic, the center of attention in spite of the cluster of children on the right or the mystery person who simply stepped out of his shoes and went away.

The details are important. Notice the child's empty car in the photograph of the girl with the wash, and the butterfly net under the arm of the girl lying on the car. Or the corner of the birdcage seen in the portrait-within-a-portrait (two sisters photographed with a framed portrait that depicts a romanticized conception of childhood in days gone by). The confines of these children's worlds must sometimes make them feel claustrophobic (they seem to know that, and even carry props that embody their own entrapment). Butterfly nets, a garden hose that circles the ground like a lasso, and a piece of fabric stretched over a person's chest like a bondage tie may at first glance seem like simple things, but because of our experiences they take on added significance. As adults, we see what the children may not see. We are the ones who have provided them with a particular world, yet we have little control over how they use the props or when they assume our postures. In quite a few of Mann's photographs the obvious leaps out at us: the girl in front of her playhouse, a man behind her, his face obliterated by shadow, towering there as the force of darkness. We quickly realize how intrusive adults can be, that adults can step into a child's world and dwarf it, as the furniture is dwarfed in the photograph. These girls have seen enough of the postures and affectations of adults to approximate or mimic them successfully.

Our response to this is complicated, however, because we see where these acts have gotten us. Is the world in which the girls exist really an innocent world in which a pose is only a pose? Paradoxically, we find that the cumulative effect of these photographs is that the danger is often implied by the adults themselves, whether it is suggested by the seemingly harmless grip of an arm, or in the futility implied by a supportive arm dropped low, enfolding the child on the lap but clearly failing to hold her attention in the adult world.

The obvious risk for the photographer when working with symbols is that the person being photographed may disappear under the weight of the message, though it seems clear that Mann's subjects transcend being understood in merely symbolic terms. Once we label something as symbolic, we are dealing in an abstraction, yet the reality of so many young faces seems so intense, so concrete, and the prints so clear, that we feel sure we have something real before us. Sally Mann acknowledges symbols—even adjusts things to compose the shots—but although we see the connection (the objects and details aren't covert; our eye goes instantly to them), we continue to study the photographs because there still seems to be more vitality to the people in them. The girl with the dark circles under her eyes, backed up against the floral-patterned drapery, wears a dress that is not very pretty, really—more like an odd improvisation on children's flowered dresses—that becomes increasingly strange as we sense that it functions as protective coloration. If it protects her (which is doubtful to begin with, since children suffer the tortures of the

damned when they don't look just like everyone else), we can't imagine how. Pictorially, Mann is expressing a figure of speech: this girl is the person who fades into the wallpaper. But in spite of her attire and the surroundings that nearly subsume her, the eyes have depth. The circles beneath them let us know that much is wrong. So dressed, the child might have vanished if Mann had not stopped to look. Similarly, if you look at the girl standing inside the charmed circle of the garden hose, it seems certain that the photographer saw how perfect the loop was. At the moment of the photograph, though, flanked by boys who either see her as a catch or will eventually see her as a catch, the girl transcends being a person caught in a symbolic situation; hands in her pockets, adopting a casual stance, it's easy to see that she is deliberately facing down the photographer (and by extension, all viewers). An outsider has to wonder what the dynamic will be when the boys, too, move out of their postures and begin to interact with her. We have before us an image that tells us something about what the present moment is in the girl's life, and that makes us imagine her future.

Consider the two girls sitting at the base of a tree that, split and repaired, now looks like a vagina in brick and bark. Though the girls probably did not see the sexual implications of the background, the photographer did, and because of that the viewer cannot help but interpret them in terms of the tree. Their pose is also casual, relaxed, a posture that would not rivet all eyes to their crotches had the girls not been positioned this way. The picture is a set-up, but because we see the symbol so quickly—

because an assessment has already been made—we back off and begin to decide things for ourselves. We study everything more intently than we might have had the tree not initially diverted us. Finally, the girls transcend their proximity to the tree in part because we *want* them to transcend it.

It can be very clear, early on, who'll rise above circumstances and who will not. A sense of humor helps, and looking at some of these photographs we smile, I think, because the subjects who smile for the camera seem to tacitly acknowledge that they are amused by what they're doing. The girl in a formal dress, atop a pedestal, has seen other pictures of beauty queens and knows what pose to take. She knows that she's young, though, and not a real beauty queen: subject and audience are in on this joke together. The pedestal/sundial is too small a surface to allow for anything but a brief moment of glory. As we study her—outdoors, instead of on a runway—we begin to sense the precariousness of her pose, and her vulnerability. Does she suppose that this momentary presentation can prevail in the larger world? Yet it's fun—you can look at her and know she was happy to have her picture taken this way—and she doesn't mind being very open about her looks: a pretty girl, pleasing her audience. The moment before the photograph was taken must have been humorous, and the moment of descent will no doubt be equally tentative, but for the time of the picture the subject and audience are united in suspended disbelief. In some ways, this image seems connected to the photograph of the girl who stands with the bloodstained laundry behind her, stretching a

stocking across her chest. What she seems to be saying to the photographer and audience is: We're both mocking something, right? Is this naughty-but-nice expression what you want? Her face lets us know that she sees there's something amusing and excessive about her pose. It's as though she's asking whether she can taunt us this way and still have us on her side, whether the suggestion of bondage isn't rather appropriate in this context. She might as well be telling us that we're all in this thing—all in this photograph—together.

It seems to me that here, and elsewhere in Mann's photographs, we *are* complicitous. We look back to childhood wanting to see aspects of ourselves that we might have forgotten, repressed, or abandoned, yet often what we see is not an ideal childhood, but a world typified by stains on the sheets. The horse's legs were broken, or our faces registered the shadows of broken glass. Or at times, exhilarated, we cast shadows as if, standing at the base of a tree, we stood at the beginning of a rainbow and it rose right out of our heads.

Sally Mann's photographs don't glamorize the world, but they don't make it into something more unpleasant than it is, either. Childhood and adolescence are resonant, significant, and sometimes symbolic—yet she never gives us the idea that her subjects can be relegated to operatives in some myth that can easily be contained in the moment. In their routines and parodies, they are far more complex. We will be amused and a little uneasy to see the narcissistic rapture exhibited by the girl with the billowing, pseudo-wedding veil, clasping the phallic bottle of

Tab to her body. In many cases, we may wish that these moments would endure and be frustrated to realize that they will not. Other times what we see—the girl on the bed, her own infant beside her and her toy doll collection shelved—may be too painful, too much of the real world, to willingly confront. In all cases, though, the undeniable physicality of these girls overpowers the viewer. In these photographs we see so many expectant faces, so much preening, so many long legs parted or prancing or drawn in to the chest for protection, that it would be wonderful if we could reach out and touch the girls who are so real. Their worlds have become still for the moment of the photograph, stopped long enough for us to really consider them. Yet time after time any impulse to interact with them is blocked. Their demeanor stops us: we're made uncomfortable as we consider intruding in anyone else's rapturous trance. In some instances, the girls have so much self-containment that we hesitate, reluctant to move forward; in others, they are laughing, in control of the joke.

There are many ways to consider these photographs. They are, I believe, cautionary. Images are not answers. Yet, like shadows, photographs do tie things together. Consider the two sisters, lounging with a painting of old-fashioned girls, the present-day world and the world of the past made contiguous by shadow. Or the patterns made by light and dark in the photograph of the girl standing on the hanging bridge, the stream of sunlight illuminating her on life's path, which is, in childhood and adulthood, suspended over fast-moving water. Those moments that

make us pause can allow us to make sense of things, sometimes, just as fast as the camera lens clicks.

Though the girls are shown vulnerable in their youthfulness—even victimized in some instances—the photographer is interested in the strength they possess. They will look hard at the camera because they're used to looking hard at people and things, and because they're already quite accustomed to intruders. Some of them are privileged and some are survivors, but in all cases: the photographer has had to make a split-second decision to capture the moment when the subject has done something truly revelatory. If the photographer is right, then the limitations of the orchestrated moment will have been overcome. That, it seems, is the exhilirating moment for all artists.

Richard Rew's Sculpture

The New Yorker, 1982

THE TENTH AVENUE Bar has been open for more than a year, and in that time it has acquired a loyal following. It's part gallery, part restaurant; our guess is that it's the only place in New York where you can eat herb gnocchi and look at an exhibit called "The Bad Light Photography Show." We met some friends there the other night and had herb gnocchi for dinner. Chip, the waiter, sometimes simply refuses to bring the same dinner two nights in a row, but it turned out that none of us had been there for days. He brought the food without protest. (Also, Patsy Cline was singing "Crazy" on the jukebox; if anything is capable of distracting Chip—and that is debatable—it's probably the fiftieth spin of "Crazy.")

Editor's Note: When this piece was published in 1982, Talk of the Town pieces were unsigned, and writers were expected to use first person plural.

A few days later, when we wandered past, we saw that another show was going up: sculpture by Richard Rew, the same young artist who had a show there a year ago. That piece, a hundred and sixty-five upside-down aluminum figures hanging over the bar, was originally titled "Discharged G.I. Joes Confront Unwed Barbie Dolls," but he later changed the title. (Interesting that before the new owners bought the building it was called the Strap, and whips and chains hung from the ceiling.)

The idea of working with aluminum came to Richard Rew when he was a student in Iowa. In 1977, he became interested, sculpturally, in TV-dinner trays. He got in touch with the chairman of the board of Campbell Soup (they make Swanson frozen foods), and soon he was at a Campbell plant in Camden, New Jersey, and sheets of aluminum were being shipped to him back in Iowa. Now, five years later, Rew, holding one of a lot of little flat pieces of burnished, cut, shaped aluminum that looked something like a fossil, talked about how he made them, in the same uninflected voice a surgeon would use to describe how an operation was to be performed: first you make the creases with a burnisher, then you do the spine, then "you fly the thing over . . ." But we'd forgotten the technicalities by the time we returned that night for the opening of "Sink A." Stapled to the ceiling, the little pieces looked like crinkly, deflated spacemen all in a row. We could easily have believed that they were being dropped from heaven, if it weren't for the regularity of their arrangement.

Bill, one of the owners of the Tenth Avenue Bar, had on a three-piece pinstriped suit. At first, we thought it was

part of the new propriety. (When tablecloths appeared in the dining room, quite a few of the regulars were surprised; we suspected that someone must be taking magic lessons, and that at some point during our meal the cloth would be pulled out, leaving our plates and glasses in place.) It wasn't part of the new propriety: Bill had just gotten back from his grandmother's funeral. Little Richard was squealing on the jukebox. The people at the bar were having a good time, and the sculpture above them was attracting more attention than, say, a chandelier would. A lot of the people at the bar looked like test patterns: black-and-white-checked T-shirts, or T-shirts with horizontal black stripes. The people were all very neat and geometric. Above them, the sculpture sparkled so much that it gave the illusion of movement. We asked Richard Rew what he did with the pieces that didn't sell. He shrugged. He said that he put them on his ceiling: "The ceiling is the last frontier."

Grant Wood Country:
A Return to the Iowa
of the Famed Painter

Life, 1983

COMING INTO CEDAR Rapids, Iowa, by plane, you see
endless geometric patterns in green and brown. The sur-
prise is that on the ground they stay the same: Except
for the flight of blackbirds that startles you with the
sudden burst of red on the wing as they fly up unexpect-
edly,there are acres of land that look as if they have been
arranged by an obsessive-compulsive wielding a com-
pass and ruler. The sky is vast, unobstructed by moun-
tains and trees: the eye searches in vain for a vanishing
point that is something other than the end of a highway.
Because there is so much sky, there is an even light; you
begin to notice gradations of color because this world is
an endless permutation of green and brown. You don't
see large shadows: you spot small patches of darkened
ground beside an occasional clump of trees or cast by
the angle of a house or a piece of equipment. Outside the

city of Cedar Rapids, as few people walk around as stroll
the lawns of Beverly Hills.

For many, Iowa—or all Middle America—will always
be defined by Grant Wood's *American Gothic*, a much mis-
understood painting that became famous after winning a
bronze medal and a three-hundred-dollar prize from the
Art Institute of Chicago in 1930. Grant Wood intended
to portray a farmer and his daughter, but people often
assume that the painting depicts a man and wife. Or, re-
acting to the stern looks and mistaking the tall vertical
house in the background for a church, they suppose the
man is a minister. Whatever they assume, they know the
image: a nearly bald man, pitchfork in hand, facing for-
ward; a young woman, hair pulled back, whose face shows
tightness at the mouth and between the brows, looking
to the side. The models were Wood's sister, Nan, and the
family dentist, Byron H. McKeeby. The painting of the
austere couple has aroused almost as much interest as has
the mysterious *Mona Lisa*.

The man who painted it was born in 1891. He grew up
on a farm outside Anamosa and moved to Cedar Rapids
with his mother and sister when his father died and he was
ten. He had a keen memory and an interest in art early
on. His sister says that he could remember the configura-
tions of insects' wings. Grant Wood thought, as a young
man, that he should go to Europe to study art, but after
a trip abroad he decided that the real task for him would
be to deal with the Midwesterners and the landscape he
knew best. In an unpublished biography by his longtime
friend Park Rinard, Wood said: "Alexander, Caesar, Napo-

leon, you all had your great moments, but you never tasted the supreme triumph; you were never a farm boy riding in from the fields on a bulging rack of new-mown hay."

Today a farm boy can still jump on top of a hay wagon, but it's not a scene you notice as you drive from the site of *American Gothic*, in Eldon, to Cedar Rapids. You wonder what Grant Wood would make of the TV antennas on top of the house he used as the background for his painting, or of all the white, saucer-shaped satellite disks tipped toward the vast blue sky in fields they share with windmills. (Wood often painted windmills; one is visible in his self-portrait, and when you begin to know the man—his practical, common-sense approach to things and his love of fun—it's easy to see that windmills captured his attention not only because they were abundant, but also because they are at once mechanical and magical.)

Once a year, in June, there is a day in Eldon to honor Grant Wood. People gather on the front lawn of what a hand-lettered sign tacked to a tree now reads simply GOTHIC HOUSE. It is, surprisingly, summer-cottage small. On the day of the celebration, the tenants are nowhere in sight, but their roof is taken over by the young Eldon Pirates ball team. Dogs that will later appear in the parade run around dressed in crinkled clown collars and an approximation of a baseball uniform. Donna Garber, a young woman who grew up in Eldon, wears a homemade version of the dress Nan Wood Graham wore in *American Gothic* and remembers playing in the deserted house when she was a child, having no idea it ever appeared in a painting.

Nan Wood Graham is also present, holding a pitchfork and wearing a sun-yellow suit she, too, sewed by hand. She never even saw the house until a few years ago. Her brother painted the background separately. She posed for him, more than fifty years ago. in a studio. There was no man standing beside her. Dr. McKeeby was painted in other sessions, after he had finished work for the day and before he went out to speed around town in his red sports car.

Nan Wood Graham says of her image: "I didn't hate it. Some people say I hated it, but I didn't hate it; it just made me feel kind of sheepish when people would snicker." She says that her brother deliberately changed her face in the painting so she wouldn't be recognizable and also painted what is now titled *Portrait of Nan* to thank her for posing. She also thinks she knows the woman whose face was an inspiration for *American Gothic*: someone in the community who pestered Grant Wood to paint her ("she was ugly") and then sell the portrait and split the profits with her.

Nan Wood Graham and her brother were always close. Until her marriage, she and her mother lived with him in a small house behind the Turner Mortuary in Cedar Rapids. She remembers the three of them leading a rather quiet, happy life; Grant was industrious, charming, and patriotic. Some of the "representational U.S. art" that *Time* magazine praised him for painting in 1934 was once so convincingly representational that he fooled the community. To raise money for Victory bonds during World War I he made a model of the Liberty Bell to sit outside a booth where the bonds were to be sold. It was wood covered with canvas

sewn by Nan and painted bronze, with a dark streak for the crack. When it was transported through town, it was mistaken for the real Liberty Bell, until it started to rain. Some people had umbrellas, and when they poked it, they found that it wasn't what they thought.

Grant Wood considered himself a member of the community and cared what people thought about him. He occasionally worked from photographs and worried that he would be thought a mere photographic chronicler. (It is interesting to note that photographer Alfred Stieglitz had already done some of his finest chronicling by that time.) Nan Wood Graham remembers that her brother once planned to do a painting of a man about to take a bath in a washtub, dressed in red flannel underwear. Wood had trouble locating the underwear and advertised for it in the Cedar Rapids and Minneapolis newspapers. Nan says, "The first of the cartoons started. It was Grant looking for the red flannel underwear. The local J.C. Penney store dyed some long johns bright red and printed an ad under a headline asking, 'Is this the underwear Grant Wood is looking for?'" When he was accused of having placed the ad for publicity, he decided not to do the painting. (Nan Wood Graham, too, has been sensitive to a few things. She has instigated several lawsuits that have been settled out of court over parodies of *American Gothic*; she now has a suit pending against *Hustler* for an undressed version.)

More out of community spirit than salesmanship, Grant Wood invited some people in Cedar Rapids to see *American Gothic* before it made the journey to Chicago.

Gordon Fennell, a handsome, indefatigable man in his eighties who still lives in Cedar Rapids, remembers going to the Art Center for the unveiling. While he admired Grant Wood and still does (he owns many paintings), he doesn't remember what Wood said. "I'm embarrassed to say I don't," Fennell says. "I wasn't really listening. Maybe my wife made me go or something."

Wood's life was often a struggle, but he had enough boosters in Cedar Rapids to make a struggling artist envious today. David Turner, who owned the mortuary, had Grant Wood move into a carriage house behind the business. Esther Armstrong, who once heard Wood speak about the importance of things indigenous to a region and his decision to paint the things he knew best, asked him to help her design the Armstrong home and acquire appropriate furniture. Her husband, Robert Armstrong, who owns the Armstrong's department store, asked Wood to design the window displays. Years later, during the Depression, Wood made lithographs of his work and his sister and her husband hand-colored them. He had a flexibility that helped people help him: He could teach, design, organize (the art colony he started at Stone City was in some ways a version of contemporary artists gatherings like the MacDowell Colony), and he wasn't above working on commission. Gordon Fennell's account of the painter's life brings to mind a Norman Rockwell world: Wood had a fireplace in the house at Turner's alley and enjoyed having people in for weenie roasts; he attended play rehearsals of the community theater at night and helped paint scenery.

Like Thomas Jefferson and Ben Franklin, Wood was a practical man with a sense of humor: He designed a wooden arm to extend out the windows of his car to give directional signals so he could keep his own arm warm in the winter. And when the Hubbard Ice Co. was retiring its trucks, he acquired them for painters to sleep in at the Stone City Art Colony. The serviceable wagons were put in a circle, but there were no Indians to guard against: it was only a WPA-like show of solidarity. On the 1923 trip to Paris with high school friend and fellow painter Marvin Cone, their canvases were stretched just the size to fit perfectly into Cone's footlocker.

The Cedar Rapids that Grant Wood knew has not entirely vanished. Armstrong's department store is still there, and one window was recently filled with cardboard cutouts of cavorting cats and signs announcing amusing alliterative information: "What's New Pussycat? ... the fit, the flare, and the freedom that's essential. ..." Close to the store, downtown, buildings are boarded up or being demolished, but on streets running perpendicular to First Street, you find quiet suburban living. Inside the houses people live comfortably, without pretension. You feel a kind of sane acknowledgment that times have changed but that the newer world can easily be integrated into the old. Marvin Cone's widow, Winifred, has hung, waist-high in one room, a small Grant Wood portrait of her husband. Not far away is Cone's self-portrait with that same Grant Wood painting as its background. Winifred Cone remembers meeting her husband-to-be and Grant Wood aboard ship when the two men were returning from

their painting expedition to Paris. Cone had a mustache and Grant Wood a red beard. "We thought they might be Finns." she laughs. "They were just plain Americans."

Many "plain Americans" do not know the name Grant Wood, but they know *American Gothic.* The title, too. might be forgotten, but they do not forget the sensibility of the painter. It is easily recognizable. It is rooted in and includes the dichotomies of the American character. Wood was a modest man (not as modest as the couple in the painting—but then, they weren't what they seemed either); he managed to find ways to stay alive in hard times while still being a genuine artist. He had many talents, was liked by the community, had a sense of humor and, quite unexpectedly, did something that suddenly made him famous. It might have been the American Dream come true, except that it made him famous without making him rich. The Stone City Art Colony lasted only two summers. He painted for a while on commission, then moved to Iowa City to teach at a time when regionalism was considered by some of the faculty to be, at best, unsophisticated, and he endured some severe criticism.

He married when he was in his forties, and people are still baffled about what attracted Grant Wood to Sara Maxon, a woman whom some describe as rather flamboyant in her personal life ("*No one wore purple pajamas*") and often lavish about spending Wood's money. People in Cedar Rapids still haven't figured out the three-year marriage and look around uneasily when they discuss it, as if the mystery is still right next door, waiting to be solved.

His friend the poet Paul Engle (who was famous early on himself for *American Song* and who says, "Grant and

I invented the Iowa wheel separately") remembers that Wood was much amused by a joke in which one hobo tells another that he's going to dream about a beautiful woman. "Wouldn't you rather *have* a beautiful woman?" the other hobo asks. With a mixture of being savvy but still sad about what hurts, the hobo replies, "As a hobo, I'll have a better one by dreaming."

Wood's mother lived with him until her death. He painted both his sister and his mother in inconspicuous, dark-colored clothes adorned with the same brooch at the neck. Some of the things he omitted from his art are as interesting as the ones he included: Driving through Iowa, you can't help noticing the purple iris and roses and, most of all, the huge peonies—bushes so heavy with flowers that the stalks pour toward the ground like a fountain. "I guess Grant thought ladies painted flowers," Nan Wood Graham says. In *Woman with Plants*, Wood's mother holds a sansevieria (common name: snake plant). The same plant is visible, barely, in *American Gothic*, behind the woman.

When Nan Wood Graham is asked what she thinks her life might have been like if she hadn't been Grant Wood's sister, she says that if her father had lived, the family would undoubtedly have stayed on their farm outside Anamosa. Because her mother sold the farm and moved to Cedar Rapids after her husband's death in order to be close to her own father, Grant Wood had the opportunity to be taught by good teachers, and he was encouraged to create his art. "I probably would have been a farmer's wife," Nan Wood Graham says, "but Grant would still have been Grant. I believe in destiny."

Simpatico in Southbury, Connecticut: Georgia Sheron's Photographs

Introduction to
Uncle John: Portraits of a True Yankee Farmer, 2013

WOULD SHE ROLL her eyes about my saying this? I met her when we were with the band. I thought she was very cool. Now, almost forty years later, I'm completely convinced. When she's photographing, it's like watching a swimmer slide into the water or a race-car driver climb into the car. But those aren't very good analogies, because while she's just as intense, she also often laughs—at things that are inherently funny, at things that have arranged themselves to be funny, at things she has arranged to be funny (she recently sent me a photograph of a still life on her back porch, taken by bug light). She smiles at herself for making a silly mistake (wrong lens; crazy setting), at her subject if he or she cracks a good joke (even when concentrating, she's open to distraction; also, she's always rooting for you). She's also amused, especially amused, when a person is experiencing a moment of High Seriousness.

She's the other prong of the tuning fork, and sometimes it's the hand of fate that gives it a flick. She's up for things, high energy, her curiosity and intelligence obvious.

Photography, of course, has changed since she started out. Everything's changed: digital cameras (though that's not primarily what she uses; the photographs in this book were taken by available light with a Nikon F and a normal lens. Five years into the project she added a wide-angle and telephoto lens and a handheld light meter). Beloved photographic papers are no longer manufactured; there are new papers for ink-jet printing; black-and-white photography has its devoted following, but most of the time people expect, photographers expect, color pushed to the max. So, in a way, there's a similarity she shares with her longtime subject, John Ludorf: the world changed, but dedicated, passionate people just keep going. Her heart is in it. It's a different beast now, photography; even cameras have a different body—but for the individual, hey: your heart's your heart. Georgia Sheron has never doubted who and what she loves. She's married to the guitar player. She was photographing then, she's photographing now.

WHAT EXTRAORDINARY WORK, so recognizably hers. Ansel Adams also photographed landscapes and the most ordinary of ordinary things, bread. He's not famous for chronicling the mundane, and those photographs were early work, done because photography was work, no different from Andy Warhol starting out by doing illustrations, or

maybe baby Mozart singing to himself in his crib. This is what so many photographers have done: they've photographed what they've been obliged to photograph; they've simply taken pictures of what's in front of them. Margaret Bourke-White photographed buildings at Cornell because she was young, and she was there; when she could call her own shots (so to speak), she remained riveted to the world as it was: the outbreak of war; the construction of a New York state highway system. She could suggest things to *Life* magazine, but she wasn't averse to the magazine suggesting things to her. Or to fate suggesting them.

As with all other art, we might not know our past or anticipate our future the same way, if some artist hadn't stopped time, or given the illusion of doing that; if someone hadn't engaged with a subject or a region or whatever they partially made their own by expending their personal time, so that some record came to exist—in writing, photography, painting—of a world, a moment, a second (photography's advantage over painting) that would otherwise have passed us by. "Uncle John" happened to be Georgia's neighbor in Southbury, Connecticut. The land was there, the tasks were implied (though not the method required to do them), and one man was quite busy for a very long time, as you will see. Not only did Georgia make a visual record of John at his daily tasks and pleasures, she asked some questions, and his responses are well worth noting. America loves iconoclasts. Who wouldn't approve when he tells Georgia, "I didn't draw up any plans for this machine [the thresher]. I had it figured out in my own mind. If I build something for myself, I dont need a plan. I carry

it in my head and know just what I want to do and that's the way I do it." I smile, but I'm also impressed, because so often people announce what they would do, could do— though they don't actually do it. The John we see in these photographs can do a lot of things. It doesn't make him a hero, but he's not just a talker, not a procrastinator, either. Nor is the photographer, whose shadow—or maybe sunshiny presence—informs these photographs. The two were clearly in sync. Maybe not always, but as often as necessary and then some. As we all know, when someone takes an interest in us, we tend to be interested in why they're interested. I didn't know Georgia when she started making this amazing document, but I'm sure John Ludorf was flattered and also intrigued. With or without her validation, though, it seems obvious he would have continued farming. Could he have suspected, then, that we'd be as fascinated by the past as by dystopian visions? But aren't we?

A PREEMPTIVE STRIKE: there's no such thing as "daily life," though the cliché exists for a reason. It's shorthand for the part representing the whole, and that's apparently a consoling notion to many people, including lazy people. I've never met a serious artist who thought he or she was representing "daily life," however. Those who observe it are humbled, if they don't start out already humble. It seems endlessly mutable, variable, unpredictable (often even in retrospect), longer or shorter depending on how everyone experiences time. We've agreed there are twenty-four

hours in a day, but that only gives us some basic guidance: one person thinks lunch should be at noontime, another at two o'clock; someone else is "a morning person," though morning may refer to dawn or to ten a.m. We live in our own worlds with our own inner clocks. Enter Georgia Sheron, who is here to tell us that moment by moment, life is exquisitely particular and that much of its beauty is to be found incrementally: there can be beauty in tedium, and vice versa. That there is a confluence between man and landscape that is sometimes humanizing, sometimes alienating. Or cautionary. Or exasperating. That people get lost in landscape, but other times landscape unexpectedly defines or energizes us. Figuration can tend toward abstraction; the opposite is true as well.

I love the way certain photographs overwhelm with the sheer immediacy and vastness of the terrain, so that it takes a few moments to realize there's a tiny person there. In other photographs, we're persuaded to perceive the way the photographer does: John's spread fingers are not so very different from the splayed branches of the towering tree; his veins are only the living version of the shape he holds. Similarly, we can be so attentive to the wrinkles in a person's skin that it takes us some time to realize that while the details are mesmerizing, while the foreground can seem to carry all meaning, the background also matters. I'm being metaphoric, I'm personifying, but in one photograph it seems like windows in the side of a barn look back at us with the blackness of their eyes: we see John entering a structure; that inanimate object looks back at us.

However energy-expending the activity being observed, the photographs are in focus (or meant to be in soft focus), stilled, which gives us the advantage of examining something that might ordinarily be recognizable, though not an inherently fascinating, incremental moment of that activity. (Muybridge, of course, showed us how action unfolded. What we saw simultaneously demystified the process while it also created greater mysteries.) But most of us aren't as familiar with the activities of someone farming as we are with glancing at a farmer or his herd or his orchard in the distance; that's paradoxically rather exotic (as was Muybridge's chronicle of how a horse ran), now that so few of us live because of our own resources. The instants in the book have been preselected, obviously, but I'm guessing few of us know someone like Uncle John, and that if we do, we know even less about their methods. Also, at the same time the viewer is discovering that everything exists specifically, the import of the photographs nevertheless speaks to the larger world. Inevitably, the viewer also comes to gradually imagine the photographer's story and involvement (this isn't Zeus's view, after all): Why did she want to give us this moment? Photographers take lots of pictures: Why this composition rather than the slightly altered possibility embodied in the next photograph? Yes, we saw his hands embracing the cup (or his fingers on the fiddle) before. What to make of the pattern on the tablecloth in a similar photograph (what to make of the fiddle held vertically—Man Ray saw the cello as the female form it clearly is)—as opposed to being held in the familiar way,

utilized? In some cases, we can read notes, or be lucky to see the outtakes or the alternative possibilities, or even to ask the photographer a question. Still, whatever they say remains their story. We have to figure out our own. As with book titles, which are often lucky accidents, something that asserts one thing over another also limits. It's easy to get a general consensus now that *The Great Gatsby* is a perfect title, or that *Catch-22* was a very good idea of Joseph Heller's editor, but certainly some of that is because those works have come to mean so much to us; we've spoken their names so often, the title has come to seem inevitable (research tells us this was never so).

A title implies, or gradually comes to imply, a way to read the text. Photo captions don't guide us in the same way, but are usually restrained to the point of making facts absurd (year; locale). But doesn't that factuality sometimes make us come up with more interpretations, with stories that resonate with us individually?

Every photographer asks us to look; whether or not we make a metaphor or hear a soundtrack (you can't stop people from doing this), we're primarily encouraged to be responsive as observers. Advantage: we're asked to stop hurrying, to really use our eyes. Disadvantage: we don't have a lot of experience with that; we tend to use our eyes more for navigation than delectation. Our eyes don't dare bore holes, so it might take us some time to see what's right in front of us.

Sometimes tone is difficult to hear when disembodied—I mean, when one piece is removed from the others that surround it. I've had the experience of hearing writers read aloud, even those times their prose is relatively un-

inflected, when the synergy of person and material sparks and the audience gets it and feels comfortable enough to laugh at the right moment while hearing a very dire story by Raymond Carver, for example.

Tone also exists in photography, and it might be even more difficult to pick up because the subjects can seem to be determining it, rather than the photographer's perspective and sensibility intervening in a way that is interpretive. Terroir explains the many variables that go into a wine's quality—the minerals in the ground, the kind of grape, whether the weather was dry or rainy that year, whether the growers were in good or bad moods, or chose to wear hats or Ray-Bans, I suppose. It's a good term because (ah, the French!) it can include so many variables. The wine contains people's narratives: Oh, that was the year of the mistral; well, at that vineyard the wife ran away with the cook and her husband gathered the grapes days too late. I'm joking (a little; I have to listen to this stuff), but I do believe that we don't always want facts so much as we want plausible explanations. As with the growing of grapes, many things contribute to our understanding of the world, some we can figure out, some we can't. Life is shaped by forces that can't all be controlled (one of the reasons for drinking wine). I sense the same dynamic going on in Georgia's photographs, some of the variables allowed to be seen (the safety pin on John's jacket), once noted (it's a safety pin), given reverential attention to the point of suggesting the sacred. In one photograph, we see the branch sprouting new growth that might make the fruit better because of man's intervention. John wanted tastier fruit, so

he grafted the flavorful onto the lackluster. But I don't see the photograph as being about his intentions. Instead, it's a presentation of practicality that contains a wish within. I also notice the loveliness of his marred fingernail, the old man's fleshy fingers, in contrast with the sturdy little upright shoots that exude their own volition. And that herringbone suit! A fabric meant to echo the bones of a fish, worn by this land-lover, so conventional it barely deserves mention, except that a real individual—one without vanity, or sense of fashion—wears it.

Sometimes in these photographs we can see that one particular day, subject and photographer were in silly moods and connected a bit differently than they did the day before. Or that the photographer must have been so bedazzled by the rectangles of light falling on her subject as he played his musical instrument that everything receded in importance, eclipsed by the patterns made by light.

Georgia is always discovering. She's often delighted, stunned by either the perfection or the imperfection of an expression, or by an inanimate object. She needs that camera. I have many times observed her arranging things— what artist does not intrude, at least slightly? And does that make a thing untrue?—though she has no scenario for that curious concept "daily life," let alone any proclivity toward orchestrating the diorama that might represent it. When she reaches out, it's to alter small things, to arrange a detail; fruit on a table (tilting the peach toward her), a scarf wound into a loose coil (the most beautiful whorled serpent in the world); a strand of her subject's hair (my own; but having been her subject allows me to say that she

has such graceful gestures, you can mistake her tiny touch for your own impulse).

Here, she's tackling big things: life as an individual lives it; life as she must always have worried would inevitably vanish, even as she lived it, at so little remove, even as it was so precious and so beautiful it couldn't be true forever. It is in this context that she has viewed John, here that she's considered someone's complexities and contradictions (or equally affecting consistencies). There is variance, though, between John tossing logs and John transporting logs. In rhe first photograph, we're observing a typical moment in John's day. The picture communicates easily. Upon further study, though, we might see what the photographer observed: a house whose windows in the background overlook the logs stacked on the open truck bed. There at first appears to be such regularity to everything, it's easy to miss the many shapes of triangles, present between John's legs, seen again between the logs he's tossing, visible as negative shapes in the trees between branches, and even in the logs themselves, one pointing like a Post-it note saying take note of this, sign here: it comes in just after the first bottom log on the left and points us right at John. There is, of course, also the white dog, viewing everything, looking both at John and at the viewer, who looks from the opposite perspective. The dog has stopped because of interest, curiosity. We don't exactly see ourselves mirrored (though I don't mind comparing myself to a dog, personally), but John gets caught in the ricochet gazes between dog and viewer. Though we're implicitly asked to look at the middle distance, it's the dog that keeps us there. And

it's the sole of John's shoe that, foot tilted onto the toes, lets us see the last point of John's body: above, the arms express energy; below, the small black shape defines the necessary balance of that forward motion. I notice that in many instances, John acts either as a fulcrum or as a figure involved in something analogous to a ballet, in which one's distribution of weight is crucial to achieving the desired movements. If, by extension, he's sometimes the center of the caduceus, that's great. We need that anchor.

Georgia was so simpatico with her "Uncle John." As you'll discover, he answers one of her questions by saying that when you plow with horses, "it seems as though you're really doing something a little greater than you would do with a tractor." That would have to be because horses are animals, not machines; because mutual effort counts for something, even if your partner is a horse (we could do far worse). John Ludorf would of course prefer interacting with the horse, and his chronicler would of course prefer interacting with someone who dedicated a good measure of his faith to himself. In his actions, in his comments on what he's undertaking, his modesty is apparent, but his competence, his strength, and his self-reliance seem almost amazingly entrenched. The opposite of narcissism, his way of thinking was Puritan-practical, at the same time it was rooted in Emersonian possibility.

Georgia doesn't judge or intrude on her subject, or on the world in which he moves (so often seen from afar, providing the long view, the bigger picture), though she refrains from conjuring up any other world, any purely subjective world, as she works.

LOOK AT JOHN throwing logs onto a flatbed and John seen from behind, driving away. Both inform us and give us a perspective on the man, the task, and the larger world in which this all takes place. (I don't know what happened to his dangling license plate, by the way.) We need the detail in order to extrapolate the larger picture. When we assess the enormity of the world that he navigates, we also yearn for the detail that particularizes. Like eyes, the pale bottoms of the logs look back at us and acknowledge tension as the subject recedes. What he's going toward seems familiar, amorphous yet luminous. These logs have been cut for a reason, and that reason unites him with what he approaches. But where are we? We might as well be cans tied to the bumper of the wedding car. The chain saw gives us the one written word in the image and also provides a kind of barrier that delineates the logs and the man and the vehicle from the passive observer. Nothing about this photograph says Hop Aboard. Rather, it moves heavily but surely in front of us, and there's no way to catch it. In the moment of the photograph, the world that will become more specific as John enters it remains an indistinct shape in the distance. Everything has been seen and altered by the photographer, who has composed the picture by making a rectangle within the larger rectangle (from the tree at the left, above John's head with the thin horizontal line, down the right side to the truck bed, which echoes the photograph's edge). It's like Mondrian.

I'm also drawn to whatever it is that curves away from John in a photo that reminds me of the Loch Ness monster, though that's always blurrily photographed. I don't want to know what it is, because I understand that the gesture the curving metal makes directs my attention with a different rhythm toward the left side of the photograph, implying that the eye should move away from what it means to consider: John doing his work, the telephone lines horizontal, his work laid out before him, everything offering a way to read from left to right (as we do with texts). Yet the dark curve interrupts our sense of harmony and order, as does the white board on the diagonal, directing our attention to the photograph's lower-right corner. Move top left? Bottom right? It's only a photograph, only one view, though significantly, the subject would never experience it as we do. He's looking straight ahead, determined to do what he's doing, while we're acknowledged as participating in a different "picture" in which we could animatedly curve away or go down the slide and exit picture right. He's somewhat like a fulcrum here, everything horizontal and balanced, as if his hands delineate the limits of their own little world, as if they have their own imperative.

John is revealed in distinctly different views. In one he seems to be moving, sitting upright, his large, pale hand remarkable as he steers the tractor wheel. But there's that safety pin, set on the diagonal; there's the tilted hand, echoing its motion. We might wonder: what's there, to the right, where our eye is subtly carried? More of the same, perhaps. The photograph, though, makes us do work, just as the subject does. Every detail makes us look into things

(through the wheel; here, it could be analogous to looking through the camera lens). The shadows on his pants echo the horizontality of the background. His large ear seems especially alert, his fingers also. His right hand tells one story (it's at rest. It seems relaxed), while his left hand is in control. We make an adjustment to accommodate facial asymmetry, but here we have to make a similar adjustment for his hands. Whether they embody paradox or you view them as more harmonious, though with different degrees of tension and purpose, and rectify the image—it's up to you. In the next view we see John from the side, on the same vehicle. Here, though, his head isn't exposed, with only the vast sky for backdrop; he's wearing his cap, his ear less pronounced, the safety pin less noticeable, his hands seeming less at odds, doing the same thing. But instead of the sky, we have a near explosion of tiny branches behind him, nature's sparkler shooting off, detail and fragility contrasted with purpose and forward momentum. Consider these sparkling branches as unframed, unlimited nature, then see what John is trying to do: to give form, human purpose and productivity to this wildness. He sits in his tractor, bringing this order, as Georgia lets him bring order to her rectangle. John forms a perfect square, up the steering wheel, across his right arm, down his left, to his left leg. Nothing about him departs radically from this rectilinear pattern. Yes, his hat is tipped horizontally, his jacket forms a graceful arabesque, but photographer and farmer share an ordering intention. This photograph also gives us information we didn't have when we looked at him more straightforwardly. That patch on his pant leg!

A hole in the fabric not subtly mended, but practically remedied. Below it is his skin, we can't help thinking. He would be exposed if the area hadn't been mended. So there we all go, right? We're generally (mercifully) unaware of little imperfections that belie our vulnerability. We live amid backdrops we don't notice, and we could be viewed as proceeding into a dream that will only come into sharper focus as we come closer to our mortality. In this moment, a vast but vague future lies in front of John, and us, as well. The camera lens can't reveal its real depth, so for a while the distance is recognizable but vague, unremarkable. Nevertheless, what surrounds us means that we act in conjunction with, or exist in tension with, a kind of stage set painted by someone else, which will alter the emotional tenor of our actions, however convincingly we try to act.

John is sometimes the fulcrum personified, as in a photo of him placing a rail atop others to build a fence. The top of his hat is almost as flat as the wood itself. The lines in the fabric of his shirt, the placement of his arms—it's dance. Above him, compositionally interesting but interpretive as well, dark leaves encroach a little ominously, and the slightly bleached-out background holds little interest. The eye could wander away, except that we know one does not place such a big piece of wood without great concentration, so we're inclined to do John the service of understanding that he's entirely focused and that, therefore, we should be as well. And then it comes into focus: in the left foreground there's a cross, formed partially by the narrow base of a tree, partly by the long piece of wood John is

placing. The lens compresses the distance. The mind races. John will never know this (unless he similarly reflects on it). Once seen—even though it is not a mere symbol, and the meaning of the photograph does not reside in it—the cross insists on its place in our understanding, as the white dog watches transfixed, as the long, dark vertical retinal windows of the barn stare back when John moves toward its interior.

Here we have the world without irony. Irony always gets to trump vulnerability. It's always cooler, less discomfiting. It's also overused, contrived. Here, with irony banished, the humor and the strangeness remain, and awkwardness takes on a kind of loveliness. That's one of the things Georgia is doing here: using the known world as a point of departure to ask questions by seeming to accept what is. She's the clever girl detective, on the case—a constant observer in sensible shoes, carrying a camera almost as heavy as one of Uncle John's logs—who believes the past speaks to our future as inevitably as a shooting star speaks to the sky.

Questioning the Quotidian:
Trisha Orr's Paintings

TRISHA AND I met in 1975, in Charlottesville, Virginia. Neither of us had focused very clearly on careers; barely at the far side of hippiedom, we didn't even think in such restrictive terms. An interesting experience, to know an artist well and then to see her way of seeing the world.

Through the years, Orr (formerly a photographer) has painted many subjects, from achingly beautiful portraits of individual seashells to flower arrangements that would have intrigued de Heem (updated, with Matisse lurking in the background). Fascinated by easily identifiable, seemingly simple forms, she painted their inner complexity for years, then—like the shell collector she has always been—came to create what is perhaps her most recognizable work: precisely detailed still lifes of antique pitchers and jars spilling forth intricate flowers spun together as if contained within a painterly spiderweb used both to de-

lineate and to further complicate the shapes, colors, and forms, along with bits of branch or leaf, arranged in compositions sometimes so radical, the perspective so deliberately skewed, that you know she has an eye not only for beauty, but for juxtapositions and contradictions. *Would I display flowers arranged that way?* you wonder. Yes, but only if you looked intensely enough and long enough at fanciful disorder to see it expressing something in its own right—stalks bent, petals falling, flower heads almost colliding, the figuration on the vessel commenting with a partial face's ironic eyeroll—rather than presenting us with a bouquet assembled because it represents reassuring aesthetic perfection.

This painter doesn't waste her time reassuring us.

Barry Lopez, in an essay in *Granta*, points out a fault in his way of thinking about describing the natural world. He noticed that his traveling companions sometimes made an "insightful remark" that he would never have thought of, for which he envied them. He pinpoints that envy as "a feeling related not so much to a desire to possess that same depth of knowledge but a desire to so obviously belong to a particular place. To so clearly be an integral part of the place one is standing in." It *is* a human impulse, which explains everything from selfies to the drowning flood of memoirs published each year. Trisha Orr has attitudes in common with Mr. Lopez, not only in being an adventurer and observer, but in wanting to *belong* to what she sees. The wrinkle? That she sees things as being in flux: the bud bursting into flower, the drowsing flower's head; no reductive, tidy prettiness attracts her eye.

Many of Orr's compositions contain riddles and enigmas, some inherent in what they are (illustrated pages from books, for example), others intuited (from her titles, you'll realize she's a reader as well as a painter). Orr assembles shapes and colors as unexpectedly as Mother Nature—and sometimes they're just as disorderly. That world is visited and revisited, the same objects (containers, vases, fabrics) transformed when seen from a different angle or in different light. There is a startling quality to the paintings, which I think of as both a display and a warning. Orr has a way of suggesting that the inanimate objects she paints are *themselves* startled. They drop a petal or bend under the weight of too-heavy heads in a way that seems analogous to our own fatigue, aging, inability to always stand upright, metaphorically. Time changes these sometimes personified compositions, too (of course). When revisited, or varied slightly, the paintings are recontextualized by how the same props vary when used differently. Cumulatively, you get the message that the vase is only technically inanimate—what it contains are not generic flowers; they are anthropomorphized improvisations of human qualities and tendencies, portrayed as they exist in time.

This painter has a fascination with order and disorder.

There's a constant vibration between what's living and what's artificial, giving us a glimpse of possibly happy or unhappy unifications between similar but ultimately disparate friends (such as elegant flower and weed)—Orr incorporates both emotional possibilities, and is entirely at peace with the literary concept of the pathetic fallacy.

She looks the flower paintings in the eye, even if she places the assemblages here or there, higher or lower. In other words, she's trusting her perception of what is inherent in the objects of her compositions without editorializing or projecting onto them; it's more a matter of being able to be comfortable with discomfort. It would be easier to paint, as she can, straightforwardly, omitting life's contradictions and complexities. It seems to me that she's meeting her match with these still lifes, finding (then taking) her distance only after knowing them, whether choosing a confrontational close-up or backing away (perhaps slowly) to give the impression that she is not there to impose herself on her subject's privacy. The *subject* retains its essence, and also, ultimately, pride of place; the artist's sensibility doesn't predominate. It's an even—and glorious, sometimes funny, clashing, colorful, even pitiful—playing field.

At first, I didn't see where Trisha Orr's "Beloveds and Others" series—paintings of her family, relatives, and friends—could be placed in her painterly trajectory, though I recognized them as uniquely hers. I was drawn to them because I have my own emotions about many of the people she depicts. As we all know, babies, cats, and dogs always steal the show, so it's better to keep them out of the picture/novel/wedding reception. But how could she do that with her muse, Georgie the dog? To say nothing of her husband, Greg Orr, her daughters, Eliza and Sophie, and their mates?

Eventually, I realized she was working to keep the instantly recognizable quality of a grabbed moment by not orchestrating her compositions, in the same way she'd

organized her still life compositions. In both cases, the painter does not exclude anything for being singular or an anomaly. Ever the photographer she started out to be, Orr is making painterly records of ordinary moments that would have been missed if she hadn't immediately taken a picture. People's expressions flicker more quickly than the way light changes a shadow cast on a wall, or the late-afternoon sun irradiates an unseen color in the upholstery for only a second before passing by, leaving the object as we've usually seen it. With a quick iPhone snapshot, she has at least the chance of returning to these moments, eventually, with the painter's eye.

Yet it wouldn't be accurate to suggest that this painter is distant or absent; these aren't models—this is her life.

For someone who can paint with photorealistic precision, these new paintings are brushy, scabby, and seem to rely on unexpected glimpses of routine moments. One way of thinking about them might be that Orr is determined to keep out an awareness of mortality. If you were lucky enough to have her show you her paintings before they were hung on a gallery wall, you'd see her carrying them the way a mother cat carries her kitten, by the neck, then plopping it on the floor. Seeing them this way, you'd see the hurried, unorchestrated initial composition before you gradually registered the alternation between specificity and detail and noticed the gestural paint strokes, the tension or cohesion (not mutually exclusive) in the dynamic between the subject's depiction and the means the painter has used to suggest *her* vision. I love Orr's painterly scribbles, her shorthand for conveying that certain things

belong to the language of painting, brushstrokes that can be quite funny in their irreverence, like mini-tantrums.

The paintings appear to be seen-on-the-run, or (at least in pretense; an artist can't alter her eye, whether actively composing or not) too casual to be mistaken for definitive. Might that stance, too, be a way of distancing thoughts of mortality? Throughout her work, Orr's been moving toward a complex vision with the pretense of not judging the moment. In *Poet in the Afternoon*, we feel we're looking at an incidental composition, which just happens to be of her husband of forty years, with his neck and head rising out of a green mountain of sweater, his amazing eyebrows echoing the peaks of nature we don't see inside the room (at least, they're enigmatically raised because of *something*). They're not easy paintings. In theory, there's no resistance to taking them in ("Oh, there's Greg!"); it's just that you can't get out of those paintings as easily as you got in.

They may seem photographically straightforward, offering us a moment in which someone's pose is "natural"; that's part of the painter's trickery. The more you look, the more you sense the artist's personality in her way of recording with her medium, paint. Orr occludes, scribbles, obscures. Far from this being dismissive, though, I see it as a willingness to show us both the underpinnings of her art and its surface. And it's on the surface—where painting, as opposed to literature, so obviously *does exist*—that slowly we realize we're looking at fondness and fancy, a sure vision of a tenuous thing. What a great paradox. She pretends to be giving us a view into someone's life, just us-

ing what happened to be handy, like grabbing a big spoon rather than a spatula. You might be a little clumsier using the spoon, and it might scratch the pot ... I won't continue with this implied metaphor. Trisha Orr is painting domestic life in our time.

In literature, it's advantageous to consider subtext: surface and depth, what's happening where. If it's off-the-page, how can it be substantiated? (Answer: Because we're human beings, and we intuit meaning, whether something can be pointed to on the page or in so-called real life, or not. Go ahead: point to love.) The difference between quickly seeing a painting and quickly seeing a text is enormous: a painting registers viscerally all at once: *Ah, a painting of a person*. With a text, time must pass before you know, in the most general terms, what "it" is. (Apologies to Bill Clinton.) But Trisha Orr is a tricky painter. Tricky without being devious. Skilled, because she puts enough into her paintings to seem to be definitive though what it is—besides something that attracted her attention—resists paraphrase.

Looking at *Thanksgiving at Rima's*, you may feel for a moment that yes, there it is, you're taking it all in. Further inspection, though, will reveal more, but basically: it's night in somebody's kitchen, somewhere, there's a lot of food, and it's dark outside. I doubt you get more instant reassurance and orientation than that. The common practice of hanging pots overhead (so sensible! frees up space!) here in Orr's hands makes me think of a storm cloud gathering in the distance. The pans don't just hang; they *hover*. They encroach. The kitchen's glaring lights are their

counterpart; I'm not sure if one of the bits of brightness is a ceiling fan or a second lightbulb, but in any case . . . they're peculiarly painted, again *overhead*. No view out the window because it's night. Your eye cannot escape. This is it, viewer: This is where you're caught, in this kitchen, with these people, all occupying their own space, all with their own stories, recognizable (the embrace) or enigmatic (the figure to the right). We're made voyeurs in this un-comfortable moment, outsiders who've happened into the kitchen during someone else's romantic embrace observ-ing a person who's at the stove, still working diligently on this meal; she has no time to see the embrace, herself (the brushstrokes suggest this; the arms are a blur of motion).

Then there's the figure on the right, clutching his beer bottle. This figure eventually rivets our attention. He's obviously out of tempo, his back turned on young love, drink in hand (with more to be had elsewhere, as the en-tire painting is about the near insanity of bountifulness). If we look away from the stove, it's with relief that we, personally, aren't at this moment enveloped in steam and expectations. Averting our eyes because we're not sup-posed to gawk at people expressing affection, we're left with the differently painted, solitary male figure whose eyes are the only ones depicted. His glance is also the only one that looks out. (We look in; he looks out.) However, we can't know what he sees. Our eyes return to what we *can* observe, and it becomes—as our own kitchens be-come—chaos. There's ridiculously plentiful food (this is America), bowls and serving implements ready to go. The Thanksgiving feast has not yet begun, though all this is

what's required to make it happen, in another room, at another time. This is the moment before The Moment, and this painter knows it's much more interesting than seeing people seated at the table.

There are too many ways to interpret *Thanksgiving at Rima's* to enumerate. But by considering the placement of the figures and the eerie quality of the pans–as–storm clouds, as well as the dauntingly bright, overhead lights that seem to glow as bright as the sun, we get a sense of people who exist below, at eye level, who have not created a world in which they're comfortable. The disorder keeps them from relating to one another. They might find themselves having a convivial, even fond moment in another painting, but not in Trisha Orr's.

All along, our jumpy eye movements have been echoed or substantiated by the editorialized, spotlit, painterly hazes (as opposed to the obliterating darkness, which is simply a fact—a very useful fact). It's not a static painting because the woman at the stove is in frenetic motion, but with the other figures, we might be peeking through a keyhole. Theirs are private moments. Enigmatic, unknowable moments. If music played inside these figures' heads, all of them would hear different sounds. Paradoxically, the painter has opened up the room in order to make it claustrophobic. She registers her subjects' lack of relation to one another, rather than inventing cohesion. Ah, the family. The cozy kitchen. Those enormous, too-filling celebratory dinners. It's dark outside, which inherently helps this painting convey meaning. And where do we think the painter is standing? And for how long? Only for a very

brief time: kisses end, the cooking will be done, the male figure on the right will have to spring into action, animated or sedated by his bottle of beer. Better that we stay in this moment, I'd say, peering only into the anteroom of chaos.

In *This Above All*, Orr's point of departure is *Hamlet*, specifically Polonius's last talk with Laertes, which has been somewhat misconstrued because of the current context that says one should be faithful to oneself—"to thine own self be true"—whereas Polonius was actually advising his son, more precisely, about guarding himself. The painter's husband is the fatherly Polonius; their elder daughter, amusingly, a very feminine Laertes. The meal is finished (cutlery on the plates, napkins discarded) and this is when people really talk—not so much during the meal itself. Greg Orr's hand is raised; his daughter Eliza's is relaxed, curled. He gestures, expansively; she receives, slightly closed off. She seems to be a figure from another painting; she seems to exist in another time. Her figure has been addressed differently from her father's. She looks French. Her pink shirt is so feminine; Vuillard with a different palette? Seen in profile, Greg's features are not revealed, whereas Eliza's eyebrows arch quizzically. In the manner of Alex Katz, father and daughter face in each other's direction, though their looks don't connect.

Consider the background (the only other place we can look, after considering the figures): quite brushy, sketchy, yet the walls unify with the tablecloth, as if the walls blend with the set table to make the interior one contiguous entity, energetically depicted, as if in motion. Against this backdrop we notice the hazy strokes atop Greg's head

(thoughts streaking past?) and the more defined, horizontal L shape boxing in the top of Eliza's head (I can't help but notice: she's called Liza). The L shape functions almost as a headpiece, adding to her elegance, while further defining and framing; when that happens, we are in stopped time.

Orr is very good at suggesting haste, haziness, unpredictable unities constructed by similar techniques. She's also very good at directing the viewer's eye, so that on first glance the painting seems to depict very little. That pose (or pretense) is characteristic of her way of looking at things, but just because she's a painter doesn't mean she has no preconceived notions. Often she gives us something predictable: backstage in the kitchen on the night of an annual celebration; two people at meal's end. The paintings might seem to have tossed-off titles, but they're not randomly named. Throughout her "Beloveds and Others" series, she's made telling choices in selecting the dominant figure, painting one figure realistically, and the other nearly caricatured. Knowing our proclivity to want quick decoding of situations and quick answers (the numbing "Have a nice day!"), you must linger with these paintings to see how much selection has gone into their composition.

IN RECENT YEARS, there have been quite a few successful museum shows of "vernacular photography," which is to say, snapshots. Things we look at and think, nostalgically, *Remember when!* This includes not only the shoes we'd once thought fashionable, but also the tree in the front

lawn before it grew. We also look at photographic prints and remember that pictures taken with a Kodak were once that size, black and white, deckle-edged. Back then, photographs were very different. Later, to prove that their composition wasn't the result of recomposing by cropping, photographers used a chiseled negative holder that would leave a black border around the image (See! I got it right! No cheating!) Trisha Orr seems not to be cheating, either, though that might be a fiction. The painting we view or the book we hold always is fiction, because in the second when what is recorded exists, all other possibilities disappear. Or seem to. Sometimes a ghostly presence finds its way in and becomes part of the visual record.

Because she's a serious reader as well as a visual artist, certain stories—whether from myth or from Shakespeare, or from places not nearly so lofty—partially define Trisha Orr's paintings, where her insights are revealed in the choice of imagery, in the composition, and in the distance between the painter and the painting. Protective coloration isn't the same thing as disappearing. I sense her there in the discordant details, in the animated brushstrokes, in the ostensibly casual way she re-creates fleeting moments in time, relying on the viewer to feel the love implied.

The Sirens' Call:
Joel Meyerowitz's Photographs

Architectural Digest, 1988

JOEL MEYEROWITZ IS good at keeping the world at bay. When he's at his studio in Chelsea, the messenger is dealt with instantly, the phone conversation is brief, and when he sits on the quilt-covered sofa to converse, his eyes don't stray to the tall windows that overlook downtown New York. The message machine is turned on. The photographic equipment is nowhere in sight. Anywhere in New York such placidity would be unusual, but here it's entirely genuine.

This is Joel Meyerowitz in the city, knowing the same thing he knows on the Cape. In answer to a question about whether he isn't sometimes annoyed to look through the camera lens and see that something he doesn't want to be part of the picture is present, he says, "Something may be in the way, or you may wish for something, but then you're ruined. If you don't wish,

then the picture survives in spite of those things." You don't talk to Joel Meyerowitz without realizing that he's interested in seeing what develops.

Though Joel Meyerowitz's work is not restricted to photographs of Cape Cod, the glorious images he has made of his part-time home have imprinted themselves on our consciousness. The Cape is a place we'd seen before, yet hadn't seen before his *Cape Light* was published, in 1978. Looking at his photographs of the Cape opens us to the exhilaration of feeling something that we thought we knew, only to have it reappear as something infinitely more complex and more beautiful.

The landscapes he photographs are of still moments, but the world they portray seems approachable rather than isolated, because of the photographer's presence—a presence of sensibility more than a physical intervention. It is with humility rather than haughtiness that Meyerowitz describes the place as "a profound natural environment." He finds no problem in accepting the fact that there is a lack of control in the world; the more important realization for him is that "you have to be aware enough to react." "It's an endless scroll of change," he says. "If you let anxiety enter—to what end? I'd rather be as innocent as I can be."

Innocent and careful. Exhilaration is a serious matter to Joel Meyerowitz. He keeps a log of what he has photographed: the light, color, time of day. He takes his view camera wherever he goes for the simple reason that he's afraid he might miss something. (A thirty-five millimeter would not give him the quality he wants; the view

camera produces an eight-by-ten negative that gives greater description.)

Photographing the horizon line was something that Meyerowitz says came on its own terms. As he was making portraits on the back deck of his house in Provincetown (wondering, as he says, "what was happening. Was the portrait just a description? Only a moment in time?"), he gradually began to realize that he was looking at the background—that the background was another subject. "Portraits of the presence of a place are really no different than a portrait of a person," he says.

These photographs, titled "The Sirens' Call," are taken from a larger series. In all the "Sirens' Call" photographs, the horizon line disappears behind a veil. Much of the wonder of them is in noticing the subtlety with which the air and water seem to fuse in an almost palpable mist. By stopping down with a view camera, Meyerowitz can photograph near and far and pull the distances together so that they exist in the photograph on the same plane. "When they begin to relate—when both are acute—there's a new meaning possible," he says.

Things that are subtle, delicate, unorchestrated, and transitory excite him. The photographs in this series must be considered carefully, though the impact registers immediately. In one we see the sky, glowing with pale pink light over the bay, and the horizon line, at times obliterated by a near-opacity of color that suggests a fusion of water and sky. The image seems to glow, empty of objects and conspicuous detail, yet the longer you look, the more inviting it seems. It is a world you feel drawn to—drawn

into—because you would have to float within it, having no place to stand. The photographs are the visual equivalent of the Sirens' whispered call, a vague seduction of sorts. You squint, accustomed to finding your way in a photograph the same way you find your way in the world, navigating by landmarks, noticing objects, detail. You stare, as if by deep thought the distance could be traversed. Meyerowitz is so convincing, the world he photographs so densely and so subtly beautiful, that what might be ephemeral seems, as it can with Rothko, palpable: the movement beneath the paint, the mass behind the haze.

In a way, the photographs lure the viewer into sharing Meyerowitz's view of what visual perception really is. They exist as a corrective of our tendency to stare *at* something. Though our attention may be drawn to a thing, we are never really looking only at that, but also above, around, and below it. "Through the camera you see everything at once," Meyerowitz says. "Reading photographs teaches you to look around the frame. The eye glides around, just as the eye should be loose in nature. A photograph just puts a border on empty space." It is clear from the way he speaks that Meyerowitz considers no space empty. His interest is in how much is there, and in how little one can make a photograph of. What he calls "the nuances of separation" fascinate him. Subtle shifts. The tiniest details. The fact that because something might seem ephemeral, it is no less substantial.

"The view camera isn't instantaneous," he says. "It allows you to work meditatively." Meyerowitz's curiosity compels him to examine a thing again and again: He re-

members the things he's questioned, what troubled him, and, often, the imperfection that he found fascinating. He is a witness who keeps a very personal record of fleeting moments. What we see when we look at one of the photographs from "The Sirens' Call" is a moment in time: serenity, with particular coloration and depth—a world with new connotations. Beyond the sheer beauty of the mysterious images is also a nudge to notice the little things: the uneven glow of the moon, the size of the lighthouse, the tiny blades of grass in the foreground that are not ordinary at all.

How interesting that a photograph—an image on a piece of paper that is a quite fragile thing to hold on to—has the power, nevertheless, to enable a moment in time to endure.

The Fates' Valentine: Holly Wright's Unavoidable Resonance

21st: A Journal of Contemporary Photography, Vol. 1, 1999

OF COURSE YOU begin to play the guessing game immediately: it's some mysterious shape, which could be . . . you wouldn't want to say that; it could also be something not quite . . . well; it could be something that, by its altered size, or because of the angle from which There's no doubt about it: the photographer has come in close on something that doesn't seem to be inherently distinctive, yet the doubling—the slightly spooky haze through which we see the, you know, the . . . oh, what is this preoccupation with subject matter, anyway? We're looking at something interesting: two forms, not quite the same, that when unfolded seem to form a heart. At first the mirroring delights us, but as we look longer, subtle variations become more prominent, more distinctive, once the variances catch your attention—forms that are at once harmonious, yet remain singular, differ-

ent halves, the more you seek to unite them. It's difficult
to believe that one half without the other would be as
involving.

In the photograph of the fingers, there's something
about the fusion that gives the shapes more power: a sort
of two-against-one that the viewer must take on its (or
the photographer's) own terms. Without the blurry, tac-
tile surround, though, without the curious terrain of the
background, the landscape of the whole image would not
emerge: the emotional intensity would surely be different.
It's at once an environment spooky and lovely, a real Vase-
line on the lens for the ageing beauty sort of photograph,
except that this isn't someone's face, it's someone's fingers.
Two fingers touch cozily (how can you not project?), the
strange loveliness of the tips animated by the suggestion
of movement—because one protrudes just a bit higher
than the other and seems a little more dominant. The
fingertip on the left appears to have its own little bit of
protection, as if ever-so-sheerly, something settled on it,
a new shape that's suggested by its outline: that little re-
minder of unexpected rainbows curving through the air,
a little curve that hovers like a planet with its own tiny
moon. The finger is touching something. It has moved an
infinitesimal distance closer to the lens, and in doing so, it
has made contact, broken the illusion that what we see is
free-floating, out of time and space. But how gently this
separateness emerges. It seems only a tiny, pale irregular-
ity. And it is, yet it divides and defines the twosome as
separate entities, plays with our assumptions by making
the similar dissimilar.

Much of Holly Wright's work resonates with the seduction and perils of symmetry, with the unease of scale, with the fog of distance. Some mysteries do have their solutions (especially if you know the photographer, I admit: that isn't a Lilliputian barbell but a baby rattle seen from a hallucinatory distance). But *solution* is hardly the right word anyway, since the rattle has also become a peculiar barbell, the minute the viewer thinks of it that way. Once we come up with our own analogies, the object is no longer only the thing itself, but an object that fits into our personal cosmos.

The photograph of the baby's rattle and the other mysterious mounds are two in a series called *Last Things*. They're simple things you might find in any child's environment, but for the photographer they also seem to contain particular power—the capacity to surprise, to puzzle, to insist on further study. Defamiliarization seems to me the inevitable step toward an object's transformation, yet it isn't easily done. Those things you're very attached to often seem, of necessity, the most stable, the most well known, so that there's little incentive to place them in a different context, or even to close one eye and squint. Strange as it may seem, those things you don't love often hold the most mysterious possibilities—so Holly has set herself a difficult task. The photographer involves us in this pursuit—or in this game, if that's how you see it: she knows what she's photographing and why, while the viewer can't be sure what he or she is looking at, and at first can only rely on some instinctive response to the image. Those times I've asked Holly what, exactly, something was, I've had two

HOLLY WRIGHT • 245

reactions in quick succession: *Aha!* And *Yes, but* ... She's tempering both childhood and adulthood in the presentations, poking a bit of fun at the same time the objects seem to demand to be taken seriously. These *Last Things* were once early-on things that a young person became attached to, whose importance has transcended that time (grown exponentially larger, perhaps, because of the passage of time), and I suspect we're being offered them in detail, placed and lit in a particular way, to see if some of that early importance can be conveyed through their now simultaneous seriousness and their ability to amuse.

The photographer revels in being of two minds: the amusing and the beautiful are often inextricably linked in her enigmatic photographs. There's often so little context from which to extrapolate meaning that it's as if you're looking without peripheral vision toward the horizon line, or as if a curious, amorphous shape somehow landed in a Mark Rothko painting. I suspect that how comfortable you feel with your own instinctive responses determines what you think when you first look at one of Holly Wright's photographs. I find them so disarming that my own mood seems irrelevant the minute I see one. Even if I wanted to, it would be impossible to project my personal state onto them. My eyes open wider, then immediately squint (Coherence! Order! It's a bird! It's a ...). The viewer has to be very active, very quickly. And of course this draws you in. Your own mixture of whatever it is—discomfort; shock; amusement—doesn't sort itself out in a hurry, either. How could it, when the photographer thinks complexly, and that's why you've got these images,

in this context, or near-non-context, to begin with. Holly Wright has a sense of humor that isn't immediately apparent when you're talking to her, but which I've come to realize is always lurking. Rather than finding things simply funny, she is more often bemused. I'm convinced I would have understood the mixture of humor and seriousness from the photographs alone, without having met Holly—it's only interesting that this being of two minds, and this sometimes bemused detachment, is reinforced when you do know her. As for the simple forms these mysterious photographs depict? Once we see these forms as the photographer presents them—or rather, as the photographer almost causes us to free-associate into coherence when we regard them—it becomes difficult to see these rather unusual shapes the same way again.

There is a similarity between the common objects in their altered context that begin to shimmer and the photograph of the heart punctuating what we probably first assume is crumpled gift wrap. But what appears to be a heart is a blood blot: one drop on blotting paper that, when unfolded, appears to form a heart. Surely, this is something the photographer could not have anticipated: an accident that has nothing to do with the emotion she feels about her drop of blood: a found emotion, so to speak, arrived at by folding paper and opening it again. The photographs in this series are the ultimate frescoes: no revisions allowed when blotting blood. Here again is the photographer who's always happy to surprise herself, though her working method is related to something ordinary: doubling is reminiscent of what we do when we

automatically strive to perceive symmetry—such as making one face of the two halves of a face, which are no more exact than real hearts are precisely and uniformly shaped. As opposed to the surgeon's various hearts, though, the photographer's heart remains clearly symbolic: a found shape with unavoidable resonance, conjuring up romance and sweetness. As with *Last Things*, though, there's been action offstage before the presentation: the world largely dropped out, including, of course, the photographer, who offers the rattle and the piggy bank as stand-ins for herself. In the heart photograph, she leaves a different, more literal trail: the shape is there because of the pricking of a finger. Off camera, there was a second of pain. And then that image turns out to be (no surprise) a surprise: a little valentine sent by the Fates back to the pricked finger, later to go public as a photograph.

I am thinking of the vulnerability of fingers. They don't always stand up smooth and companionable in an environment that, as a haze, seems to take on a life of its own, and to shimmer. When pricked, they bleed. They're all too real. They are also absent from the image of the blood-blot. Depending on how you viewed them, they might have faded into some mystical Dreamy Finger Land, or gone off to Funny Fingerville. When all that remains is the stain from a drop of blood, though, you eventually think of the realness of the finger that gave the blood—not a transformed finger, but a real one that left its mark and went away. I don't mean to judge one sort of photograph against another. They are obviously different in emotional intensity, as well as intent. I just want to suggest what might be

overlooked, because it's so obvious: artists—like everyone else—are vulnerable. Out of that vulnerability can come different challenges at different times: they can remove themselves from a photograph (except for the mark they make, quite literally), yet because they have had such a particular vision and because of the manner in which they decide to execute it, their sense will permeate the photograph, while pricking one's finger and completely disappearing, letting whatever emerges emerge . . . well: there *is* no complete disappearance, is there? Artists leave tracks in the snow, shadows on the wall, blood on the blotter, so to speak. (Also, I can't resist pointing out that making an impression—leaving a blood stain—is a literal act that immediately becomes a metaphor for what artists do.

Adults, no different from children, are fascinated by seeing something when it's first unfolded: the simply cut Valentine heart; the paper doll with its opposite arms raised. You can't quite believe the simple magic will work, that you'll have two halves that form a whole. Holly Wright's blood blots are not meant to be simple and reassuring. Aside from inadvertently representing something, like the shape that appears to be a heart, they often remain the two sides that *don't* interlock, like the twin fingers that are either fraternal or identical, mirrored but altered, shapes that exist to show variation rather than inherent qualities, images that belie the notion of wholeness. In the last two images of *Last Things* we see divisions: the cut that divides the halves of the piggy bank, which itself, in dividing, seems to take on its own disquieting, primary importance and, next, the two halves of the baby rattle

that seem energized from within, poking almost, but not quite equally, into an amorphous atmosphere. One suspects that in Holly Wright's hands, even her cookie cutter would develop an irregularity, and that is the point when she would become truly interested.

Animating the Unextraordinary: The Photographs of John Loengard, Sleuth

Introduction to *As I See It*, 2005

I HAVE A friend, a very good poet, who takes offense when poetry is invoked to make specious comparisons between genres. He hates it if someone approves of a passage of fiction as "poetic." Therefore I cringe, though I can't help myself: one of the reasons I react so strongly to John Loengard's photographs is because I find them so literary. He has set about to reveal the inner life of his subjects, but his narrative must be evocative, connotational, rather than sustained and linear. In the photograph titled *The Acrobatic Theater*, we see a giant panda riding a motorbike. It is a humorous but discomfiting picture: one likely to provoke surprise but also a what-has-the-world-come-to response. As a photograph, it's wonderful: here it comes, this odd creature, steering toward us as if it might break through the picture plane.

In his notes, Loengard writes: "'A giant panda practices for the Tour de France,' was all *Travel & Leisure* magazine told its readers about this bear riding a motorbike at the Acrobatic Theater in Shanghai. That was probably enough. Of course, if you could read the panda's mind, there'd be a lot more to say." That's an understatement, but it's also modest: Loengard instantly understood that it was the panda's story, and he offered it to us so we could not help but read the panda's mind. He involved us not from the distant perspective from which we might have viewed the scene, but through the eyes of the unlikely main character. (Also, what's interested him after the fact, after the photograph, is that the caption writer was no doubt amused to adhere to the convention of only factually presenting a photograph. This would amuse John Loengard, who often wonders, within the context of his photographs, why conventions shouldn't be broken.)

Consider his famous photograph of the Beatles: Were these examples of shock-Ed-Sullivan exuberance best photographed as floating heads? Well, yes: because Loengard thought to do it and it worked. Without this image, they would remain the long-torsoed, mop-haired, upright musicians who overwhelmed a generation (or two); here, we're able to infer separate personalities by understanding the moment of the photograph from the separate perspective of all four participants in this Shanghai circus, so to speak. The world looks different (as we came to find out it did) to John, Paul, George, and Ringo.

I think of John Loengard, however, as a perceiver of inner realities—and that is, again, why I think of him

working as a novelist does. It helps if the subject expresses something marvelous, as Georgia O'Keeffe did in displaying her favorite stone. It can sometimes be an advantage if the subject closes his eyes for a moment. But this can work only if the photographer intuits something true about the subject, so that the moment of the blink isn't an outtake, but an interpretation. These photographs do not record extremes. Instead of going for the outburst, the genuine, big smile (not so many of those when you're the subject, I assure you), he finds a way to put himself in a symbiotic relationship with the subject, and then not miss the tenor of what is revealed (Allen Ginsberg: "I sat on the floor in front of Allen Ginsberg ..." Lady Bird Johnson: "Lady Bird Johnson, widow of the 36th President of the United States, laughed at something I said"). I suppose lucky accidents happen all the time—think of how you met your mate, how you came to get your dog—but as far as I can tell, Loengard does not believe there's a litmus test of anything, so a so-called lucky accident offers no guarantee.

In other words, to provoke a subject does not guarantee you'll get the photograph you want; to befriend the subject does not make it more likely (one of Loengard's most amazing photographic portraits is of the outcropping of houses his subjects, whom he didn't know, left before he arrived). In any case, manipulation would be beyond him. Oh, a little nudge, an astute leading question ... but he has a talent for considering how you want to reveal yourself (how you really want to reveal yourself, not a preconceived notion of how you should pose for

maximum protection), and a talent, as well, for taking a photograph that gives the impression that that moment is—however real—just a second in time, not definitive. The panda cyclist opens the parameters of the picture and raises more questions than even the most long-winded novelist. Similarly, the quality of an expression sometimes lets us know not just the obvious, that the subject has withdrawn, but also that such an external impression of inward retreat shows us the paradoxical power, yet lack of power, any photographer has.

Jimmy Carter, no different from all of us, cannot always look like this. He must have greeted the photographer, so there was the moment before the photograph, but the moment after it was taken seems even more worthy of our attention, which I think the picture suggests: the hand will be lowered, eyes cast up. We're seeing him just before he reconnects with us, but we can imagine the moment to come.

People often ask fiction writers, "Why did you end it there?" What they're saying is that they hear the resonance differently than you do: to the writer, the perfect word or image at story's end may resonate, but if other people hear on a different frequency, they don't get it. You know what? They won't. What's necessary is to try to connect with the artist's reality, and with this collection by John Loengard, which so quickly draws you in, there is ample opportunity to connect. You won't need anyone to point out the recurrence of hands (potentially as expressive as any face) or the emotional connotations of his having come in close or—just as revealing—having stepped back. He gives equal

respect to the famous and the not-famous, equal respect to himself and his subjects. He's a modest man, with the reflexes of a cobra.

When I look at his photographs, my silent reaction is, "Really?" Not that there's anything there to make me doubt them; there's nothing phonied-up or self-consciously artsy. Quite the opposite: Really, you're telling me that these people, inhabiting the same world I do, have been stopped in time without giving the impression that time has been stopped long enough to make a definitive, nondefinitive photograph? They resonate instead.

Years ago, in my quasi-youth, my husband and I were photographed by John Loengard. He came to Virginia— had we met previously or did I only know his photographs and know that we had a good mutual friend? We went to a seafood restaurant, talked, had a good time, and the next day he came to the house and we started in. But the sofa I might have stretched out on didn't have sides, so I slumped somewhat awkwardly, and what could my husband, Lincoln, and I do together that didn't seem made up for the moment? Loengard had but to ask, and I spontaneously admitted to what Lincoln and I thought of as "Bothering Michael"—our friend who ran a bookstore. The picture is here, we are still here, Michael is too, though the store was run out of business by Barnes & Noble. For a moment, we danced, and Lincoln tipped me backwards. I trusted him, so I dipped; I trusted John Loengard, so I gave up any pretense that I could determine what image he came up with. What do I see, now? Three people in a photograph, one of them—in spite of not registering on film—pleased and

maybe even applauding, because you have only to look at Loengard's photographs of his family to know how capable of love he is. The house is sold, but until the day I left I often thought of him, unexpectedly. Other photographers had photographed me there, but something was so kinetic in the connection between the three of us that day that only Loengard lingered.

It interests me, sometimes, to read the footnotes before the main text, to flip to the back of James Wright's collected poems and, analagously, read the index of first lines listed alphabetically, rather than to read the actual poems. What you can understand with footnotes is a changed tone of voice that reveals something about the author you wouldn't know from the text, such as a sense of humor; with Wright, a dozen first lines, or twenty, compose a found poem. Read John Loengard's brief descriptions of his photographs, and you'll be overwhelmed by a humane quality you'd never expect anyone could work into a factual account. Any novelist could look at the text, without the photographs, and have a good idea about where to start the novel about Loengard. It would have to express a sense of the world that is always curious but never churlish. The dry sense of humor would be important. The humility. The sheer quality of the vision. And then the novelist would have to bring in the minor characters, all at this moment left abstract: the snow; the light; the trees; the cat on the fence; the breeze—all things of the natural world, which cradle his vision.

Andrea Modica and the Stuff of Fiction

21st: A Journal of Contemporary Photography, Vol. 5, 2002

WHEN I GOT in touch with Andrea Modica, she had just returned to Colorado from Montana and was busily packing for an almost yearlong stay in New York. I had just returned to Maine from New York and was trying not to think about the packing I had to do to prepare for a two-month stay in Rome. I mention this not because artists are peripatetic (they seem to be either that or complete stay-at-homes), but because I had forgotten, looking at her photographs, that the same fortuitous accidents that befall me as a fiction writer must also befall her (where did she *get* this stuff?), but those moments have to be pursued deep into the woods or deep into the inner city. Perfect moments are like animals used to outsmarting you: they're endlessly elusive, and can almost always slip through your fingers. The frustrating thing about metaphors is that they don't want you to find them.

I had seen these photographs before we spoke, and was intrigued by their strange but serious beauty and by their lightness. The five photographs certainly did not have to be related, but that's my tendency as a writer: to see whether the dots can be connected. I understand that this is also what a photographer is doing when she sets up her camera to compose the photograph, but still: I romanticize photographers as being hunters needing to capture beauty before it escapes entirely (or, just as interesting, ugliness), looking for that moment that is simultaneously simple and complex. The difficult question is how to get both things. Yet without both possibilities presenting themselves, an image, or a sentence, seems to lack conviction and vitality. Andrea Modica speaks about "the subconscious eye" of the photographer, so that while the photographer has not necessarily decided certain things before composing the photograph, she can see later—perhaps in the contact prints, perhaps later than that—things that were not premeditated, but nevertheless have revealed themselves, and in so doing made the photograph dynamic. (Artists envy other artists who work in different mediums—in spite of the fact that when I'm working with words, multiple drafts are necessary to make the writing appear fresh, I find it a pleasant and necessary delusion to imagine that someone else can just go out and *take what's there*.)

Andrea Modica uses an 8 × 10 camera that she says "invites a celebration of my subject." The photographs *are* celebrations but of an unexpected sort, in that what they're celebrating is death. Not the fact of it, but the aftermath, or the strange quality of life-in-death and death-in-life,

as presented by its remnants. The photograph of the skull, dug up from the grounds of a state mental institution in Colorado (possibly, the mass graves were created during two flu epidemics), is so starkly a reminder of mortality that the viewer initially recoils. But the angle from which she chose to photograph the skull makes it as interesting as it is repellent, I think: the blackness through which we peer offers no vanishing point, so we have to make our own—and of course whatever we are looking toward has much to do with who we are and what we believe before seeing the image that presents the paradox of our fragility and durability (the teeth), then directs our eye through the skull, as if it's only a tunnel through which we must proceed. If death itself is ultimately unreadable, Modica makes of the human skull a kind of handheld Plato's Cave. We see only our projections.

The photograph of the dead cow is different in almost every respect from the presentation of the skull, except that the unknowable darkness into which our eye tries to look finds its counterpart in the white space of the distance. The curved landscape suggests that someone (or something) contains this entire scene in the palm of a hand; the eye rocks from left to right—always noting the bloated cow—but then the eye lifts from the scene and yearns to penetrate the distance, the white sky, given the illusion of greater depth because of the overhanging branches in the foreground. In both photographs, a shape, white or black, takes on its own reality with the starkness of a map, but one that won't guide us out of a world more or less obviously inhabited by death.

A bit more about this photograph: we are at first transfixed by the oddity of seeing the fallen animal this way. It's as riveting and as incongruous as a super-bright shooting star would be in a painting by Corot. Such things are not what you expect, of course. It's the error you try to blink away, though fallen things, in Andrea Modica's photographs, remain as solid as statues (which, of course, announce their solidity even more when toppled). We have so much space to view, yet the eye can hardly depart from the tiny form. It is a prototypical lovely landscape, except for the unexpected—which is to say, it's true to life. Approached aesthetically, one could say that the animal punctuates the scene: that it is a version of Auden's Icarus, his fall completed, though this time we, the peasants, do most certainly see it: death is, incontrovertibly, what has happened while we've been looking elsewhere. It's *Blow-Up*, and we're the people who thought we were just off for a nice day in the park.

John Loengard has written: "Often the tension that exists between the pictorial content of a photograph and its record of reality is the picture's true beauty." That, I think, is what is being celebrated in the picture of the skull and in the landscape. The photographs do seem to me quite beautiful, quite tranquil, while at the same time hardly devoid of tension. The apparent placidity, coupled with the stark reality of what we see, creates tension that can't be dissipated. Surely there were photographs leading up to these that the photographer missed (the creation of the mass graves; the moment the animal died), but since nothing could be stopped then, something can

be stilled now. Those previous moments seem to linger in the images. When we stop and see through the photographer's perspective, it's undeniable that what we missed was momentous (I can only hope that everyone has read Joseph Heller's great novel, *Something Happened*). If a person photographs the aftermath, there is hardly any clearer way to state that something profound has happened, and we can best judge its consequence by its mysterious aftereffects. Andrea Modica says: "Sometimes something is so frightening I must look at it this closely or dismiss it altogether. Sometimes it's so stunningly beautiful I feel completely left out. With either extreme, photographing makes me have to deal with it." And, of course, it makes the viewer have to deal with it.

Yet the photographs we see here are not confrontational. They're permeated with too much peacefulness to be merely shocking. In part, this is because the photographer's eye has seen the beauty in death, registered its textures, its shadows, its awkwardness and peculiar dignity. Modica's photographs are quiet in the sense that an empty room may seem to contain a sound within its silence after a significant event has transpired there.

Consider the not-quite-plaited hair of the photograph, taken in Tunisia, of a young boy holding a severed goat tail. It's at once a little awful and a little fascinating, the hair's downward fall cascading our eye downward, also, though that brings us only to the end of the photograph and the revelation that there's nothing more to be known (as there is nothing definitive in the black space of the skull or the white distance of the landscape). The hand is so carefully

laid across the cut hair that it could seem awkward—not proprietary so much as placed, consciously placed, an ordinary hand that happens to be touching something not all of us would be happy to feel beneath our fingers. John Loengard has a photograph called "Actor in Los Angeles, 1969," in which we see the elderly actor's hand amid publicity stills of himself in various past roles. I thought of that photograph when looking at the picture of the goat tail, perhaps because both describe lives by presenting fragments as keepsakes, even though there's a basic difference in that Loengard's subject could hardly be more intimately connected with what he holds (himself). I have no way of knowing, but I suspect that Andrea Modica is getting at the same thing, in terms of the interrelationship of people and things, defining her subject by showing us what he touches. We wonder whether this is repugnant to him (no; he's too relaxed), and exactly what connotation the severed tail has for him. In Loengard's photograph, we know. That story would be easier to decipher. But Modica implies a story also—it's just that we have to extrapolate meaning on the basis of seemingly unrelated things. Where the two photographers exhibit a shared sensibility is in what they chose not to present: Loengard omits the man's face in favor of the more telling hand (its physical appearance making the man's face extraneous); Modica presents her subject severely cropped, represented by his arm and hand. The fingernails are almost surreal in their whiteness. In displaying the animal's darkly colored tail, I suspect that what he thinks he's doing is showing us something other, something other than him. But the

longer we look, the more we realize who the real subject of the photograph is. Loengard's photograph says *This is who I was*; Modica's says *This is what I am* in spite of the fact that the subject probably doesn't know it. In Modica's photograph, it's also interesting to note the proximity of the white fingernail to the nub at the top of the severed tail: one is an outgrowth, suggesting that things continue; the other has been lopped off and definitively conveys an end. As usual with Modica, it's not easy to look at an image and have only one emotion. There are always elements in counterdistinction to one another; there is always tension between the beautiful and the grim reality beauty carries with it.

The severed lamb's head we look at differently from the way we would if it was not disembodied. The eerie thing is that the head looks the same way it would look if not severed. Your eye tries to connect with its eye, but you are at an impasse: there is nowhere to go; there is no way in and no way out, because its eye will never connect. You will forever be an outsider. The head has for the split second of the photograph become the extension of an arm tattooed with hearts indicating the person's love for someone I presume to be other than the lamb. Behind this photograph is a story I will never know. Well: I know in general, but no one ever cares about anything he or she knows in general. As a fiction writer, what story would I make up? I'd have to start by ignoring all the givens. It would be too easy to editorialize, or to project my own feelings about the slaughter of animals, or even my feelings about the pointlessness of trophies. The writer

always asks: If all this is a given, what is not given? Subtext also interests Andrea Modica. She is able to look at things unflinchingly—perhaps because they are on the surface. They are givens. Facts. Or maybe she does flinch, but we don't have to see that: we can just see what she's confronted. We understand what we're looking at pretty quickly, if not immediately. Yet the whole history of what transpired eludes us, and may forever elude us (as may the mystery of the mass graves). That itself seems to be a significant point: the unknowability of things—the unknowability of death—which in our anxiety and defensiveness is a notion we fight against, quickly finding some way, fictionally, or by the common delusion that our projections are not fiction, to try to demystify that which cannot be easily explained.

My favorite photograph is of the young child's mouth. On first glance, you would probably say—I guess at first I would have identified it as—a photograph of the dead bird. Which it most certainly is (and part of a series of photographs Andrea Modica is making at family-owned slaughterhouses.) "The subject matter is what determines the formal arrangement of the photograph. . . . I start off wanting to photograph something in the world and as long as I go with that the formal elements fall into place," Modica has said. Yes, but quite often those things she offers us are both part of the world and departed from the world. If there is such a thing as a spirit (whatever word you want to use, there seems to be some quality the dead communicate in these photographs), the tenor becomes complicated when a living person intervenes: the arm

holding aloft the severed sheep's head; the hand holding the goat tail; the little girl whose lips echo the shape of the expired bird—her lips so tactile it's as if you feel her breath as she regards this thing that becomes even more breathless by the proximity of her breathing. It seems to me that it's almost a photograph of something ineffable—as surprising a photograph as one that miraculously captured the image of a ghost, because while the bird is dead, the visual link between the girl's lips and the bird make you wonder whether the bird couldn't be animated—couldn't once again be part of the world that contains the child and her amazing mouth that reveal as much or more than looking into an eye. Though dead, the bird is echoed in the dark shape of the parted lips, its presence reinforced by the shadow that falls beneath it, on which the bird seems to float. There are many ways to photograph a dead bird, but this one seems to be a very subjective, interpretive way of presenting the creature, making us contemplate the aspects (or spirit?) that make of it more than it is. It is contained by its shadow; it rests on a chair whose curve suggests movement and a little girl presides over it—at least for a time—and unwittingly breathes the breath it cannot.

In these photographs, death is a fact, and death is the stuff of fiction.

George Burk's
Brush-and-Ink Drawings

"Passages from Maine" exhibition catalog, 1991

WHEN GEORGE BURK first showed me his spiral notebook
filled with brush-and-ink drawings of rural Maine, I was
astonished. It was clear from the first second that they had
been done with amazing precision. They were so highly
detailed that the concept of particularizing began to van-
ish from my mind; everything was uniformly detailed,
except the mysterious surfaces deliberately skipped by his
painting pen: the cloudless sky; the surface of water when
no shadows fell there and when nothing was reflected;
the sun-bleached surfaces of rock; and—perhaps most
surprising—swaths of road, pure white, that seemed con-
vincingly but arbitrarily to divide the same terrain. This
was a land the viewer's eye moved through with no indi-
cation of an end in sight, a road taking us away instead of
leading us in as it narrowed, receding toward a vanishing
point. Who could care what that vanishing point would

be when the larger intention of the drawing seems to have been to make us stop, and to appreciate with a new sense of wonder what might have been described as rather anonymous terrain: those trees we pass every day; the familiar outcroppings of rock along the coast; the trees in the distance—so often, trees in the distance, their shapes as familiar as cookie-cutter forms and nothing spectacular about them, unless, perhaps, one stops to wonder at the fact of them.

As I first looked at the drawings, I was fixated on the consoling sameness of the landscape. After all, it was a landscape I thought I knew rather well, perhaps because it was, in part, archetypal. I quickly realized that George was revealing complexities within the context of invoking the familiar. I was able to hunt for sameness only so long. Depending on context, the familiar fir trees were a dense mass obliterating the background, or separate and distinct, their branches overhanging the clearing like small, feathery calligraphic strokes on white paper. If George was being true to the way sunlight fell, then we might perceive a looseness about the woods, partially the result of seeing forms backlit, which tended to distinguish them from one another, and also give the impression of being more fluid. The presence of a curving guardrail, implying civilization's arrangement of a path that was determined for us, is both consoling and obtrusive. There are no cars in these drawings because the mere presence of the road tells us they are there. Similarly, there is no figuration, so having been provided with no one onto whom we might project, we remain the primary observers. Something about these

drawings gives me the illusion that I'm the only observer of a scene available to anyone. In the same way that people forget the others around them in the darkness of the movie theater, there's the suggestion that your experience, as you view these drawings, is private, and can therefore be as personally informative and involving as you'd like it to be.

It is because of his eye and his sense of form and light that George has selected telling moments, applying his method of revelation equally to trees and rocks, to the animate and the inanimate. Light is an active presence: it transforms. When trees or bushes form their own composition—when they cluster instead of being distinct—the emotional resonance changes. Compositionally, I think the drawings are no more random than opera. And if we indulge a tendency to personify, the rocks can be seen as creeping forward, aggressing upon us, stopped only by a man-made embankment. When delicate branches grow upward, they have the quality of fire, set apart from the darkness of the road and the ravine by coronas of light that suggest a mystical, or religious, quality.

We have, quite simply (and also quite complexly), the natural world, naturally arranged—forms that, under the grace and precision of the artist's pen, carry the double significance of being at once concrete and abstract. As a writer, I'm surprised to find that I have almost no desire to read into what I see, or to make analogies. The drawings have the power of a riveting photograph; at the same time, the technique brings to mind woodcuts and reminds me of the physicality involved in the long, delicate process of

carving. George's sensibility reveals itself not only in the way he ever-so-subtly interprets aspects and areas of every drawing, but also in the remarkable fact that he stopped so many times to look. The drawings are, inevitably, about the road less traveled. Whether for mere seconds or for much longer, there exists the world, alone. It's made to seem approachable, though paradoxically, in the moments the artist depicts, no one moves within the landscape. Although seeming to invite us in, wouldn't projecting ourselves into the drawing be obtrusive, or presumptuous?

The cumulative effect of seeing George Burk's drawings grouped together is quite different from looking at them individually. The common denominators, the recurring images, even the technique (I feel the need to state the obvious: these are not drawings that can be easily revised to correct any mistakes), seem to me both soothing and puzzling. Context, and light, and shade, and perspective, and the decided upon dimensions change everything. A very alert artist has seen this, and turned our attention to the complexity of the well-known world we must now view differently. These drawings are, among many other things, about the constancy of change.

An Abbreviated Adage Underlies Curt Richter's Fully Developed Portraits

Introduction to *Thousand Words*, 2016

KEY WEST IS hyped to the sky (blue, as you'd expect). There's the tourist board's Key West; there's the locals' (the Conchs') home turf; the miscreants' playground (bring on the bail bondsmen). There's also the artists' Key West, and in some ways they're the ones who've defined the place. They've provided the songs, the books, the paintings, the photographs. Key West has a long and well-known literary history: Ernest Hemingway; Tennessee Williams; Elizabeth Bishop; James Merrill; Alison Lurie; John Hersey; Robert Stone; Harry Mathews; Richard Wilbur; and too many others to enumerate. Some of the departed have plaques on their houses. Others, still with us, hide between bowers of bougainvillea, and if pranksters steal their house numbers in the night, they're temporarily without an address. (Granted: the preferred joke is to remove a particular mailbox off Fleming Street and drive it to the parking lot

at the shopping center on the highway. Why? Also, how, since it's sunk in cement? Still, off it goes.)

It's often noted that we're at land's end, at the tippy tip of Florida—the southernmost point in the continental United States. Sometimes, if people rent a catamaran and don't know what they're doing, they've been known to end up in Cuba (true story; ninety miles). The best guidebook remains Joy Williams's *The Florida Keys*, which makes it clear this is a place where there's always been a lot of posturing and High Seriousness, along with plenty of craziness to laugh at or debunk. (Instead of a guidebook, it's sometimes best to consult the *DSM*.) People come this far to let loose, to let fly, to dance a pas de deux with a beer barrel and turn their dreams into a party. One night in the ER, I stood in a curtained cubicle. On one side was a man whose ribs had been broken when a motorscooter jumped the curb and plowed into him; on the other, the parents of an infant, whose tattoo was infected. (Let's all sing a chorus of "Wastin' away again in Margaritaville.")

But let me hasten to say that it's Paradise. It's called Paradise. Joke's on us: it might be Paradise. At the very least, it's sometimes too far out for its own good, intermittently seductive, bizarre, edgy, grungy, and druggy. At the very most, it's filled with excesses of tropical foliage (may the better man—or plant—win), inherently sequined iguanas that make 1960s regalia pale in comparison, sailboats and yachts floating atop their own pools of colored lights, night skies sparkling with stars, stunning sun and wavery breezes, bougainvillea that grows the way ivy does elsewhere, people riding bikes with their pets plunked in baskets (the pets of-

ten wearing more attire than the bicyclists), the cool Tropic Cinema where you can watch the Academy Awards in real time wearing shorts and a tank top, flowering trees whose familiar (as opposed to Latin) names make them sound either like Southern debutantes, or strippers: Royal Poinciana. The hotels have pools shaped like some of our more obscure internal organs. Legendarily, on New Year's Eve, "Sushi" descends (during the one minute all year when anyone here pays attention to time) in a large glittering slipper lowered from atop a bar on Duval Street, as a preponderance of Americans, psyched for the descent, get doused at midnight by the contents of shaken beer bottles raining down from balconies.

Therefore, one January, why should it have been surprising to see Curt Richter biking down the street? James Merrill used to bicycle all over town (though I admit I'd be shocked if I saw Curt in argyle socks). He likes it here, and the place likes him. January features the Key West Literary Seminar, held at the San Carlos Institute. The Seminar was begun by writer David Kaufelt. David and his wife, Lynn (and later, their son Jackson), arrived early and did something sort of radical: they lived here. It was David's idea, thirty-four seminars back, to have people gather annually to discuss literature, to enjoy the island's ambience. (The 2017 seminar sold out in twenty-five minutes; his idea obviously became popular.) The Seminar takes place over four days, with topics ranging from "Literature in the Age of AIDS" (1997) to "Shorts" (primarily the short story, 2016). All require an audience. What the attendees see isn't a performance in the pejorative sense of that word, but scientists

and poets and editors onstage, hoping to make something clear (often, to themselves), thinking on their feet, voicing hunches and concerns, as well as reading from their notes. (If you're a little starstruck, you can sometimes see your favorite writer's purple socks, or a piece of jewelry flashing under the spotlight like a beacon sent to mislead pirates.) Margaret Atwood! Annie Dillard's giving the keynote! Murray Gell-Mann seems to have quite a sense of humor! After the day's events—drinks sipped, books signed—they move from the public moment to the private (before social media makes that public), and sometimes they're approached by Curt and agree to let a photo be made later.

But he came with no notion of this particular book project—though it was his idea, once that project got going, to include the staff and the workers behind the scenes who made it all happen. My husband, Lincoln Perry, and I have lived here in the winter for almost twenty-five years. I'd been photographed by Curt for his book *A Portrait of Southern Writers*, but we lost touch ... until he suddenly reappeared, with that mass of curly hair and his way of conversing that's like listening to someone talk at the same time his words echo from the far shore, they bounce around and come back at you so quickly. He might be fine at small talk, but he certainly doesn't prefer it. And like every other good photographer, he's on the move even if he isn't going after a picture. He's trained not to miss an instant. You become more alert in his presence, in that aura of hyperawareness; even if you don't see exactly what he sees, you're aware of someone's heightened sensitivity. He's the first jumper-cable clip to get attached. He's also capable of standing statue-still when the

situation requires it. He's not always in the United States, let alone in Key West. Which I think is sort of perfect: he lives with his family in Finland and New York, but he also works the margins. Curt's intensity, focus, and talent, coupled with his fleeting presence (a few weeks? a month?) make him perfect for a town built on crumbly coral, where the surfaces are seductive and the people often hard-edged.

He works in a small, borrowed room (thanks to long-time resident David Wolkowsky, who has a penthouse atop the Kress building). I'd love to be there after a session when Curt looks at what he has and selects, his eye alert to composition and light and shadow, feeling no obligation to flatter the sitter. He's as happy to talk about the qualities of certain kinds of film as a great chef is to talk about the special-ordered Himalayan salt. He has a good time in Key West, and he's valued. Everything's fleeting (it is everywhere, though things do have a way of happening in speeded-up time here), from the businesses that morph overnight into other identities, to the trees that drop their blooms in a single gust of wind, like enormous scared birds. It's difficult to get a handle on Key West because it's always changing, always moving beyond you, beyond your expectations.

I've stressed the island's absurdity, unpredictability, and abundance, but the photographs you'll see are the antithesis of chaos. Especially if you live here, you could mistake these images for embodying tranquility. As being an antidote. They might achieve some of their effect because of the photographer's decisions about composition, where he's located in relation to the subject, and/or because they

ask something of you as the viewer. Is there such a thing as edgy tranquility? In our busy world, these images offer one individual on one page—the bonus being that tension creeps in, because you can look as long as you want.

But I don't see these portraits as peaceful or as human visages raised up as a kind of altar to inspire meditation. I see, for example, the subject slightly straining forward (which makes me ask myself a question about balance, both literally and metaphorically). I notice facial asymmetry that informs me of our quick reflex to fabricate harmony out of two different parts. I see Jim Gleick in profile the way he'll never see himself (except in this photograph), because one can't simultaneously have downcast eyes and also see oneself in a mirror. If the subject moves his or her eyes, the photograph becomes something else; if the photographer doesn't miss the instant, that variation, that unexpected stance, that internal thought expressed physically, then the photographer potentially has something unique. "For years I would never let the subject look into the lens," Curt says. "If they did, they wouldn't be alone. Neither would the viewer."

While we hope or assume we know how we're presenting ourselves, of course people see us differently. These photographs sometimes present an image that's inherently startling, taken from an unexpected angle, enabling us to see the abstract in the figural. For Curt, it's very nice if you like your picture, but that's not what it's about. He'll run away from that conversation as fast as he can. As with any other artist, something of what emerges in a visual image or in a story emanates from inside the perceiver, who will

inevitably project certain feelings. So, to some extent, what's in play in these photographs is a question about objectivity and subjectivity. They imply questions, rather than nudging anyone in the direction of an answer.

As John Loengard (once photo editor of *Life*) noted: "What's photographed can't be altered on reflection." Writers, by the nature of what they do, get to reflect (and revise and recast, omit, or decide to view the parade from another street). "Moreover," Loengard continues (as he speaks from the point where the crosshairs of common sense intersect with a koan), "the most intriguing subjects may exist only for a moment." Someone sitting (or standing) for a portrait is, of course, there longer than a leaf falling through air, but in a portrait, the cast of the subject's eye changes in a moment. Curt's always involved in mutability—though like the rest of us, he may recognize the transformation after the fact. I don't know how many times he takes the photograph in the instant he sees vulnerability, or if the mere presence of vulnerability is no more definitive than a long list of other things. (Arguably, the vulnerability in a photograph may also be the photographer's.)

What strikes me as I consider these portraits is that quite often I know the people, but their essence seems to radiate in a different way. Conversely, when I don't know someone, I can feel as close to that person as I do to an old friend. Amazingly, they rely so little on externals that the entire act of conveyance rests only with the sitter and the photographer. (As all writers know, the white space between sentences and paragraphs has to do as much, and sometimes more, than the written words; similarly, his undefined

backdrops sometimes seem almost electrified.) In photographs, people's self-images enter with them, as jewelry, or well-combed hair, as very messy hair, or with the stripes of a shirt. How is someone—both photographer and, later, the viewer—to see beneath the surface? That's always the question for a writer: we all attempt to read X-rays. I doubt, beyond the basic requests, that Curt tells people to pose bare chested, or to lose the jewelry, or to cover their eye. But having observed him at work, and having sat in front of his camera, it's equally true that he doesn't vanish. Two people are in the room to communicate; no one expects the illusion of a magic act—neither subject nor photographer. I'd even hazard a guess that—at least sometimes—whatever dynamic has taken place in the chosen image, a mystery seems to have been created, but at other times, the photographer is demystifying.

Quite intentionally, on his part, Key West does vanish, leaving us focused on the individual. Here, the photographer himself takes the pose of merely presenting. But even if you don't know Bob Richardson, you notice his posture, and his placement in an area that seems to inherently compress him, as if he's trying to walk out of the frame. This is a photographer who's willing to let the off-moment, or the accidental (or at least the uncalculated) register—which very much describes those qualities that are so surprising and disorienting about Key West itself. He values the abstraction in the figurative, the texture of skin as it appears printed on the tracing paper on which he sometimes prints, the fissure in the nearly perfect.

He's photographed rockets, too.

Bob Adelman Brings Raymond Carver's World into Focus

Introduction to *Carver Country*, 2013

RAYMOND CARVER, so often willingly or unwillingly the center of so many interpersonal dramas, was also a modest man who had a great talent. We have his essays that attest to the difficulty of supporting a family and also finding time to write; we have the evidence—so well known, I don't need to restate it—about his alcoholism, his quitting drinking, and his eventually becoming one of the acknowledged masters of the short story. At least at the time, it seemed he was the anointed Great Story Writer. If he had detractors, they weren't his fellow writers. He was appreciated, admired, in many cases loved. I can't believe Tess Gallagher would have held any different opinion, even if they'd never married. He had a reputation for excellence among writers long before the *New Yorker* published him, or the *New York Times Book Review* gave him such a big thumbs-up that anyone reading the praise

might have looked upward to see if you-know-who was beaming down agreement. All enthusiasm deserved, his mixture of talent and magic is still not taken for granted in even the most perceptive and appreciative readers' minds. He beat the odds; he beat the system (he never wrote a novel; he was a poet and short-story writer who was most praised for his stories); he didn't beat death, but his poems suggest that he didn't expect to, either. Also, that he hugely valued what he'd had. On the personal level, it had come at quite a price. On the professional, his talent had come to astonish almost anyone who came in contact with him, including editors and publishers.

Mark Doty, writing about Elizabeth Bishop's brilliant poem "The Fish," says, "When our imagination meets a mind [the fish's mind] decidedly not like ours, our own nature is suddenly called into question." Of course this can be disconcerting. Even embarrassing. But if we've taken the plunge, why not get from the experience what we can? After all, we wear costumes on Halloween, or dress up for parties or even just to impress. Carver's characters, however, were fish. They were what they obviously were: waitresses, or enigmatic fat men ordering way too much food from those waitresses, or people who would declare bankruptcy the next day. Still, in the ordinary resided convoluted insights and truths, though we had to get down there, get to the level of the fish, who were only inhabiting their natural world, to see something from their perspective. That's what short stories do. They don't attempt to convince you that a character is right or wrong, most of the time (though of course they allow those of us

so inclined to rush to judgment); instead, they ask readers to inhabit the minds and bodies of some pretty unlikely characters who are nevertheless recognizable enough that they might act as temporary guides to something that shimmers right in front of us that we don't know, or have neglected to acknowledge. In this finality of awareness, poems seem more related to stories than to novels—so it's interesting that Carver wrote in both genres. The novel has no less lofty intentions, but chronological time can allow us to let ourselves off the hook: sure, something that is gradually revealed can still have an enormous impact, but if it devolved over time, time alone can soothe the realization. It's the compactness of a story that asks for so much from the reader, so quickly. The reader will only have a brief amount of time to spend in a character's company, and even if the story can be reread, all attention must be given from the first to the reality or lack of reality of the situation. The implicit question is: Where do you, the reader, stand in relationship to this? Because as Flannery O'Connor trenchantly observed, "The average reader is pleased to observe anybody's wooden leg being stolen." We're not reading for edification, or to figure out how to live our lives. We're reading to see where we stand vis-à-vis the characters, whether if we had a wooden leg, we'd behave like O'Connor's character; whether if we were declaring bankruptcy, we'd have made the frightening unspoken pact Carver's Toni and Leo have in "Are These Actual Miles?" So many short stories contain a world of worries and pain. Sometimes, even worlds of high hilarity and bravado. But Carver positions himself elsewhere. His

fascination is with the real and the probable (even if we only recognize that in retrospect); his devices are many, including humor, matter-of-factness (ask any good comedian how important this is), brevity to the point of suggesting to the reader a panicked descent into projected, imagined depths (as did Beckett).

IF YOU ARE familiar with his work, you will already know this, and much more. You will not have heard his exact tone before, and we haven't heard it again. There has been ample time for imitation or for continuing on a path he cleared. That has happened, sometimes wonderfully well, even advantageously. But he was the first one out there with a particular vision, not only of his characters, but also with the implication—the faith—that the reader could be guided toward figuring out what shivered and shuddered below the surface when reading individual stories. Because they wouldn't exist if you didn't.

How risky. But it worked.

When you look at Bob Adelman's photographs— sometimes of Carver himself, other times of the glaringly inauspicious settings where he based his stories or from which he derived his inspiration—you'll see a rather anonymous world that has been made so particular by Carver's visitation, we can no longer just turn away from its bleak, formulaic postcard facade. Bob and Ray certainly shared an odd sense of humor, though neither makes easy jokes at the expense of the audience. If these people and places don't exactly announce themselves, remember that Carver

himself warmed to them as subject matter slowly, often conflicted about approach or avoidance, which he incorporated, ultimately, into his stories.

To recognize the extraordinary in the ordinary is a much-commended pursuit; to make something ordinary yours, even after it really has been yours, is much more unusual, simply because it's so difficult to separate yourself from it and get enough distance. My reading of Carver's stories makes me yearn not so much for a decoding of the actual versus the possible or the imaginary; instead, I want to think I've sunk to the bottom (or close to it, oftentimes) with Carver, who gives me clues but who shows me around a little, then soon absents himself. Which leaves me with the story. And with myself. These photographs are a good point of departure, too, a reference, an unlikely stage set for a performance. Notice the respect with which author and photographer move. I see where I am, but where are each of them in the picture? (They can be found.)

A NOTE ON THE TYPE

More to Say has been set in Caslon. This modern version is based on the early-eighteenth-century roman designs of British printer William Caslon I, whose typefaces were so popular that they were employed for the first setting of the Declaration of Independence, in 1776. Eric Gill's humanist typeface Gill Sans, from 1928, has been used for display.

Book Design & Composition by Tammy Ackerman

ALSO BY ANN BEATTIE

A Wonderful Stroke of Luck
The Accomplished Guest
The State We're In
Mrs. Nixon
The New Yorker Stories
Walks with Men
Follies
The Doctor's House
Perfect Recall
Park City

My Life, Starring Dara Falcon
Another You
What Was Mine
Picturing Will
Where You'll Find Me
Love Always
The Burning House
Falling in Place
Secrets and Surprises
Chilly Scenes of Winter
Distortions